WORDS OF LIGHT

WORDS OF LIGHT

Theses on the
Photography of History

Eduardo Cadava

PRINCETON UNIVERSITY PRESS · PRINCETON, NEW JERSEY

Copyright © 1997 by Princeton University Press

Published by Princeton University Press,

41 William Street, Princeton, New Jersey 08540

In the United Kingdom: Princeton University Press,

Chichester, West Sussex

Library of Congress Cataloging-in-Publication Data

Cadava, Eduardo.

Words of light : theses on the photography of history /

Eduardo Cadava.

p. cm.

Includes bibliographical references and index.

ISBN 0-691-03450-8

ISBN 0-691-00268-1 (pbk.)

1. Photography—Philosophy. 2. Historiography.

3. Benjamin, Walter, 1892–1940. I. Title.

TR183.C33 1997

770'.1—dc20 96-17708 CIP

This book has been composed in Dante Typeface

Princeton University Press books are printed on acid-free
paper and meet the guidelines for permanence and
durability of the Committee on Production Guidelines for
Book Longevity of the Council on Library Resources

Second printing, and first paperback printing, 1998

http://pup.princeton.edu

Printed in the United States of America

P

La photographie montre la réalité de la pensée

—Jean-Luc Nancy, *Le poids d'une pensée*

CONTENTS

ILLUSTRATIONS

ACKNOWLEDGMENTS

LIKE THE photograph that can never capture the entirety of any given moment, the memory of acknowledgments can never remember well enough the numerous gifts to be acknowledged. It can never entirely express the gratitude and indebtedness from which any work is born. This is why, if this memory tells us anything, it tells us that the solitude of work has nothing to do with being alone. This book could never have come to light without the support and encouragement of many friends and colleagues. I am grateful to my colleagues at Princeton, in particular to Diana Fuss, Anke Gleber, Michael Jennings, Thomas Keenan, Thomas Levin, Eric Santner, Thomas Trezise, and Michael Wood, whose friendship and conversations have left their traces in many of the following pages. I would especially like to thank Anke Gleber and Gerhard Richter for checking all of my translations. Any infelicities that remain are entirely my responsibility. I am also blessed to feel myself a part of a broader community of friends and colleagues whose readings and comments at various stages of this project have been indispensable to my thinking about Benjamin and photography. I have benefited especially from discussions with Ian Balfour, Homi Bhabha, Judith Butler, Cynthia Chase, Peter Connor, Karin Cope, Kelly Dennis, Deborah Esch, Chris Fynsk, Eva Geulen, Maria Gough, Werner Hamacher, Wolf Kittler, David Lloyd, Elissa Marder, Patrice Petro, Eric Rentschler, Larry Rickels, Avital Ronell, Allan Sekula, Charles Sherry, Sally Stein, Andrzej Warminski, Samuel Weber, Patricia Williams, and Laura Zakarin.

I am grateful to Dr. Konrad Scheurmann, the Museum of Modern Art in New York, the Scottish National Portrait Gallery in Edinburgh, the Kracauer Estate, Deutsches Literaturarchiv in Marbach, the J. Paul Getty Museum, Klaus Wagenbach, the George Eastman House of International Photography in Rochester, Gisèle Freund, Hattula Moholy-Nagy, Arnold H. Crane, the Royal Commission on the Historical Monuments of England in London, the Bauhaus-Archiv in Berlin, the Adorno-Archiv in Frankfurt, Suhrkamp Verlag, Gary Smith, Günther Anders, and the community of Port Bou, all of whom helped me secure the prints that appear in the book and granted me

the permission necessary to reproduce them. I thank Princeton University's Committee for Research in the Humanities for monies that helped subsidize my research and production costs.

Portions of the book have appeared in various forms in *diacritics* (fall–winter 1992); *Fugitive Images*, ed. Patrice Petro (Bloomington: Indiana University Press, 1995); *Genre* (summer 1996); and *Aleph* (fall 1996). I am grateful to the editors for their permission to reprint this material.

I want to thank Mary Murrell for being such a wonderful editor. Her enthusiasm and support for this work has been inspiring, and her patience, receptiveness, and generosity throughout the project are exemplary. I thank her for her friendship. I am also thankful for the devoted and scrupulous attention that Jane Taylor and Beth Gianfagna gave to the manuscript.

Finally, I would like to thank my parents for their continued faith in me and my son, Gerry, whose own experiments with light helped me formulate its magic. This book is for him, with my gratitude for everything that he is.

ABBREVIATIONS

B Walter Benjamin, *Briefe*. Ed. Gershom Scholem and Theodor W. Adorno. Frankfurt am Main: Suhrkamp Verlag, 1978.

BW *Walter Benjamin/Gershom Scholem. Briefwechsel, 1933–1940*. Ed. Gershom Scholem. Frankfurt am Main: Suhrkamp Verlag, 1980.

C *The Correspondence of Walter Benjamin, 1910–1940*. Ed. Gershom Scholem and Theodor W. Adorno. Trans. Manfred R. Jacobson and Evelyn M. Jacobson. Chicago: University of Chicago Press, 1994.

CB Walter Benjamin, *Charles Baudelaire. A Lyric Poet in the Era of High Capitalism*. Trans. Harry Zohn. London: New Left Books, 1973.

CBS *The Correspondence of Walter Benjamin and Gershom Scholem: 1932–1940*. Ed. Gershom Scholem. Trans. Gary Smith and Andre Lefevere. New York: Schocken Books, 1989.

CP Walter Benjamin, "Central Park." Trans. Lloyd Spencer. *New German Critique* 34 (winter 1985): 32–58.

D Walter Benjamin, "Doctrine of the Similar." Trans. Knut Tarnowski. *New German Critique* 17 (spring 1979): 65–69.

GS Walter Benjamin, *Gesammelte Schriften*. Ed. Rolf Tiedemann and Hermann Schweppenhäuser. 7 vols. Frankfurt am Main: Suhrkamp Verlag, 1972–.

I Walter Benjamin, *Illuminations*. Ed. Hannah Arendt. Trans. Harry Zohn. New York: Schocken Books, 1968.

N Walter Benjamin, "N [Theoretics of Knowledge; Theory of Progress]." Trans. Leigh Hafrey and Richard Sieburth. In *Benjamin: Philosophy, Aesthetics, History*. Ed. Gary Smith. Chicago: University of Chicago Press, 1989.

O Walter Benjamin, *Origin of German Tragic Drama*. Trans. John Osborne. London: New Left Books, 1977.

OWS Walter Benjamin, *One-Way Street, and Other Writings*. Trans. Edmund Jephcott and Kingsley Shorter. London: New Left Books, 1979.

R Walter Benjamin, *Reflections*. Ed. Peter Demetz. Trans. Edmund Jephcott. New York: Harcourt Brace, 1978.

SE Sigmund Freud, *The Standard Edition of the Complete Psychological Works of Sigmund Freud*. Ed. and trans. James Strachey. 24 vols. London: Hogarth Press, 1953–74.

T Walter Benjamin, "Theories of German Fascism." Trans. Jerolf Wikoff. *New German Critique* 17 (spring 1979): 120–28.

PREFACE: PHŌTAGŌGÓS

THERE IS no preface that is not an opening to light. Like the small window that lets in the morning light or the aperture of a camera that gives way to images, the preface allows us to experience a kind of light. This light is a condition and matter of presentation. It casts a future tense on the significance of what has already been written. Like the photographic negative that can only be developed later, it traces the imprint of what is to come. At the same time, it is written only in order to be left behind. This is why the preface takes place in the interstices of the past, present, and future. A photograph of time, it throws its light on the passage that it is. Like the image that, in the writings of Walter Benjamin, flashes up and then vanishes into darkness, the preface names the transit between light and darkness that we might also call writing. In linking the activity of writing to that of photography, it can be said to consist of words of light.

Words of light. With these words from a notebook entry of 3 March 1839, William Henry Fox Talbot names the medium of photography.[1] Presenting this book under the illumination of these same words, I want to evoke what is in Benjamin the citational structure of both history and photography. Citation, I would argue, is perhaps another name for photography. When Benjamin claims that "to write history therefore means to *quote* history" (N 67 / GS 5:595), he suggests that historiography follows the principles of photography. *Words of light.* This names, then, not only the relation between history and photography but also the relation between language and photography. Photography is nothing else than a writing of light, a script of light, what Talbot elsewhere called "the pencil of nature." Its citational character tells us as well that history is sealed within the movement of language. This is why photography requires that we think about the impact of history on language: there is no word or image that is not haunted by history. Or, as Benjamin would have it, history cannot occur without the event of language, without the corresponding emergence of an image. *Words of light.* This phrase also names the relation between language and light, between language and the

possibility of lucidity, and of knowledge in general. Evoking photography's relation to both language and light, it bears the traces of Benjamin's reflections on the technologies of reproduction.

Theses on the Photography of History. Encrypting an allusion to Benjamin's "Theses on the Concept of History"—reproducing the title even as it alters it—this phrase substitutes the word *photography* for the word *concept* and, in so doing, calls forth what Benjamin understands to be the technical dimension of thought. Indicating the convergence of a thinking of history and a thinking of photography, it suggests an irreducible link between thought as memory and the technical dimension of memorization, the techniques of material inscription. In other words, photography—which Benjamin understands as "the first truly revolutionary means of reproduction" (*I* 224 / *GS* 1:481)—is a question not only of historiography, of the history of the concept of memory, but also of the history of the formation of concepts in general. *Theses on the Photography of History.* What is at stake here are the questions of artificial memory and of the modern forms of archivization, which today affect, with a speed and dimension that have no common measure with those of the past, every aspect of our relation to the world.[2] The phrase obliges us to rethink what links these processes of technological reproduction to our so-called psychical and interior memory. The extent to which memory and thought can be said to belong to the possibility of repetition, reproduction, citation, and inscription determines their relation to photography. Like the camera that seeks to fix a moment of history, thought wishes to bring history within the grasp of a concept (the word *Begriff*, concept, comes from *begreifen*, to conceive, to grasp).[3] *Theses on the Photography of History.* In the wording of Siegfried Kracauer, "historicism is concerned with the photography of time" ("Photography," 50). Both historiography and photography are media of historical investigation. That photographic technology belongs to the physiognomy of historical thought means that there can be no thinking of history that is not at the same time a thinking of photography.

Words of Light: Theses on the Photography of History. Placed together by the two dots that simultaneously join and separate them, these two phrases suggest that the following theses are themselves words of light—words about light, words about the history of the relation between words and light. That "words of light" also refers to photography means that we can view these theses as a series of photographs, snapshots in prose of Benjamin's own words of light, his own theses. *Words of Light: Theses on the Photography of*

History, then. This book attempts to understand Benjamin's concept of history by analyzing his persistent recourse to the language of photography in his discussions of history. Focusing on his discussions of the light, the flashes, the images, or the development of history, it suggests the ways in which photography becomes a means for Benjamin to reconsider not only the relation between history and historicism but also the relation between aesthetic ideology and the fascist aestheticization of politics. This recourse to the language of photography is readable not only in his 1931 essay, "A Short History of Photography," in his "Work of Art" essay, and in his "Theses on the Concept of History"—the essays that we might associate most readily with his investigations into the relation between history and technology—but also throughout his entire corpus. It can be accounted for in part by his interest in the practice of photography. Benjamin contributed to the avant-garde journal *i10*, which, under the direction of László Moholy-Nagy, focused on the technical media and, in particular, on film and photography. He was also the only writer associated with the "G Gruppe," a circle of artists and theorists from different disciplines—including Mies van der Rohe, Walter Ruttman, Naum Gabo, and Raoul Hausmann—who contributed regularly to the dadaist and surrealist journal *G*. He translated Tristan Tzara's "Man Ray and the Photography of the Converse" for the first issue of *G* in 1923, he reviewed numerous photography books (many of which he mentions in his essay on photography), and his friends included the photographers Sasha Stone (who designed the cover for his *Einbahnstraße*), Gisèle Freund (whose *La photographie en France au dix-neuvième siècle* formed the basis of many of his statements on the history of photography), and Germaine Krull (whose images he wished to use as illustrations for his arcades project, the *Passagen-Werk*).[4] This practical and personal interest in photography, however, is inseparable from his more philosophical and political interests in the medium. The questions raised by the links between photography and history touch on issues that belong to the entire trajectory of his writings—the historical and political consequences of technology; the relations between reproduction and mimesis, images and history, remembering and forgetting, allegory and mourning, visual and linguistic representation, and film and photography. We could even say that the constellation of motifs and themes around which Benjamin organizes his texts forms a lens through which we can begin to register and rethink the intersection between the question of history and that of photography.

I have tried to put these motifs and themes into syntactical relation with one another by inscribing them within the movement of a series of theses, Benjamin's own privileged mode of presentation. In this way, I have tried to replicate formally—as Benjamin so often did—the caesura of the historical event, the separation and discontinuity from which history emerges. If Benjamin suggests that there is no history without the capacity to arrest historical movement, he also requires a mode of writing that can remain faithful to this movement of interruption or suspension. Like the gaze of the camera that momentarily fixes history in an image, the thesis condenses a network of relations into a frame whose borders remain permeable. A photograph in prose, the thesis names a force of arrest. It signals in writing the interruption of writing. As Benjamin explains, it is because historical thinking involves "not only the flow of thoughts, but their arrest as well" that photography can become a model for the understanding of history, a model for its performance. Like the stage setting that in Benjamin's *Trauerspiel* book names the spatial enclosing and freezing of history (*O* 92 / *GS* 1:271), photography names a process that, seizing and tearing an image from its context, works to immobilize the flow of history. This is why, following the exigency of the fragment or thesis, photography can be said to be another name for the arrest that Benjamin identifies with the moment of revolution. Although Marx identifies revolutions as the "locomotives of world history," Benjamin suggests that "perhaps it is completely otherwise. Perhaps revolutions are, in this train of traveling generations, the reach for the emergency brake" (*GS* 1:1232). This moment of arrest is linked in Benjamin's thinking with what he sees in his essay on Goethe as the sudden emergence of the expressionless, in his "Critique of Violence" as the interruptive character of the general strike, in his writings on Baudelaire as the petrified restlessness of the image, in his writings on the mimetic faculty as the flashlike perception of similarity, and in his "Theses" as the messianic intervention into history. In each instance, Benjamin traces the effects of what he calls "the caesura in the movement of thought" (*N* 67 / *GS* 5:595). This caesura—whose force of immobilization not only gives way to the appearance of an image but also intervenes in the linearity of history and politics—can be understood in relation to what we might call the photograph's Medusa effect.[5] It belongs to the paratactic character of the thesis and it suggests that the demand for Benjamin's formal innovation is not only an epistemological demand but also a political one.

The following theses are also meant as a work of memorialization: they work to preserve the memory of Benjamin's own thetic method of writing, which Ernst Bloch once likened to "photomontage" (*Heritage of Our Times*, 335). They suggest a mode of thinking history that can neither be narrated in a linear, temporal sequence nor understood within the confines of a philosophical concept. History is rather constructed from images, from what Benjamin terms "dialectical images." These images, I suggest, can be understood best in terms of Benjamin's reflections on the relation between photography and history. The concept of the image is central to all of Benjamin's works— the imagistic character of his thought is legible from his early writings on language to the *Trauerspiel* book to the arcades project to his last text on the concept of history. It is the aim of the arcades project, he suggests, "to demonstrate that the materialistic presentation of history is imagistic in a higher sense than in traditional historiography" (*N* 51 / *GS* 5:578). This is why, comparing Benjamin's thought to a "photographic snapshot," Theodor Adorno suggests in his 1955 "Introduction to Benjamin's *Schriften*" that Benjamin experiences the world through a kind of "intellectual optic" (228, 230). Adorno had already described this optic specifically in relation to photography in his afterword to Benjamin's *Berliner Kindheit*. There, he encrypts an identification—mediated by the Hölderlinian aeronaut, Salomo—between Benjamin the writer and Nadar the photographer, that is, between Benjamin and, in particular, the Nadar who invented aerial photography. Referring to the photographic character of Benjamin's autobiographical text, Adorno writes: "The fairy-tale photographs of the 'Berlin Childhood'—they are not only ruins [seen] from the bird's-eye perspective of a life long transposed but also snapshots from out of that airy state, snapped [*knipste*] by that aeronaut, by asking his models kindly to keep still" ("Nachwort," 76).[6] Like Nadar's aerial photographs, Benjamin's writings seek to capture the shifting world beneath his gaze—and to do so within a field of fugitive images whose ruins name the essential relation between photography and death. In what follows, I suggest that this imagism—this photographic *Bildlichkeit*—at the heart of Benjamin's style of writing and thinking is linked to his effort to position the question of the image at the problematic center of modernity.

Ranging across the corpus of Benjamin's writings, the following theses therefore wish to trace the physiognomy of its images, to bring together various elements of his texts that are not generally thought of in relation to

one another. Moving from his discussions of photography to those of alle-
gory and mourning, from technology to writing, philosophy to psychoanaly-
sis, theory to its relation to light, ethics to danger, persons to cameras, they
present a series of photographs in prose that together reflect on what he sees
as the essential rapport between the fragmentary, thetic form of his writing
and his effort to write a history of modernity—a history that includes, among
many others, the writings of Marx, Blanqui, Baudelaire, Bergson, Freud,
Kafka, Proust, and Bloch. Moreover, working to clarify the ways in which
Benjamin's reflections on history and photography are linked to his analysis
of fascism, the theses place Benjamin's discussions of photography in relation
to the language of his contemporaries, especially that of Jünger and Kra-
cauer, but also against propagandistic writings that state the importance of
technology within the Nazi regime. In this way, they may help us measure
the enormous stakes, the urgency, of his having placed the question of the
image at the heart of any possible deconstruction of the history of modernity.

We can begin to suggest this urgency by recalling a passage from Jünger's
"Über den Schmerz," an essay devoted to describing the effects of technol-
ogy on our capacity to experience pain. Writing in 1934, the year of the
Nuremberg rallies, Jünger noted:

> Today wherever an event takes place it is surrounded by a circle of lenses
> and microphones and lit up by the flaming explosions of flashbulbs. In
> many cases, the event itself is completely subordinated to its "transmis-
> sion"; to a great degree, it has been turned into an object. Thus we have
> already experienced political trials, parliamentary meetings, and contests
> whose whole purpose is to be the object of a planetary broadcast. The
> event is bound neither to its particular space nor to its particular time, since
> it can be mirrored anywhere and repeated any number of times. These are
> signs that point to a great distance. (183)

There is no event, he suggests, that is not touched by the technical media,
that is not transformed into images of light or sound. Not only is the meaning
of an event transmitted across great distances by technical mediations—by
photographic lenses and radiophonic microphones, for example—but the
event *as* event is inscribed within the language of communication, represen-
tation, and information. Like the thought of the eternal return that, accord-
ing to Benjamin, transforms the historical event into a mass article (*GS* 5:429),
the technical media's instantaneous transmission of this image-event implies

that the meaning of an event can be experienced repeatedly, wherever it is viewed or heard. If Jünger suggests that time and space are now inconceivable without "the flaming explosions of flashbulbs," he also suggests that what we encounter here is an experience whose reproducibility removes it from temporal and spatial determinations altogether. In other words, it is because the media event (and for Jünger there is no other kind of event) is oriented toward the production of images that transmissions, in order to be what they are, must be pluralized, multiplied, reproduced: they must be able to be "mirrored anywhere and repeated any number of times." What makes an event an event is its technological reproducibility. What we see of a political or historical event is determined by the lenses and microphones that, zeroing in on the event, confine its meaning to an imposed sense. As the recent works of Avital Ronell have suggested, the politics and history of technology today tell us, among other things, that politics and history can no longer be considered prior to technology.[7] Politics and history are now to be understood as secondary, derivative forms of telecommunications. The media revolution's desire for instantaneous transmissions—for what Jünger elsewhere calls the "total mobilization" of the illusion of the world, of an entire world that would be "telepresent" at every moment—is therefore inseparable from its desire for images of light and sound. Since World War I, he explains, there has been no significant event that has not been captured by "the artificial eye" of the camera ("Über den Schmerz," 181). Wishing to transform the world into an image, into an object that can be distributed and circulated by the operative instruments of planetary information, the telephotographic image transforms our vision of the world. We no longer even need to look at the world: the camera now looks for us. Or rather, we have become, like the camera, nothing less than instruments for the recording of images and sound. This transit between persons and the instruments of the technical media is one of the reasons that, as Benjamin tells us in his *Passagen-Werk*, "the relationship of transmission to techniques of reproduction must be investigated" (*N* 58 / *GS* 5:586).[8] Nothing perhaps indicates this obligation more clearly than the Nazi effort to impose its *Weltanschauung*, its "vision of the world," on the German nation through the technical media.[9]

Pointing to the deracinating force of photographic and filmic mass media, Jünger also suggests that these media distance us from both the earth and ourselves. They intensify the process of objectification and detachment that characterizes our relation to technology. What is at stake for Jünger is the

articulation of a space in which the growing objectification of life would corre-
spond to our increased capacity to endure pain, in which "the growing pet-
rification of life could, in a deeper sense, be justified" ("Über den Schmerz,"
183). To the extent that photography and film contribute to this objectifica-
tion and petrification, they already express a silent fascist revolution taking
place under the name of modern technology, a revolution that had already
begun with the Nazis' seizure of power in 1933. Media technology's incursion
into the domain of politics played a central role in the Nazi's programmatic
Gleichschaltung (coordination) of the communications media. The press and
radio, the film and photo industries were mobilized in order to reproduce
and circulate earlier forms of Nazi propaganda. It is from this point of view
that we can understand Nazism as the most pervasive figure of media vio-
lence, the most virulent example of the political exploitation of the instru-
ments of modern telecommunications.[10] As Benjamin puts it in the *Passagen-
Werk*, "there is a kind of transmission that is a catastrophe" (*N* 63 / *GS* 5:591).
This catastrophic transmission would be the one that works to articulate a
single thing—whether it be the single meaning of a body, idea, community,
people, nation, or leader. It would be the one that, mobilized in order to
ensure the continuity and transfer of this single meaning, aligns itself with
what Jean-Luc Nancy has called the phantasms of immediacy and revela-
tion.[11] To the degree that all of Benjamin's writings can be said to be directed
against the logic of this immanence and revelation, they are to be read as
eminently political acts, even when they are not articulated in explicitly polit-
ical terms, but rather in linguistic and visual terms. If, for example, Adorno
claims that the images of Benjamin's *Berliner Kindheit*—in all of their "es-
tranging proximity"—"are neither idyllic nor contemplative," it is because,
as he puts it, "the shadow of Hitler's Reich lies upon them" ("Nachwort," 74).

Claiming to bring us closer to history, closer to the immanence, the real
time, of an event, the media obscures its relation to distance and death.
Although it seems to determine our conception of reality, it also distances us
from the already distanced reality it presents to us. That it claims to over-
come this distance—to reduce, that is, the distance between people and
events, or people and places—only enables it to install a greater distance. If
it brings people and events or places together at all, it is only in order to keep
them apart.[12] This is the kind of contradiction that lies behind Benjamin's
conception of aura, which, in one of its formulations, names the "singular
phenomenon of a distance however close it may be" (*I* 243 / *GS* 1:480). What

is brought close to us through lenses and microphones still can remain distant, he suggests, even as what is distant can be very close to us. This oscillation between space and time, between distance and proximity, touches on the very nature of photographic and filmic media, whose structure consists in the simultaneous reduction and maximization of distance. As Heidegger wrote in his 1947 lecture "The Thing," in a discussion of the ways in which technology has reduced distances in time and space: "Man puts the largest expanses behind him in the shortest time. He puts the greatest distances behind himself and thereby brings everything before him at the shortest range. Yet the rushed abolition of all remoteness brings no closeness; for closeness does not consist in the reduction of distance. What is least removed from us in terms of expanse, through the image in film or through sound in radio, can still remain remote. What in terms of expanse is unimaginably far removed, can be very close to us. Reduced distance is not in itself closeness. Nor is great distance remoteness" ("The Thing" 165 / "Das Ding" 163).[13] In other words, if the distance of an event is reduced through the various technical media that, acting over a distance, bring the event to us, at the same time, everything is even more distant than ever before: the event is not only torn from the context from which it takes its meaning, but what we are brought closer to is the event's reproduction. What we are brought closer to, that is, is something other than the event. What we encounter is the distance without which an event could never appear: a distance that comes in the form of an image or reproduction. Benjamin makes this point in his "Work of Art" essay. He writes:

> To bring things spatially and humanly "closer" is a no less passionate incli-
> nation of today's masses than is their tendency to overcome the uniqueness
> of every given [event] through the reception [*Aufnahme*] of its reproduc-
> tion. Every day the need grows stronger to get hold of an object as closely
> as possible in the image, that is, in the likeness, in the reproduction. And
> unmistakably the reproduction, as offered by illustrated magazines and
> newsreels, distinguishes itself from the image. Uniqueness and duration are
> as closely linked in the latter as are transitoriness and repeatability in the
> former. The prying of an object from its shell, the destruction of its aura,
> is the signature of a perception whose "sense of the sameness in the world"
> has increased to such a degree that it extracts it even from the unique by
> means of reproduction. (*I* 223 / *GS* 1:479)

The "passionate inclination of today's masses" to reduce or overcome distance—a passion linked to their desire for images—reveals an aporia. As Samuel Weber explains, "to bring something 'closer' presupposes a point or points of reference that are sufficiently fixed, sufficiently self-identical, to allow for the distinction between closeness and farness, proximity and distance. Where, however, what is 'brought closer' is itself already a reproduction—and as such, separated from itself—the closer it comes, the more distant it is."[14] If the desire "to bring things closer" implies a desire for immediacy and presence, a desire to coincide with history itself, Benjamin and Heidegger suggest that this wish to abolish distance only leads to more distance. Kracauer elaborates this point in his 1927 essay "Photography." There, in a passage that links the technical media not only to distance but also to a kind of amnesia and death, he writes:

> The aim of the illustrated newspapers is the complete reproduction of the world accessible to the photographic apparatus. They record the spatial impressions of people, conditions, and events from every possible perspective. This method corresponds to that of the weekly newsreel, which is nothing but a collection of photographs. . . . Never before has an age been so informed about itself, if being informed means having an image of objects that resembles them in a photographic sense. . . . In reality, however, the weekly photographic ration does not at all mean to refer to these objects or ur-images. If it were offering itself as an aid to memory, then memory would have to determine the selection. But the flood of photos sweeps away the dams of memory. The assault of this mass of images is so powerful that it threatens to destroy the potentially existing awareness of crucial traits. . . . In the illustrated magazines, people see the very world that the illustrated magazines prevent them from perceiving. The spatial continuum from the camera's perspective dominates the spatial appearance of the perceived object; the resemblance between the image and the object effaces the contours of the object's "history." Never before has a period known so little about itself. In the hands of the ruling society, the invention of illustrated magazines is one of the most powerful means of organizing a strike against understanding. Even the colorful arrangement of the images provides a not insignificant means for implementing such a strike. The *contiguity* of these images systematically excludes their contextual framework. . . . The "image-idea" drives away the idea. The blizzard of photographs betrays an indifference toward what the things mean. . . . It does not

have to be this way; but in any case the American illustrated magazines—which the publications of other countries emulate to a large degree—equate the world with the quintessence of the photographs. This equation is not made without good reason. For the world itself has taken on a "photographic face"; it can be photographed because it strives to be absorbed into the spatial continuum which yields to snapshots. . . . In the illustrated magazines the world has become a photographable present, and the photographed present has been entirely eternalized. Seemingly ripped from the clutch of death, in reality it has succumbed to it. (58–59)

Jünger suggests that an event can only be an event if it can be reproduced; Kracauer notes that it is precisely this reproducibility that prevents us from experiencing and understanding the event. The sheer mass of historical images, he suggests, threatens the link between memory and experience as well as the possibility of knowledge and perception in general. It is because the illustrated magazines and newspapers work to reproduce and present the entirety of the world through these images that the history of the world is in danger of becoming a rapidly expanding collection of images that, although leaving its truth behind, is nevertheless easily retrievable—that is, readily available in the eternal present made possible by the technical media. Like the giant film that Kracauer imagines would be able to depict "temporally interconnected events from every vantage point" (ibid., 50), history now names a movement of potentially boundless transmission that enables us to see what is happening everywhere in the world. To say that it is both constituted and effaced through the images that compose this movement means that the transmission of information in the form of photographs and film simultaneously leads us both toward and away from history. In other words, if there has never been an age "so informed about itself"—with so many images of itself—there has at the same time never been an age that has "known so little about itself." Grasping the world as an image does not mean having the world at hand. As Kracauer suggests, the world cannot be equated with the "quintessence" of photographs. The flood or blizzard of photographs "betrays an indifference toward what the things mean" and thereby reveals the historical blinding or amnesia at the heart of photographic technicalization. Substituting for the object and its history, the image represents a trait of the world that it at the same time withdraws from the field of perception. The event that gives the age of technological reproducibility its signature is the event of this withdrawal from sense.

Kracauer suggests that this "strike against understanding" is both the con-
sequence of the ways in which photographic images can be constructed and
manipulated and a structural component of photography and film in general.
Although images may help constitute the "truth" of an event, although they
may claim to present a "real event," they do not belong to the domain of
truth. In fact, the more illustrated magazines claim to bring the whole world
to their readers, the less these readers are able to perceive or understand this
world. Wishing to effect a strike against the strike against understanding
produced by such magazines, he tries to suggest the conditions of under-
standing within the context of this withdrawal of understanding: he argues
that the significance of photography lies not with its ability to reproduce a
given object but rather with its ability to tear it away from itself. What makes
photography photography is not its capacity to present what it photographs,
but its character as a force of interruption. If he suggests that there is no event
before this interruption, it is because the world's "photographability" has
become the condition under which it is constituted and perceived. As he
explains, "the world itself has taken on a 'photographic face.'" There is no
world before photography—which means that the world appears only in its
death.

We could even say that any collective or political program motivated by
a will to absolute and eternal immanence is organized around the production
of death. Seeking to eternalize its objects in the time and space of an image,
the photographic present returns eternally to the event of its death—a death
that comes with the death of understanding. That the photograph is always
touched by death means that it offers us a glimpse of a history to which we
no longer belong.[15] Kracauer's hope is that this glimpse, in exposing us to an
encounter with mortality, will enable a more general reflection on death.
Such a reflection would not only include a political dimension. It would also
engage what is for him the essence of the political. There can be no politics
in Kracauer without an organization of the time and space of death and
mourning.[16] Within the context of the Weimar Republic, Kracauer reads this
politics in its technical modernity—that is, in the relation between contem-
porary technical media and several experiences of the relation to death (in-
cluding those that are reducible neither to the memory and trauma of World
War I's technological mass destruction nor to the devastation brought about
by Taylorized systems of production). What remains at stake for him is the

possibility of a politics that, beginning from the presupposition of our mortality, asks us to be answerable for these deaths. As Miriam Hansen has recently put it, "the question for Kracauer was how film could turn its *material disposition* toward a confrontation with death into [an] . . . *aesthetic and political practice*, whether and how it could enable new forms of experience and subjectivity" ("'With Skin and Hair,'" 466). This interest in the possibility of "new forms of experience and subjectivity" can also be registered in Benjamin. As he explains, again in his "Work of Art" essay, film blasts the world asunder "by the dynamite of the tenth of a second, so that now, in the midst of its far-flung ruins and debris, we calmly go on adventurous journeys. With the close-up, space expands; with slow motion, movement is extended. The enlargement of a snapshot does not simply render more precise what was, albeit indistinctly, visible 'anyway': it reveals entirely new structural forms of the subject matter" (*I* 236 / *GS* 1:499–500).

Benjamin's entire corpus can be said to be organized around his effort to analyze these "new structural forms of the subject matter" in relation to the questions of reproducibility that inform his reflections on the technical media. His recourse to photographic language forms an essential dimension of the historical physiognomy of his writings, but also signals his engagement with what for him is the fundamental event of modernity: the production of the image. It is the task of the historical materialist, he tells us, to analyze the stratified network of differential sociopolitical relations within which such production takes place. This is why, in a note to his Baudelaire essay, he claims that the image in Baudelaire can be compared to "an image in a camera." He says that "societal tradition is this camera. It belongs to the instruments of critical theory, and it is among those an indispensable one" (*GS* 1:1164). In other words, there can be no critical theory without an understanding of the relation between social tradition and photography, without a sense of what an image is and of what it might mean to assume responsibility for one. It is this understanding and sense that make Benjamin not only one of Weimar Germany's most incisive political and cultural critics but also, even today, one of the most profound and probing thinkers of the relation between technology and the reproducibility of the image. It is an understanding and sense that he shares with László Moholy-Nagy. Claiming that "this century belongs to light," Moholy-Nagy states that "a knowledge of photography is just as important as that of the alphabet."[17] This is why, he adds, in

WORDS OF LIGHT

The true picture of the past flits by. The past can be seized only as an image which flashes up at the instant when it can be recognized and is never seen again. . . . For it is an irretrievable image of the past that threatens to disappear with every present that does not recognize itself as intended in it.

—WALTER BENJAMIN, "Theses on the Concept of History"

I.

HISTORY. — The state of emergency, the perpetual alarm that for Benjamin characterizes all history, corresponds with the photographic event. In his "Theses on the Concept of History," assembled while fleeing from Nazi Germany, shortly before his suicide in 1940, Benjamin conceives of history in the language of photography, as though he wished to offer us a series of snapshots of his latest reflections on history. Written from the perspective of disaster and catastrophe, the theses are a historico-biographical time-lapse camera that flashes back across Benjamin's concern, especially in his writings of the 1930s, over the complicity between aesthetic ideology and the fascist aestheticization of politics and war. Evoking images of the past that flash up only to disappear, inaugural moments of new revolutionary calendars that serve as moving cameras, and secret heliotropisms that link the past to the history of light, the theses work to question those forms of pragmatism, positivism, and historicism that Benjamin understands as so many versions of a realism that establishes its truth by evoking the authority of so-called facts.[1]

For Benjamin, there can be no fascism that is not touched by this ideology of realism, an ideology that both belongs and does not belong to the history of photography. Benjamin's consideration of the historical and philosophical questions suggested by the rise and fall of photography can therefore be understood as an effort to measure the extent to which the media of technical reproduction lend themselves to social and political forces that, for him, go in the direction of the worst. It can also be understood as a means to think

through the revolutionary potential of such media, especially in their decon-struction of the values of authority, autonomy, and originality in the work of art—values that, for Benjamin, helped formulate what Philippe Lacoue-Labarthe has called the national-aesthetic myths of origin prevailing in fascist Germany at the same time.[2] Benjamin's critique of "formalization," his read-ing of the relation between the emergence of fascism and the concept of the aesthetic, offers an account of the link between the ideology of organicism and a commitment to technological power. His concern with photography—its invention and its history—coincides with his interest in the effects of technology on our understanding of the aesthetic, effects that delineate the features of our modernity. The advent of photography, for Benjamin, raises the problem of the work of art in the age of its technological reproduction as the problem of fascism, and hence inaugurates a rethinking of a series of "concepts, such as creativity and genius, eternal value and mystery . . . whose uncontrolled (and at present hardly controllable) application would lead to a processing of data in the Fascist sense" (*I* 218 / *GS* 1:435).[3]

His insistence on the necessity of addressing these questions and relations today—then in the 1930s as well as now, under the light or darkness of a scarcely less disastrous historical moment—is, above all, a call to responsibil-ity, a call that requires a passionate and determined effort of reflection.[4] One can no more escape this obligation to think than one can escape the obliga-tion to act. And what must be thought and acted on, under the illumination or darkness of these questions, is the possible convergence of photography and history, a convergence that Benjamin often locates within the historio-graphical event. He writes:

> The tradition of bourgeois society may be compared to a camera. The bourgeois scholar peers into it like the amateur who enjoys the colorful images in the viewfinder. The materialist dialectician operates with it. His job is to set a focus [*festzustellen*]. He may opt for a smaller or wider angle, for harsher political or softer historical lighting—but he finally adjusts the shutter and shoots. Once he has carried off the photographic plate—the image of the object as it has entered social tradition—the concept assumes its rights and develops it. For the plate can only offer a negative. It is the product of an apparatus that substitutes light for shade, shade for light. Nothing would be more inappropriate than for the image formed in this way to claim finality for itself. (*GS* 1:1165)[5]

II.

HELIOTROPISM. — There has never been a time without the photograph, without the residue and writing of light. If in the beginning we find the Word, this Word has always been a Word of light, the "let there be light" without which there would be no history. In Villiers de l'Isle-Adam's *Tomorrow's Eve*, God gives Adam the gift of history by giving him photography. The first days of creation bring to light a universe of photons whose transmission within time requires the photographic fix. Linking biblical exegesis to questions of electricity, Villiers raises the question of why God had to make light more than once. For light to survive, to survive itself, it must come again, and this coming again has, as one of its names, the name of photography.[6] In the ancient correspondence between photography and philosophy, the photograph, relayed by the trope of light, becomes a figure of knowledge as well as of nature, a solar language of cognition that gives the mind and the senses access to the invisible. What comes to light in the history of photography, in the history that is photography, is therefore the secret rapport between photography and philosophy. Both take their life from light, from a light that coincides with the conditions of possibility for clarity, reflection, speculation, and lucidity—that is, for knowledge in general. For Benjamin, the history of knowledge is a history of the vicissitudes of light. For him, there can be no philosophy without photography. As he writes in his *Passagen-Werk*, "knowledge comes only in flashes" (*N* 43 / *GS* 5:570), in a moment of simultaneous illumination and blindness.[7]

III.

ORIGINS. — Photography prevents us from knowing what an image is and whether we even see one. It is no accident that Benjamin's 1931 essay "A Short History of Photography" begins not with a sudden clarity that grants knowledge security, but rather with an evocation of the "fog" that he claims surrounds the beginnings of photography—a fog that, although not so thick as the one that shrouds the early days of printing, nevertheless serves as an obstacle to both knowledge and vision. From the very beginning, then, the

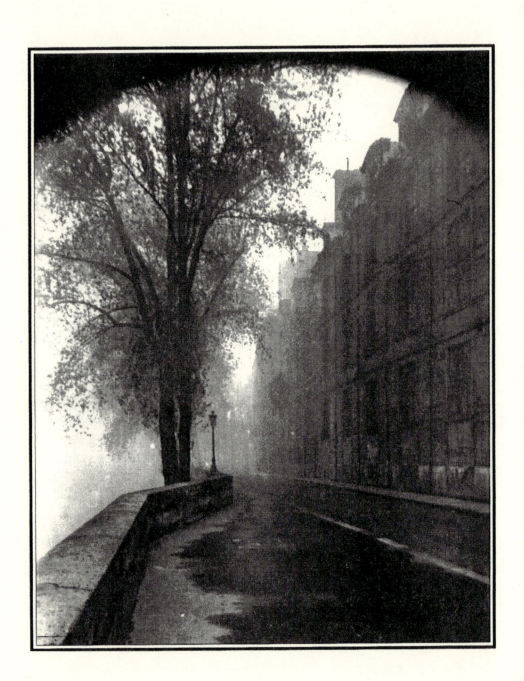

fog occludes the ostensible object of the essay: it disturbs the possibility of a linear historical account of photography's origins. For Benjamin, there can be no history of photography that would begin with the "once upon a time" that characterizes history's *cliché*—the click of history as well as the negativity from which it develops. This inaugural haze, this luminous mist—a figure Benjamin often uses to allegorize the atmosphere within which memory works—covers nothing that we might understand or encounter in memory. Immediately different from itself, always taking another form, the fog spreads its mist throughout the essay, and in so doing interrupts the dream of knowing and seeing that structures the history of photography, that informs the desire of the photographic event—even before it begins.[8] If a fog encircles the childhood of photography—as it does Benjamin's own recollections of childhood in his *Berlin Chronicle*, recollections that are, in essence, a series of snapshots in prose—it is in part because, in the experience of the photograph, it is as if we cannot see a thing. In the twilight zone between seeing and not seeing, we fail to get the picture.

IV.

MORTIFICATION. — The incunabula of photography—its beginnings, its childhood, but also its burial place, its funereal plot, its relation to printing and inscription—flashes the truth of the photo. This truth says, if it can say anything, that what structures the relationship between the photographic image and any particular referent, between the photograph and the photographed, is the absence of relation, what Benjamin calls—referring to what, in Eugène Atget's photographs of deserted streets in Paris, anticipates surrealist photography—"a salutary estrangement between man and his surroundings" (*OWS* 251 / *GS* 2:379). This is why, he explains, "it would be a misreading of the incunabula of photography to emphasize their 'artistic perfection'" (248 / 376). Rather than reproducing, faithfully and perfectly, the photographed as such, the photographic image conjures up its death. Pierre Mac Orlan makes this point in his preface to the 1930 edition of *Atget photographe de Paris*. There, he writes that "the power of photography consists in creating sudden death. . . . The camera's click suspends life in an act that the developed film reveals as its essence" ("Preface," 43).[9] Read

against the grain of a certain faith in the mimetic capacity of photography, the photographic event reproduces, according to its own faithful and rigorous deathbringing manner, the posthumous character of our lived experience. The home of the photographed is the cemetery. Benjamin exhibits this insight in his discussion of the early portraits of David Octavius Hill:

> In short, all of the possibilities of this portrait art arise because the contact between actuality and photography has not yet occurred. Many of Hill's portraits originated in the Edinburgh Greyfriars cemetery—nothing is more characteristic of this early period, except maybe the way the models were at home there. And indeed this cemetery, according to one of Hill's pictures, is itself like an interior, a separate closed-off space where the gravestones, propped against gable walls, rise from the grass, hollowed out like chimneys, with inscriptions inside instead of tongues of flames. (*OWS* 244–45 / *GS* 2:372–73)[10]

For Benjamin, Hill's Edinburgh portraits offer a "literarization" (*Literarisierung*) of the conditions of living (*R* 225 / *GS* 2:688), of the living social context within which we are positioned: we live as if we were always in a cemetery, and we live in this deadly way among and *as* inscriptions. The portraits bear witness to the recognition that we are most ourselves, most at home, when we remember the possibility of our death. We come to ourselves through these photographs, through these memories of a mourning yet to come. This experience of our relation to memory, of our relation to the process of memorialization, is not at all accidental: nothing is more characteristic. We appear to ourselves only in this bereaved allegory, even before the moment of our death. Subjects of photography, seized by the camera, we are mortified—that is, objectified, "thingified," imaged. "The procedure itself," Benjamin explains, "caused the models to live, not out of the instant, but into it; during the long exposure they developed, as it were, into the image" (245 / 373).

What is most striking about the strange situation that Benjamin describes here is that it allows us to speak of our death *before* our death. The image already announces our absence. We need only know that we are mortal—the photograph tells us we will die, one day we will no longer be here, or rather, we will only be here the way we have always been here, *as* images. It announces the death of the photographed. This is why what survives in a photograph is also the survival of the dead—what departs, desists, and withdraws. "Man withdraws from the photographic image" (*I* 226 / *GS* 1:485),

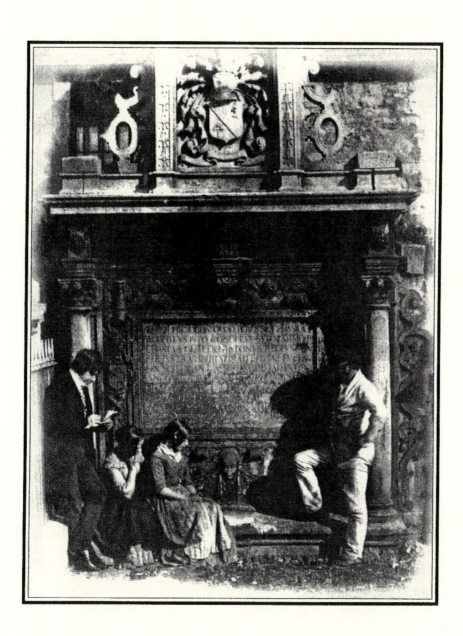

Benjamin writes in his artwork essay. This withdrawal does not consist in the various forms of shyness that attend the photographic event: in the instance of Hill's photographs, for example, the "discreet reserve" of his camera, the shyness of his subjects "in the face of the apparatus," or the photographer who, looking at his photographs, shies away from the looks of his subjects, assuming that they can see him. The withdrawal to which Benjamin refers here is not an empirical withdrawal, but rather a withdrawal that is funda-mental to the temporal structure of the photograph. There can be no photo-graph without the withdrawal of what is photographed. Like the paintings of Charles Meryon, which, in the words of Gustave Geffroy, "are taken directly from life" but nevertheless "give an impression of expired life, of something that is dead or is going to die" (CB 88 / GS 1:592), photographs bring death to the photographed. The conjunction of death and the photographed is in fact the very principle of photographic certitude: the photograph is a cemetery. A small funerary monument, the photograph is a grave for the living dead. It tells their history—a history of ghosts and shadows—and it does so because it *is* this history. As Roland Barthes explains, if the photograph bespeaks a certain horror, it is because "it certifies that the corpse is alive, *as corpse*: it is the living image of a dead thing" (79).[11]

This identification between image and corpse—the being-toward-death of the image—is the focus of Maurice Blanchot's 1955 essay, "The Two Versions of the Imaginary." There, he suggests that "the cadaver's strangeness is per-haps also that of the image" (256). If it is true that the power of the image belongs to the power of death—to what Blanchot calls "the power of the negative" (261)—then it is only from the point of view of death, from the point of view of the photographed, that an image can be said to be possible. In other words, there can be no image that is not also an image of death. Nevertheless, this image-corpse, a kind of tomb in which subject and object are encrypted, at the same time points to what cannot be reduced to the photograph—the photograph itself. As its own grave, the photograph is what exceeds the pho-tograph within the photograph. It is what remains of what passes into history. It turns in on itself in order to survive, in order to withdraw into a space in which it might defer its decay, into an interior—the closed-off space of writ-ing itself. In order for a photograph to be a photograph, it must become the tomb that writes, that harbors its own death. If the photograph is the allegory of our modernity, it is because, like allegory, it is defined by its relation to the

corpse. Like the characters of the *Trauerspiel* who die because, as Benjamin says, "it is only thus, as corpses, that they can enter the homeland of allegory" (*O* 217 / *GS* 1:392), the photograph dies in the photograph because only in this way can it be the uncanny tomb of our memory.

V.

G H O S T S. — Photography is a mode of bereavement. It speaks to us of mortification. Even though it still remains to be thought, the essential relation between death and language flashes up before us in the photographic image.[12] "What we know that we will soon no longer have before us," Benjamin writes, "this is what becomes an image" (*CB* 87 / *GS* 1:590). Like an angel of history whose wings register the traces of this disappearance, the image bears witness to an experience that cannot come to light. This experience is the experience of the shock of experience, of experience as bereavement. This bereavement acknowledges what takes place in any photograph—the return of the departed. Although what the photograph photographs is no longer present or living, its having-been-there now forms part of the referential structure of our relationship to the photograph.[13] Nevertheless, the return of what was once there takes the form of a haunting. As Benjamin suggests in his 1916 essay on the *Trauerspiel*, "the dead become ghosts" (*GS* 2:136). The possibility of the photographic image requires that there be such things as ghosts and phantoms.[14] This identification between the photographic process and the figure of the ghost is made in the name of Atget in Robert Desnos's belated notice of the photographer's death. "Atget is no more," he writes. "His ghost, I was going to say 'negative,' must haunt the innumerable poetic places of the capital" ("Spectacles of the Street," 17). Suggesting that it is from the ghost of Atget that we will be able to make innumerable, poetic prints of Paris, Desnos here evokes the irreducible relation between life and death that structures the photographic event. We could even say that the lesson of the photograph for history—what it says about the spectralization of light, about the electrical flashes of remote spirits—is that every attempt to bring the other to the light of day, to keep the other alive, silently presumes that it is mortal, that it is always already touched (or re-

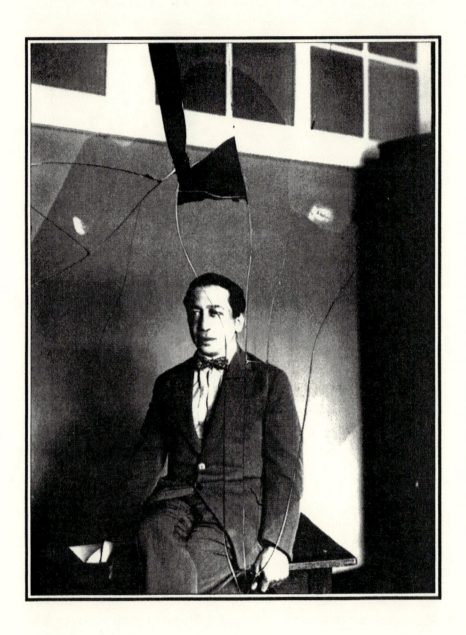

touched) by death. The survival of the photographed is therefore never only the survival of its life, but also of its death.[15] It forms part of the "history of how a person *lives on*, and precisely how this afterlife, with its own history, is embedded in life" (*C* 149 / *B* 220). As Kracauer explains, anticipating Benjamin's insight:

> The image wanders ghostlike through the present. Ghostly apparitions occur only in places where a terrible deed has been committed. The photograph becomes a ghost because the costume doll lived. . . . This ghostlike reality is *unredeemed*. . . . A shudder goes through the viewer of old photographs for they do not illustrate the recognition of the original but rather the spatial configuration of a moment; it is not the person who appears in his photograph, but the sum of what is to be deducted from him. It annihilates the person by portraying him, and were he to converge with it, he would not exist. ("Photography," 56)

This is why it is precisely in death that the power of the photograph is revealed, and revealed to the very extent that it continues to evoke what can no longer be there. Since this possibility is exposed at death, we can assume it exists before death. In photographing someone, we know that the photograph will survive him—it begins, even during his life, to circulate without him, figuring and anticipating his death each time it is looked at.[16] The photograph is a farewell. It belongs to the afterlife of the photographed. It is permanently inflamed by the instantaneous flash of death.

VI.

MIMESIS. — The forgetting of the photograph's ghostly or spectral character, of its relation to a death that survives itself, corresponds to what Benjamin refers to as "the decline of photography."[17] This decline is at first presented as a decline that can be understood temporally, that can be traced within the history of the photographic event. Early photographs are described as having an aura, an atmospheric medium that lends them a phantasmatic, instantaneous, hallucinatory quality—a quality that, as he tells us, is "by no means the mere product of a primitive camera" (*OWS* 248 / *GS* 2:376). Later photographs, however, are said to be marked by an increasingly mi-

metic ideology of realism, an ideology reinforced by advances in the technical sophistication of the camera. What is surprising is that photography's decline does not coincide, as one might expect, with a decline in the technical efficiency of the camera or in its capacity to register what is photographed. Rather, it corresponds to the technical refinement of the camera's performance. "In that early period," Benjamin writes, "object and technology are as exactly congruent as they become incongruent in the following period of decline. For soon advances in optics made instruments available that overcame darkness entirely and recorded appearances like a mirror" (248 / 376–77).[18] The conquest of darkness by the increased light of photography conjures a link of fidelity between the photograph and the photographed. Advances in the photographic apparatus, in the optical system formed by the lenses that transfer photographed images into an image recorded on a plate or film, and, finally, in the chemical process whereby the object of the optical system is revealed, seem to make possible a coincidence between the moment of the act of recording and the moment of the referent. Yet it is precisely the conviction in this coincidence, in the photographic possibility of faithful reproduction, that for Benjamin marks the decline of photography. As Baudelaire explains, in a passage cited by Benjamin, "In these sorry days, a new industry has arisen that has done not a little to strengthen the asinine belief . . . that art is and can be nothing other than the accurate reflection of nature. . . . A vengeful god has hearkened to the voice of this multitude. Daguerre became his Messiah" (256 / 384–85).

For both Benjamin and Baudelaire, the historical and mimetological schema presupposed and enacted within the time of the decline of photography—(1) the decline inaugurated by the advent of photography in the way we perceive the relation between the work of art and what it represents; (2) the decline that happens *in* photography, within the history of photography; and (3) the decline that *is* photography—perverts, because it forgets, the disjunctive power that Benjamin locates in the structure of the photographic event. This is why the photographic light that "overcomes darkness entirely" fails to illuminate the photograph, and fails precisely because it forgets what a photograph is, because it dissimulates the photograph's inability to represent. Benjamin's reversal—a reversal that follows Baudelaire's own—of the values of incongruency and congruency, infidelity and fidelity, suggests that the decline of which he writes is not a decline that occurs in and with time. "There are no periods of decline" (*N* 44 / *GS* 5:571), he explains elsewhere. If

there are no *periods* of decline, it is because there is no period *without* decline. This is why the decline of photography needs to be understood as structural, a necessary dimension of any photograph, rather than as merely a moment in a temporal process. The decline of photography names the photograph's own decline, its movement away from the schema of mimetic reproduction. It suggests that the most faithful photograph, the photograph most faithful to the event of the photograph, is the least faithful one, the least mimetic one— the photograph that remains faithful to its own infidelity. It dislocates—it *is* the dislocation, from within, of the possibility of reflection. Immobilizing and interdicting the passage between the photograph and the photographed, the decline of photography names both the involuntary conjuring of a distance, of an aura, and the forgetting of this ghostly emergence. The doctrine of mimesis that organizes Benjamin's essay on photography—a doctrine that anticipates the general theory of mimesis he offers in his two 1933 essays, "The Doctrine of the Similar" and "On the Mimetic Faculty"[19]—presupposes a congruence between subject and technique that corresponds to, is congruent with, an essential incongruence. The photograph, the medium of likeness, speaks only of what is unlike. It says "the photograph is an impossible memory." Because this forgetting is inscribed within every photograph, there is history—the history of photography as well as the history inaugurated by the photograph.

VII.

TRANSLATIONS. — The disjunction that characterizes the relation between a photograph and the photographed corresponds to the caesura between a translation and an original. As Benjamin notes in his 1923 essay "The Task of the Translator"—written as an introduction to his own translation of Baudelaire's *Tableaux parisiens*—"no translation would be possible if in its ultimate essence it strove for likeness to the original" (*I* 73 / *GS* 4:12). Like the photographer who must acknowledge the infidelity of photography, the Benjaminian translator must give up the effort to reproduce the original faithfully. Or rather, in order to be faithful to what is translatable in the original, the translator must depart from it, must seek the realization of his task in something other than the original itself. "No translation," Benjamin

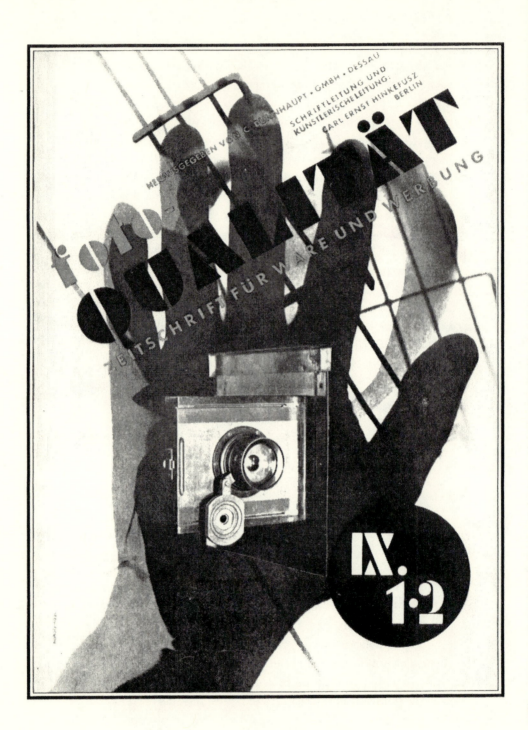

FOTO-QUALITÄT

ZEITSCHRIFT FÜR WARE UND WERBUNG

HERAUSGEGEBEN VON C. BRANHAUPT · GMBH · DESSAU

SCHRIFTLEITUNG UND
KÜNSTLERISCHELEITUNG:
CARL ERNST HINKEFUSZ BERLIN

IX.
1·2

writes, "however good it may be, can have any significance as regards the original" (71 / 10).[20]

If translation is not a matter of communication, not a task aimed at imparting sense to the original, it is also because the essential quality of the original, of the literary work in general, does not itself belong to the domains of communication or meaning (69 / 9). This is why, Benjamin explains, "translation must in large measure refrain from wanting to communicate something, from rendering the sense. . . . The original is important to it only insofar as it has already relieved the translator and his translation of the effort of assembling and expressing what is to be conveyed" (78 / 18). Claiming that a translation remains faithful only to the extent that it holds to an emancipation from sense, Benjamin here suggests that the translation must pursue "its own course according to the laws of fidelity in the freedom of linguistic flux" (80 / 20).

The task of translation is not to render a foreign language into one we may call our own, but rather to preserve the foreignness of this language. As Benjamin explains, translation is "only a somewhat provisional way of coming to terms with the foreignness of languages" (75 / 14), including our own. If languages remain foreign—to other languages and to themselves—it is because, unfolding in time, and according to heterogeneous and discontinuous paths, they change incessantly. That a language is always in the process of becoming different from itself—that it is in fact never itself—can be understood, according to Benjamin, in relation to the fugacity of images. Like the image that always flits past cognition, language eludes the grasp of the translator. The attempt to "grasp the genuine relation between an original and a translation" therefore "requires an investigation analogous to the movements of thought by which a critique of cognition would have to prove the impossibility of an image theory" (73 / 12). Just as this critique would demonstrate "that in cognition there could be no objectivity, not even a claim to it, if it dealt with images of reality" (73 / 12) a critique of translation would show the essential "disjunction" (*Gebrochenheit*; 75 / 15) between a translation and the original. "For in its afterlife," Benjamin writes, "which would not be called that if it were not a transformation and a renewal of something living—the original undergoes a change. Even words with fixed meaning can undergo a maturing process" (73 / 12). If an original can only live on in its alteration, it is no longer alive as itself but rather as something other than itself. To say that "a translation issues from the original—not so much from

its life as from its afterlife" (71 / 10) is therefore to say that translation demands the death of the original. Or more precisely, like the photograph that names both the dead and the survival of the dead, translation names death's continued existence. The original lives beyond its own death in translation just as the photographed survives its own mortification in a photograph. If the task of translation belongs to that of photography, it is because both begin in the death of their subjects, both take place in the realm of ghosts and phantoms.

VIII.

INSCRIPTIONS. — The aura of a work of art refers to its "here and now, its unique existence at the place where it happens to be" (*I* 220 / *GS* 4:475). "The here and now of the original," Benjamin writes, "constitutes the concept of its authenticity. . . . The whole sphere of authenticity withdraws from technical—and, of course, not only technical—reproducibility" (220 / 476). If what is authentic is outside reproducibility, this does not necessarily mean that Benjamin is here making a distinction between the "authentic" and the reproduced. Rather, as Rey Chow suggests, "once the process of reproducibility has begun (and it has always already begun) . . . 'authenticity' itself is always *on the outside*: it does not really exist" ("Walter Benjamin's Love Affair with Death," 70). In removing the criteria of authenticity from the evaluation of an artwork, the possibility of reproducibility contributes and corresponds to the decay of the aura: "what withers in the age of the technological reproducibility of the work of art is its aura. . . . The technology of reproduction, one might say generally, detaches the reproduced object from the domain of tradition" (*I* 221 / *GS* 4:477). The prevalence of techniques of reproduction within the field of photography, for example, makes it possible to replicate any given negative an indefinite number of times. This capacity for reproduction and circulation undermines the notion of an artwork's singularity, what Benjamin calls its "cult value" (224 / 482). In so doing, it "detaches" the artwork from the history of a tradition that has always privileged the artwork's uniqueness, that has always valued the concepts of genius, creativity, and originality. Rather than being defined by its "cultic value," the artwork is now characterized by its "exhibitional value,"

by its ability to circulate and to be exhibited. Benjamin's discussion of "technological reproducibility" therefore indicates the transformation effected on the significance of the work of art by the predominance of techniques of replication: to the extent that technology is related to the realm of aesthetics, it works to question aesthetics as an autonomous realm by exposing its reliance on historical processes of production and distribution.

The questioning of aesthetics that Benjamin traces in relation to the advent of film and photography recalls his argument about the relation between allegory and art in his earlier work on the *Ursprung des deutschen Trauerspiels*. The intrusion of baroque allegory into the field of art (and Benjamin claims that allegory has never been absent from this field) can be described, he writes, "as a disorderly conduct directed against the peace and the order of artistic lawfulness" (*O* 177 / *GS* 1:353). Its emphasis on the inevitability of repetition, on the citational and scriptural character of history, suggests that the notion of an "original" or "unique" work of art is already as difficult to sustain in the German baroque mourning play as it will be with the emergence of photography and film. "Origin," he claims, in a famous but enigmatic formulation, "although a historical category, has, nevertheless, nothing in common with emergence. What is meant by Origin is not the becoming of something that has sprung forth, but rather what springs forth out of coming to be and passing away. . . . The original never reveals itself in the bare and manifest existence of the factual" (45 / 226). What is "mourned" within baroque allegory is not only the loss of the artwork's originality or singularity, however, but also that of the transcendent radiance "which was at one time . . . used in an attempt to define the essence of artistry" (180 / 356). In both instances—the loss of the aura of originality and the loss of the artwork's relation to transcendence—the *Trauerspiel*'s technical and allegorical emphasis on emblems, ruins, and inscriptions, like the techniques of reproduction characteristic of film and photography, raises a series of questions about the possibility of defining the specificity or "essence" of the artwork.

These questions are often organized in Benjamin's discussions around the scriptural or linguistic dimension of either allegory or photography. As Samuel Weber notes, "in the same way that film and photography come to require captions, legends, and inscriptions, the fragmentation and dislocation of the phenomenal world in baroque allegory engenders a temporality of repetition characterized by a prevalence of inscription: legends become necessary to mark the way and to bridge an image with its meaning, with the

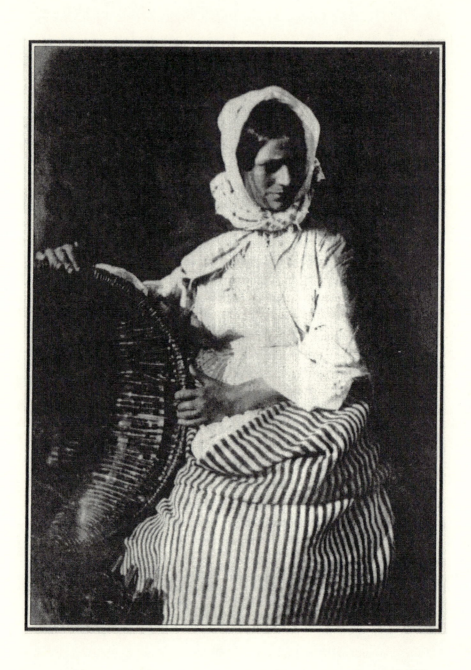

result that the images themselves signify only as elements in a pictorial script
(*Bilderschrift*)."[21] It is not surprising that these legends share in the light of
photography. Referred to as a "flashing in the entangling darkness of alle-
gory," they have the same function "as lighting in baroque painting" (*O*
197 / *GS* 1:373). For Benjamin, the lesson inherent in the authenticity of the
photograph is the link between the photograph and writing, between pho-
tography and the prevalence of inscription. As he states at the end of the
photography essay, citing László Moholy-Nagy without acknowledging him,
" 'The illiteracy of the future,' it has been said, 'will be ignorance not of
reading or writing, but of photography.' But must not a photographer who
cannot read his own pictures be no less considered an illiterate? Will not the
inscription become the most essential part of the photograph?" (*OWS* 256 /
GS 2:385). He elaborates this point in his 1934 address to the Parisian Institute
for the Study of Fascism, "The Author as Producer." There, arguing that the
photographer must learn how to underline his image with a caption that
gives it revolutionary value, he suggests that this demand can be made more
forcefully only when writers break through the "barrier between writing and
image" and "start taking photographs" (*R* 230 / *GS* 2:693).

IX.

LIGHTNING. — Like photography, lightning in Benjamin names the
movement of writing and inscription.[22] Linked to the flashes of memory, the
suddenness of the perception of similarity, the irruption of events or images,
and even the passage into night, Benjamin's vocabulary of lightning helps
register what comes to pass in the opening and closing of vision. It tells us
what brings sight to writing. Related to the Hegelian lightning bolt that gives
birth to the image-structure of a new world, the Hölderlinian lightning that
speaks the divine language of the gods, and the Nietzschean words that come
in the form of lightning, the lightning that traverses Benjamin's writing also
comes as language. Adorno makes this association between the force of
Benjamin's writing and that of lightning when, discussing Benjamin's corre-
spondence, he notes that "flashes of imperiousness dart through the often
nebulous early letters like lightning bolts in search of tinder" ("Benjamin the

Letter Writer," 237). Lightning signals the force and experience of an inter-
ruption that enables a sudden moment of clarification or illumination. What
is illumined or lighted by the punctual intensity of this or that strike of light-
ning, however—the emergence of an image, for example—can at the same
time be burned, incinerated, consumed in flames. Like the "light pattern" or
"fire-writing" that for Johann Wilhelm Ritter—whom Benjamin cites in his
Trauerspiel book—indicates the "inner connection of word and script," the
wordlike character of "the whole of creation" (*O* 213–14 / *GS* 1:387–88), light-
ning brands and stamps whatever it illumines or destroys and the cinders it
leaves behind remain as its signature.

Not only is the writing-that-lightning-is immolated at the very moment of
its emergence, but the illumined objects of its reflections go up in flames in
order to make reflection itself possible. The truth-content of any given reflec-
tion can only arise, that is, with the destruction of what the reflection seeks
to understand. As Benjamin writes in his discussion of the German mourning
play, "truth is not a process of exposure that destroys the secret, but a revela-
tion which does justice to it." Beauty, the content of truth, "does not emerge
in an unveiling, rather it manifests itself in a process that one might call, in
a simile, the flaming up of the veil that enters the circle of ideas, the burning
of the work, in which its form reaches the high point of its luminosity"
(31 / 211). A luminosity that blinds as much as it enlightens, the flame tells us
that truth springs forth in the burning of the work—the work that burns, that
is being consumed by the flame, but also the work that burns its contents.
Remaining faithful to the work's secret, truth reveals its inability to present
itself, to be presented.[23] We could even say that truth means the making of
ashes. That there can be neither truth nor photography without ashes means
that, like allegory, both take place only in a state of decay, in a state that
moves away from itself in order to be what it is. Like the photograph that
tells us what is no longer before us, truth can only be read, if it can be read
at all, in the traces of what is no longer present. This is why Benjamin links
the flash of lightning to that of reading. Noting the irruptive temporality of
allegory, he writes: "Fundamentally, then, the *Trauerspiel*, developed in the
realm of the allegorical, is according to its form a reading-drama. . . . The
situations changed infrequently, but when they did, they did so in a flash
[*blitzartig*], like the look of the print-type when one turns the page" (185 /
361). Like the "sign-script [*Zeichen-schrift*] of transience" that inscribes the

word "history" on "the countenance of nature" (177 / 353), these flashing letters figure not only the transitory character of allegory itself but also the scriptural character of history. That both allegory and history are to be read in their transcience means that their truth comes in the form of ruins. As Benjamin writes in "Central Park," in a passage that, associating life with the coming of death, evokes the striking force of allegory, "Whatever is struck by the allegorical intention is severed from the contexts of life: it is at once destroyed and conserved. Allegory holds fast to ruins. It offers the image of petrified unrest" (CP 38 / GS 1:666). These ruins name the shifting site of photography's truth. A site wherein the photographed is both "destroyed and conserved," the photograph is itself a ruin, an "image of petrified unrest." Like allegory, it "signifies precisely the nonbeing of what it presents" (O 233 / GS 1:406).

The sheer alterity of the flame's becoming and disappearing—in one sense, the photographic condensation of the lightning flash itself—had already been linked by Benjamin to the moment of the emergence of truth in the opening paragraph of his 1921 essay on Goethe. There, in a passage that understands the work of criticism as a work that, beginning with commentary, asks about the survival of the work of art, Benjamin writes: "The history of works prepares their critique. . . . If, to use a simile, one views the growing work as a flaming pyre, then the commentator stands before it like the chemist, the critic like the alchemist. Where for the former only wood and ashes remain as the object of his analysis, for the other only the flame itself bears an enigma: that of the living. Thus the critic asks about the truth whose living flame continues to burn over the heavy logs of the past and the light ashes of past experience" (GS 1:125–26). The history of works, he suggests, tells us that all works are funereal: they bear an essential rapport to their finitude, and indeed survive only to the extent to which they exhibit their death. If the commentator reads what enlivens the flame, what the flame leaves behind, the critic encounters its enigma, that of life. Life is enigmatic because it comes with death: there is no life that is not already dying, that is not already being consumed by the flame in which it is sealed. That is to say, there is no life except the "life that signifies death" (CP 39 / GS 1:667). This is why we can say that there is no photograph, no image, that does not reduce the photographed to ashes. As Man Ray wrote in 1934, in an essay entitled "The Age of Light," images are the "oxidized residues, fixed by light and

chemical elements, of living organisms. No plastic expression can ever be more than a residue of an experience. . . . [It is rather] the recognition of an image that has survived an experience tragically, recalling the event more or less clearly, like the undisturbed ashes of an object consumed by flames" (53). Benjamin makes this point again in his essay "The Storyteller" in a passage that identifies flame with the reader.[24] The reader is said to "annihilate" and "devour" the "stuff" or "subject matter" [*Stoff*] of a novel "as fire does logs in a fireplace" (*I* 100 / *GS* 2:456). What sustains this reader-flame is no longer just wood and ashes—even if these are now transformed into a text—but a question that keeps the reader's interest burning: how to learn that death awaits us? As Benjamin notes, that "the 'meaning' of a character's life is revealed only in death" means that, in order to read, the reader must know "in advance that he will share [this] experience of death" (*I* 101 / *GS* 2:456). The living reader-flame burning over the logs of the past and the ashes of past experience learns to read by learning of its mortality. Reading means learning to die.[25]

If the critic distinguishes between the past and the past as it has been experienced, he or she also suggests that what has been experienced of the past is far less than the past itself. The enigma of life therefore names both the enigma of death and that of memory. As Benjamin writes in his discussion of Kafka's story "The Next Village":

> The true measure of life is memory. Looking backwards, it runs through life like lightning. In the little time taken to turn back a few pages, memory moves from the next village to the place where the rider decided to set off. Those for whom life has transformed itself into writing—as with the Ancients—can only read such writing backwards. Only thus do they encounter themselves, and only thus—fleeing from the present—can they understand life. (*R* 209–10 / *GS* 6:529–30)

Like the dialectical image that comes as "a flash of ball lightning covering the whole horizon of the past" (*GS* 1:1233), memory traverses the trajectory of a life that comes as writing. Mobilizing the figures of lightning, writing, and the turning of pages in the direction of an understanding of life that begins with a departure from life, Benjamin suggests that a life measured by memory is lived not in the present but in a text. That this text can be understood photographically is suggested in a passage from his brief essay "On the Mi-

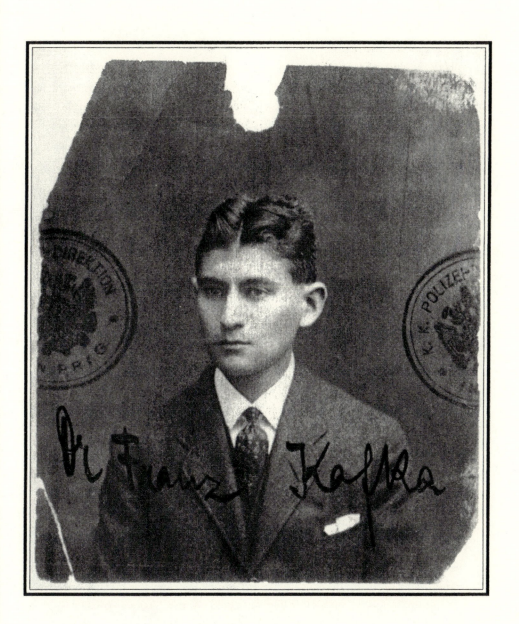

metic Faculty." There, evoking the mimetic capacity of language in terms of both flame and lightning, Benjamin alludes to photography's capacity to "create similarities" (R 333 / GS 2:210):

> The mimetic element in language can, like a flame, manifest itself only through a kind of bearer. This bearer is the semiotic element. Thus the context of words or sentences is the bearer through which, like a flash, similarity appears. For similarity's production by man—like its perception by him—is in many cases, and particularly the most important, predicated upon a flash. Similarity flits past. (335 / 213)

X.

S T A R S. — The history of photography can be said to begin with an interpretation of the stars. Benjamin not only associates stars with a photographic language that focuses on the relations between light and darkness, past and present, life and death, reading and writing, and knowledge and representation—motifs that all belong to the history of photographic phenomena—but he also links them to the possibility of mimesis in general. In both "The Doctrine of the Similar" and "On the Mimetic Faculty," for example, Benjamin begins his history of the production of similarity by suggesting that, thousands of years ago, star constellations not only inspired imitation but were already objects whose mimetic character announced their relation to the possibility of meaning. "As inquirers into old traditions," he writes, "we must assume that there were meaningful formations, that is, a mimetic object-character"—even where we are unable to suspect it—"for example, in the constellation of stars" (D 66 / GS 2:206). Celestial processes were imitated, he suggests, because "the possibility of imitation" already "contained the order to manipulate an existing similarity." In other words, the stars bore within them both the demand that they be imitated and the means—the existing similarity—whereby this demand could be met. The star constellations exerted "a powerful compulsion to become similar and also to behave similarly. . . . What [they] effected millenia ago, in a human existence in the moment of being born, wove itself into it on the basis of similarity" (69 /

210). Like photography, stars are therefore another name for what makes similarity possible, for the process of mimetic reproduction. They are the models on which Benjamin bases the theory of likeness that underlies his reflections on language.[26]

This is why, even if "we no longer possess what once made it possible to speak of the similarity that exists between a star constellation and a human," we can still register this mimetic faculty within language and writing. It is no surprise that the stars—which are the media of mimesis—also cast their light on the beginnings and futures of reading and writing:

> If, in the dawn of humanity, this reading from stars . . . represented reading as such, and further, if there were mediating links to a new kind of reading, as represented by the runes, then we can well assume that the mimetic faculty, which was earlier the basis for clairvoyance, quite gradually found its way into language and writing . . . thus creating for itself in language and writing the most perfect archive of nonsensuous similarity. Language is hence the highest application of the mimetic faculty. . . . In other words: it is to writing and language that clairvoyance has, over the course of history, yielded its old powers. (68 / 209)

Configurations of nonsensuous similarity (that is, of the relation between what is like and what is unlike), star constellations live on as language and writing. When Benjamin speaks of the reading of stars, however, reading is not to be understood in terms of possession: the nonsensuous similarity of stars prevents them from being seized either by the language that they now are or by the work of understanding in general. As in the movement of language, the perception of similarity is bound instead to an instantaneous flash: "The perception of similarity is in every case bound to a flashing up. It flits by. . . . It offers itself to the eye as fleetingly, transitorily as a star constellation. The perception of similarities thus seems bound to a moment of time [*Zeitmoment*]. It is like the supervention of the third, of the astrologer to the conjunction of two stars, that wishes momentarily to be grasped" (66 / 206–7). Benjamin here suggests that the event of the perception of similarity—an event that emerges with the suddenness of a flash of lightning—is unable to hold this similarity fast; he adds that the astrologer who wishes to read the flash of the stars, who tries to register the event of similarity, becomes part of the flash that enables similarity to occur in the first place. As Carol

Jacobs has noted, "the astrologer does not perceive the constellation or name it from outside. Nor is any treasure or reward [*Lohn*] made present at hand. Rather the moment of interpretation, what Benjamin calls the perception of similarities, is one in which the reader-astrologer completes and is assimilated into the constellation in a flash" ("Benjamin's Tessera," 44). The emergence of an astral image, like that of the dialectical image, happens not only with the flashing perception of similarity—that is, the transformation of luminous points into a constellation—but with the identification between reader and image.[27] This identification suggests that the constellation already demands a mode of reading. Or to be more precise, reading—and therefore the possibility of knowledge in general—begins in the reading of stars.

This is why Benjamin so often links his theory of knowledge to the astronomical metaphor of the stars and their constellations. In the introduction to his *Trauerspiel* book, for example, he calls the ideas that gather together the dispersed elements of thought "configurations" or "constellations." "The idea belongs to a fundamentally different realm than that which it grasps," he tells us. "The ideas relate to things as constellations to stars" (*O* 34 / *GS* 1:214). If his analogy works to associate ideas with constellations—he says later that "ideas are eternal constellations" (34 / 215)—it is because the movement from star to constellation is also a matter of representation. In particular, this movement belongs to a representation that, bringing the past and the present together, suddenly emerges "into a constellation like a flash of lightning" (*N* 50 / *GS* 5:578). Toward the end of his essay on the doctrine of similarity, Benjamin again links the emergence of the constellation, the astral image, to the question of speed: to "that swiftness in reading or writing that can scarcely be separated from this process" and that becomes, as it were, "the effort, or gift, of letting the mind [*Geist*] participate in that measure of time in which similarities flash up fleetingly out of the stream of things only in order to become immediately engulfed again" (*D* 68 / *GS* 2:209). This similarity that emerges only in order to vanish, this oscillation between appearance and disappearance, can be read in the light of a star. This light, which in a flash travels across thousands of light-years, figures an illumination in which the present bears within it the most distant past and where the distant past suddenly traverses the present moment. This emergence of the past within the present, of what is most distant in what is closest at hand, suggests

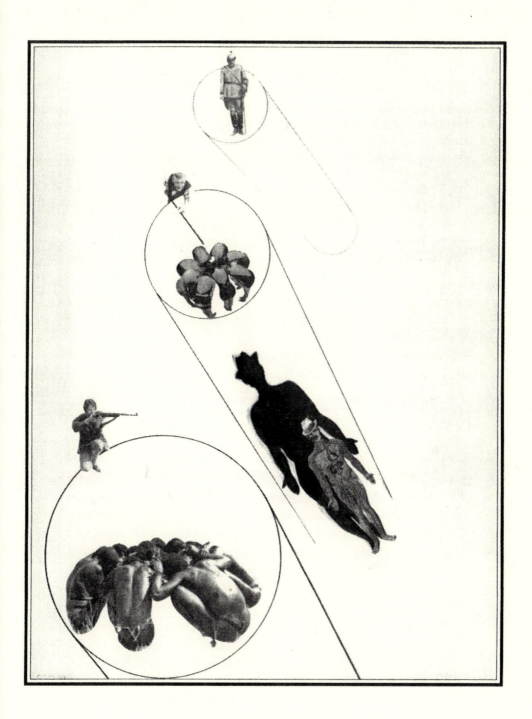

that, like the flash of similarity, starlight appears only in its withdrawal. It also suggests that the star constellation is another name for the experience of aura.[28] Like the photograph that presents what is no longer there, starlight names the trace of a celestial body that has long since vanished. The star is always a kind of ruin. That its light is never identical to itself, is never revealed as such, means that it is always inhabited by a certain distance or darkness. In a letter of 9 December 1923 to Florens Christian Rang, Benjamin discussed this relation between stars and darkness in the context of a discussion of the work of art's historical character. Referring to ideas that are still not yet fully articulated, he writes:

> These ideas are the stars, in contrast to the sun of revelation. They do not shine their light into the day of history, but only work within it invisibly. They shine their light only into the night of nature. Works of art are thus defined as models of a nature that does not await the day. . . . The night preserved. And in the context of this consideration, criticism . . . is the representation of an idea. . . . Criticism is the mortification of works of art. . . . The task of interpreting works of art . . . is to set a focus [*festzustellen*]. (C 224–25 / B 323)

If the task of criticism, like that of the photographer, is "to set a focus," Benjamin tells us that it is at the same time an act of mortification. In other words, interpretation—the representation of an idea or a work of art, and therefore of a star—is involved in the production of death. Put another way, the idea, the star, and the work of art can only be revealed in their deaths. The effort to bring the idea or the work of art to light—like that of trying to bring the star into the day of history—can only remove them from the night to which they belong and that makes them what they are. To represent a star, then, is to bring it to death, to touch it with the death that inhabits representation. It is to bring to the light of history what, not waiting for the day, cannot be brought to light. This is why the reading of stars involves the destruction of stars.[29] As Kant explains in his *Critique of Practical Reason*, "The observation of the world began from the noblest spectacle which was ever placed before the human senses and which our understanding can bear to follow in its vast expanse, and it ended—with the interpretation of the stars [*Sterndeutung*]."[30] To say that the history of photography begins in the interpretation of stars is to say that it begins with death.

XI.

ETERNAL RETURN. — The thought of the eternal return is a thought of technological reproducibility. It is, as Benjamin puts it, "a dream of the amazing discoveries yet to come in the area of reproductive technology" (*GS* 5:429). Turning "the historical event itself into a mass article" (ibid.), it says that time repeats itself endlessly. This means, however, that what is repeated is a process of becoming, a movement of differentiation and dispersion—and what is differentiated and dispersed is time itself. There can be no passing moment that is not already both the past and the future: the moment must be simultaneously past, present, and future in order for it to pass at all. This is why this eternal repetition does not mean "the return of the same" but rather the return of what is never simply itself. What returns is the movement through which something other is inscribed within the same, which, now no longer the same, names what is always other than itself.[31] If the eternal return therefore comes as the eternal repetition of alterity, we could say, somewhat elliptically, that this eternal return is the return of returning itself.[32] It is the desire for things to return. As Benjamin explains in the *Passagen-Werk*:

> The thought of the eternal return makes the historical event itself into a mass article. But this conception also bears on another point of view—we could say on its opposite—the traces of economic circumstances to which it owes its sudden currency. The latter is heralded at the moment when the security of life's conditions was considerably reduced by the accelerated succession of crises. The thought of the *eternal* return came to light because it was no longer possible, under all circumstances, to count on the return of conditions in smaller time frames than eternity provided. The everyday constellations became less everyday. Their return became increasingly more rare and with that the obscure presentiment arose that one would have to content oneself with cosmic constellations. (429–30)

That the thought of the eternal return can be traced in part to an experience of crisis and finitude means that it emerges as a response to death in general. It is because of the transitoriness of the "everyday constellations" that we project our desire for eternity onto the skies in the form of an image: that of

the star constellation. This phantasmagoric projection becomes a figure of the eternal return, but it also suggests the relation between this particular form of repetition and commodity capital. As Benjamin explains, pointing to Baudelaire's use of the figure of stars, "Stars represent in Baudelaire the picture-puzzle [*Vexierbild*] of the commodity. They are the always-again-the-same [*Immerwiedergleiche*] in great masses" (429). Linking the structure of this "always-again-the-same" to the possibility of reproduction—to the reproduction of both images and masses—he at the same time mobilizes the concept of the eternal return against that of progress.[33] Within a cosmic process of repetition, the notion of progress belongs to the domain of phantasmagoria.

The constellation of figures that Benjamin sets into motion here—eternal return, stars, death, crisis, image, phantasmagoria, and progress—is inscribed within the name that he associates most closely with the possibility of a revolutionary dismantling of the notion of progress: the name of Auguste Blanqui.[34] Celebrated as the most unrelenting insurrectionist of his age, Blanqui spent most of the last forty years of his life buried alive in the prisons of a monarchy, an empire, and two republics. He nevertheless exercised wide influence in his role as a journalist and orator, especially during the revolutions of 1830, 1848, and 1870–71. Known in the popular imagination as *l'enfermé*, "the imprisoned one," Blanqui serves Benjamin as a figure not only of the arrest of history that makes revolution possible but of arrest in general. He was imprisoned in the Fort du Taureau during the Commune and it was there, near the end of his life, that he set down his cosmological speculations in *L'éternité par les astres*. Benjamin calls this text—which he first read in 1937 and which he states "presents the idea of eternal return ten years before *Zarathustra*, in a manner scarcely less moving and with an extreme hallucinatory power" (GS 5:75)—the last phantasmagoria of the nineteenth century, claiming that it constitutes a criticism of all the others. Blanqui develops his theory of the eternal return from his interpretation of celestial bodies and stellar formations. Turning to what he calls "the theater of these grand revolutions" in the skies (*L'éternité par les astres*, 34), the great revolutionary of the nineteenth century argues that—given the infinity of time and space in the universe and the finite number of elements that can be combined—all the possibilities of the world are repeated endlessly an infinite number of times and in an infinite number of places throughout the universe. Describing a universe in which "everything new" unveils itself "as nothing but a reality

that has always been there" (*GS* 5:1256), his thought of the eternal return suggests that the notion of progress is "the phantasmagoria of history itself" (*GS* 5:75). As Benjamin tells us, here is the essential passage:

> The entire universe is composed of stellar systems. To create them, nature only has one hundred simple bodies at its disposal. Despite the prodigious advantage that it knows how to take from its resources and the incalculable number of combinations that they offer to its fecundity, the result is necessarily a finite number, like that of the elements themselves, and to fill the expanse, nature must infinitely repeat each of these original combinations or types. Every star . . . exists therefore in infinite number in time and space, not only under one of its aspects, but such as it is found at each of the seconds of its duration, from birth until death. . . . The earth is one of these stars. Every human being is therefore eternal in each of the seconds of its existence. What I am writing in this moment in a prison cell in the Fort du Taureau, I have written and I will write for all eternity, on a table, with a pen, in these clothes, in circumstances wholly similar. And so it is for everyone. . . . The number of our doubles is infinite in time and space. In conscience one can scarcely ask for more. These doubles are in flesh and bone, indeed in pants and coat, in crinoline and chignon. They are . . . the present eternalized. Nonetheless, we have here a great defect: there is no progress. Alas! No, they are only vulgar re-editions, redundancies. . . . What we call progress is locked shut in every earth and vanishes with it. Always and everywhere . . . the same drama, the same decor, upon the same narrow stage, a noisy humanity, infatuated by its grandeur, believing itself the universe and living in its prison as in an immensity, soon to be destroyed along with the globe that has carried, with deepest contempt, the burden of its pride. The same monotony, the same immobility in alien stars. The universe repeats itself endlessly, stamping its foot in place. Eternity imperturbably plays the same performances throughout infinity. (*L'éternité par les astres*, 73–76)[35]

The stars that compose Blanqui's universe exist only because of an infinite process of repetition and reproduction. There is nothing in this universe—no star, comet, meteorite, person, thing, or event—that does not begin in this movement of eternal reproduction. This is why we can say that the universe in its entirety works like a gigantic photographic machine. The linguistic physiognomy of Blanqui's theory of the eternal return is a photographic

one.[36] His discussion of the reproducibility of the universe is throughout cast in a photographic language that focuses on the questions of repetition, reproduction, images, negatives, originals, copies, translations, death, and mourning. Not only are stars and meteorites like photographs of the sun's birth (he writes, for example, that "a meteorite that catches fire and is consumed in flames as it traces the air" is "the image in miniature of the creation of the sun" [40]), but all celestial bodies are classified in terms of the photographic relation between originals and copies. Within this mimesis of the stars— Blanqui states that the stars are constituted by the laws of similitude and repetition (57)—"the originals are the ensemble of globes that each form a *special type*. The *copies* are the *repetitions*, the *exemplars*, the *negatives* of this type. The number of *original types* is limited, that of *copies* or repetitions, infinite. It is through this type that the infinite is constituted. Each type has behind it an army of doubles whose number is without limits" (52). Like the photographic negative from which an infinite number of prints can be made, the copy—already a negative that results from the photographic process whereby the original is reproduced—can be reproduced infinitely. The original type is itself a kind of photograph since it replicates the limitless doubles, the ensemble of globes that define its singularity. In other words, it is never really originary. Like the planetary system that cannot provide a contemporary trajectory because all of its history is "entangled and interlaced" in every one of its moments and elements (54), the original type contains the entire history of all of the doubles and worlds that make it what it is—and that thereby prevent it from ever being simply itself. As Blanqui puts it, "there is not a single one that is not composed of the remains of all the others" (41).

This vast ensemble of doubles also includes us. Each of our doubles, Blanqui tells us, is "the double itself of the actual earth. We belong to the copy. The earth-double reproduces exactly everything that is found in ours and, consequently, each individual, with his family, his house . . . all the events of his life" (55). The entirety of our existence, that is, undergoes precisely the same process of duplication and reproduction that characterizes both the mass-produced commodity and the technically produced photograph.[37] There is no aspect of our life that is not subject to this process of reproducibility. We could even say that we are who we are only to the extent that we are reproducible. It is this shared feature of reproducibility that makes us doubles of both the earth and the stars. Like a camera that takes and then endlessly prints its own self-portrait, the earth reproduces itself an infinite number of

pearance of the stars. All stars, Blanqui writes, are always in the process of vanishing or fading away. They are always already dying, and most of them have perhaps already died. As he explains, "these globes of flame, such splendid representations of matter, do they enjoy the privilege of eternity? No, matter is only eternal in its elements and in its entirety. All its forms, humble or sublime, are transitory and perishable. Stars are born, they shine, they fade away, and surviving perhaps thousands of centuries in their vanished splendor, they surrender to the laws of gravitation only as floating tombs" (33). Like a photograph, the diminishing light of the stars is a commemorative sign of what is no longer there. But it is not the only sign of death in the heavens. Blanqui's skies are nothing but an enormous cemetery for the celestial bodies. From the dying stars whose half-extinguished light seems stitched into the firmament, to the dying sun that turns water into blocks of ice, to the comets that come as phantoms or messengers of death to the corpse of the moon, Blanqui's universe endlessly unfolds as an eternal work of mourning. It is, in the wording of Jeffrey Mehlman, "a vast *Trauerspiel*" (*Walter Benjamin for Children*, 44).[39] We could even say that the photographic dimension of this universe can be registered in its structure as a work of mourning. If the photograph requires the possibility of mourning, the universe of the eternal return—in which there is nothing that is not always passing away, that is not eternally running down and in decline—begins in bereavement. It is no accident that the evanescence of the celestial bodies, the eternal transitoriness of matter, leaves its traces in the sky in the form of a celestial funeral. As Blanqui tells us, in a passage that includes the flashes and phantoms of photography, "If we must believe some chroniclers of the heavens, from the sun just beyond the terrestial orb stretches a vast cemetery of comets, from whose mysterious flashes the evenings and mornings of pure days appear. We recognize the dead of these phantom-lights, that let themselves be traversed by the living light of stars" (22).[40] This intersection between light and death—the site at which Blanqui's cosmic photographs are taken—is elaborated later when he asks, "what would happen if the old dead suns, with their chaplets of deceased planets, indefinitely continued their funereal procession, lengthening each night with new funerals? All these sources of light and of life that shine in the firmament would die one after another, like the fairy lights of an illumination. Eternal night would cover the universe" (40). Emphasizing the funereal context within which the sky's revolutions take place, he delineates the transit between life and death that, casting its

phantom-light on the dead celestial bodies stretching across the sky, moves through this sky like the living dead who move through old cemeteries (35). This revolutionary return to the cemetery encrypts a reference to the work of memorialization that characterized the politics of the Blanquists and other veterans of the French revolutionary movement. Emphasizing the role of memory within revolution, they repeatedly participated in pilgrimages to Père-Lachaise, Paris's eastern cemetery—the graveyard in which the Commune's heroes were buried and the site of the Commune's last stand in May 1871.[41] These rites of commemoration can also be associated with the revolutionary repetition of what we might call the "eternal return" of the French Revolution.

Blanqui suggests that, within this work of memory, the stars gather together the moments of the past, present, and future in view of an overwhelming catastrophe: the threat of a total annihilation of light that would leave in its wake an eternal darkness. Nevertheless, even though there may be "billions of frozen cadavers" hovering in the night of space, awaiting their hour of destruction, he suggests that this hour of destruction will be at the same time an hour of resurrection: "If the tomblike night stretches out for finished stars, the moment comes when their flame is rekindled like lightning. On the surface of planets, under the solar rays, the dying form breaks up quickly, in order to restore its elements in a new form. The metamorphoses follow one another without interruption" (33). The only way for a dead star to be rekindled, to regain its energy and be reinscribed within the process of the eternal return, is through a catastrophic collision with another extinguished star. Like the "posthumous shock" that for Benjamin characterizes the photographic event (*I* 175 / *GS* 1:630), the shock of this collision interrupts the death that seizes the waning star. It should be noted that Blanqui's description of this collision, of this renewal of dying or dead stars, is cast in a language whose references to revolution, struggle, mass movements, battlefields, conflagrations, death, and uncertainty make it one of the many places in which his cosmology can be read as an allegorical response to the other revolutions and struggles in which he was involved throughout his life.[42] He writes:

> When after millions of centuries, one of these immense whirlwinds of stars, born, revolving, dying together, comes to pass through the regions of open spaces before it, it collides at its frontiers with other dying whirlwinds. . . . A furious struggle ensues for innumerable years, across a battle-

field billions of billions of leagues long. This part of the universe is no longer anything but a vast atmosphere of flames, endlessly traced by the lightning of the conflagrations that instantly volatize the stars and planets. . . . The successive shocks reduce the solid masses to a vaporous state, at once seized again by the gravitation that groups them into nebula turning upon themselves through the impulsion of the shock, and throw them into a regular circulation around new centers. Faraway observers can then, through their telescopes, perceive the theater of these grand revolutions, under the aspect of a pale glimmer. . . . Is this exactly how worlds are reborn? I don't know. Perhaps the dead legions that collide in order to gain life are themselves less numerous, the field of resurrection less vast. But certainly, this is only a question of numbers and scope, not of means. . . . Matter does not know how to diminish, nor how to add even an atom to itself. Stars are only ephemeral torchlights. Therefore, once dying, if they are not rekindled, night and death, in a given time, take over the universe. But how can they be rekindled, if not by the movement transformed by heat into gigantic proportions, that is, by a collision [*entre-choc*] that volatizes them and calls them to a new existence? (34–35)

It is because Blanqui's universe is perpetually in the process of transformation that he can offer an account of the transformation of life into death and death into life. This oscillation between life and death, he suggests, evokes the enigma that is "permanently before each thought" (72). In other words, in this universe of permanent catastrophes—in which there is one catastrophe after another, but in which each one is already a repetition of the one before it—there is no thought that is not touched by both life and death. This is why Blanqui organizes the enigmatic and catastrophic structure of the eternal return around the birth and death of the stars. If what is sealed within this return is not only the intersection of life and death but also that of all of the doubles at work within its cosmos, it is because it tells us what is endlessly photographed and printed by the enormous camera that Blanqui's world is. What is photographed each time, what returns as in a photograph, is the reproductive mechanism at the heart of the eternal return. What gets photographed is what eternally comes to pass—simultaneously what passes away and what survives this passing, that is, passing itself. As Blanqui notes, "The universe is at the same time life and death, destruction and creation, change and stability, tumult and repose. It knots and unknots itself endlessly,

always the same, with beings always renewed. Despite its perpetual becoming, it is clichéd [that is, stereotyped, plated, imprinted, turned into a negative] in bronze and incessantly prints the same page. In its entirety and in all of its details, it is eternally transformation and immanence" (72).

That what is seized and set in focus is the process of perpetual becoming means, as Benjamin suggests, that "petrified unrest becomes, in Blanqui's conception of the world, the status of the cosmos itself. The course of the world thus truly appears as a single, great allegory" (GS 5:414). This is why, he reminds us, Nietzsche claims, writing of the eternal return, that this "great thought" should be understood as "a Medusa's head" (GS 5:175) that petrifies all the traits of the world. In other words, there can be no eternal return without the Medusa effect that arrests all development or progress. Like the stars, Blanqui suggests, we too are "frozen in place" within the movement of this history (L'éternité par les astres, 39). We might even say that Blanqui's conception of history belongs to this history of arrest—both his own and the one that, like the head of the Medusa, freezes the moment of history into an image. It is therefore not surprising that, in his reading of Baudelaire's poem "Revolt," Benjamin identifies the head of Blanqui with the cameralike head of Medusa, stating that "from between the lines [of Baudelaire's poetry] flashes the dark head of Blanqui" (CB 23 / GS 1:524). Like the "great Medusa face surrounded by flashes of red lightning" (26 / 527) in Pierre Dupont's 1850 Le chant du vote, Blanqui's head appears here in the form of a camera flash. Even if Benjamin claims that "everything in Blanqui's cosmology turns around the stars that Baudelaire banned from his universe" (GS 5:417), he nevertheless identifies Baudelaire's poetry with the name of Blanqui—or rather, more particularly, with his head. Benjamin reminds us twice that Baudelaire had drawn a sketch of Blanqui's head from memory alongside a draft of one of his poems (GS 5:169, 329).[43] This identification between Baudelaire and the decapitated, Medusa-like head of Blanqui is reinforced by the figure of "petrified unrest" that Benjamin understands to be the formula for Baudelaire's image of life—a life that, as he puts it, "knows no development" (414). If Medusa, petrified unrest, the eternal return, perpetual becoming, and technological reproducibility form a constellation of figures organized around the photographic character of the universe in which Blanqui and Baudelaire are both inscribed, we can say perhaps that, within this constellation, petrified unrest becomes another name for the eternal return whose

reproducibility makes the world possible, for the photographic principle without which the eternal return could never return. The movement of history that emerges from this principle of reproducibility names the immobilization that, like the photographic apparatus, seizes the thing or event in the process of its disappearance. The world of the eternal return is a world that incessantly fixes and returns to the event of a vanishing, and what vanishes in this return is not only the finite subject matter before the cosmic camera in which the world begins but the possibility of returning itself. A return without return, Blanqui's eternal return tells us that the photographed, once photographed, can never return to itself—it can only appear in its withdrawal in the form of an image or reproduction.

XII.

REPRODUCIBILITY. — There will have always been technological reproducibility. What Benjamin means by technological reproducibility, however, is not what the French and English translations have always described as mere "mechanical reproduction." For Benjamin, the "technical" is not the same as the "mechanical"; its meaning is not circumscribed by the machinery of science. As he explains in his essay on Eduard Fuchs, "technology is obviously not a purely scientific phenomenon. It is also an historical one" (_OWS_ 357 / _GS_ 2:475). He suggests that technical reproducibility can only be understood by considering the historical relations between science and art—especially in terms of their relation to the historical conditions of production and reproduction. Although the word "technical" is never "defined" by Benjamin in any prolonged or explicit way, it is linked, as Weber rightly notes, "not to the empirical fact of 'reproduction,' but to the possibility of _being reproduced_, to reproducibility as a mode of being. However clumsy even in German the noun _Reproduzierbarkeit_ may be, it has the virtue of distinguishing between a structural attribute and an empirical fact" ("Theater, Technics, and Writing," 17). In other words, technical reproduction is not an empirical feature of modernity; it is not an invention linked to the so-called modern era. Rather, it is a structural possibility within the work of art. "In principle," Benjamin tells us, "a work of art has always been repro-

ducible" (*I* 218 / *GS* 1:474). It has always been able to be copied. In the seem-ing progression from Greek founding and stamping, to bronzes and coins, to woodcuts, and on through printing, lithographs, photography, and sound film, if the technological reproducibility of a work of art suggests something new, this something new is not a "first time" in history. Rather, it marks the intense acceleration of a movement that has always already been at work within the work. "Historically," Benjamin notes, technical reproducibility "advanced intermittently and in leaps at long intervals, but with accelerated intensity" (ibid.). The "something new" with which Benjamin is here con-cerned is not, then, merely "reproduction as an empirical possibility, a fact which was always more or less present since works of art could always be copied," but, as Weber suggests, "rather a structural shift in the significance of replication itself. . . . What interests Benjamin and what he considers his-torically 'new,' is the process by which techniques of reproduction increas-ingly influence and indeed determine the structure of the art-work itself" ("Theater, Technics, and Writing," 18)—or even, of our existence in general. For as we know, every moment of our life, of our relation to the world, is touched directly or indirectly by this acceleration, an acceleration that had already prepared for the coming of the camera—where replication and pro-duction tend to merge. Indeed, the technology of the camera also resides in its speed, in the speed of the shutter, in the flash of the reproductive process. Like the irrevocable instantaneity of a lightning flash, the camera, in the split-second temporality of the shutter's blink, seizes an image, an image that Benjamin himself likens to the activity of lightning: "The dialectical image flashes [*ist ein aufblitzendes*]. The past must be held fast as an image flashing within the Now of recognizability" (*N* 64 / *GS* 5:591–92). And this recognition coincides with a moment of blinding, with the production of an *afterimage*. An instrument of citation, the camera here cites the movement of lightning, a movement that never strikes the same place twice. In the same way, repro-ducibility has always reproduced itself, but never in an identical manner.

The question of the meaning and origin of photography precedes or at least corresponds to the question of the meaning of technology. There can be no understanding of photography without a thinking of the relation be-tween photography and the history of technology. This is why technology can never simply clarify or explain the photographic event.[44] This is also why the age of technological reproduction includes all of history. "To each age

correspond quite specific techniques of reproduction," Benjamin writes, himself reproducing a passage from Fuchs. "They represent the prevailing possibility for technological development and are . . . a result of the specific requirements of the time" (*OWS* 384 / *GS* 2:503).

XIII.

POLITICS. — What is at stake in the question of technological reproducibility—in the question of photography, for example—is not whether photography is art, but in what way all art is photography. For Benjamin, as soon as the technique of reproduction reaches the stage of photography, a fault line traverses the whole sphere of art: photography transforms the entire notion of art. The presumed uniqueness of a production, the singularity of the artwork, and the value of authenticity are deconstructed. As soon as one can reproduce, the function of art is reversed:

> Technological reproducibility emancipates the work of art for the first time in world history from its parasitical attachment to ritual. To an ever greater degree the work of art reproduced becomes the reproduction of a work of art designed for reproducibility. From a photographic negative, for example, a multitude of prints is possible; to ask for the authentic print makes no sense. But the instant the criterion of authenticity ceases to be applicable to artistic production, the entire social function of art is reversed. Instead of being founded on ritual, it begins to be founded on another practice— that is, to be founded on politics. (*I* 224 / *GS* 1:481–82)

The semblance of its autonomy disappears forever. By substituting a plurality of copies for a unique original, technologically produced art destroys the very basis for the production of auratic works of art—that singularity in time and space on which they depend for their claim to authority and authenticity. Every work is now replaceable. The changes in the technical conditions for the production and reception of art constitute a break with tradition that effectively removes the previous ritual or cultic bases of art and facilitates the predominance of the political function of art. "This is not a time for political art," Adorno writes in his essay on political commitment. "Politics has migrated into autonomous art, and nowhere more so than where it appears to

be politically dead" ("Commitment," 93–94). If politics, however, fascist no less than communist, depends on photography and film's capacity to exhibit and manipulate bodies and faces, then all politics can be viewed as a politics of art, as a politics of the technical reproduction of an image.[45]

This relation between art and politics is a motif that runs through the work of many of the fascist regime's most important ideologues. Joseph Goebbels, for example, made this point in an open letter to Wilhelm Furtwängler that was published in the *Lokal Anzeiger* of 11 April 1933. There—responding to Furtwängler's claim that the only viable distinction within art is that between "good" and "bad" art, and not one made on the basis of race—Goebbels writes:

> It is your right to feel as an artist and to look upon matters from the living artistic point of view. But this does not necessarily presuppose your assuming an unpolitical attitude toward the general development that has taken place in Germany. Politics, too, is perhaps an art, if not the highest and most all-embracing there is. Art and artists are not only there to unite: their far more important task is to create a form, to expel the sick trends and make room for the healthy to develop. As a German politician I therefore cannot recognize the dividing line you hold to be the only one, namely that between good and bad art. Art must not only be good, it must also be conditioned by the exigencies of the people or, rather, only an art that draws on the *Volkstum* as a whole may ultimately be regarded as good and mean something for the people to whom it is directed. (Cited in Reimann, *Man Who Created Hitler*, 171)

If, as Lacoue-Labarthe has suggested, "the political model of National Socialism is the *Gesamtkunstwerk* [the total artwork]," it is because "the *Gesamtkunstwerk* is a political project . . . which does not merely mean that the work of art (tragedy, music, drama) offers the truth of the polis or the State, but that the political itself is instituted and constituted (and regularly re-grounds itself) in and as a work of art" (*Heidegger, Art and Politics*, 64). This is why the entirety of Benjamin's "Work of Art" essay can be read as a critical response to the fascist effort to mobilize works of art—including photography and film—toward both the production of an organic community and the formation of this community (the German people or nation) as a work of art itself. Benjamin's insistence on the disintegration of the auratic character of the artwork, for example, belongs to his effort to deconstruct the values of orig-

inality and community at work within the fascist program of self-forma
and self-production.

To the extent that the essence of the political is to be sought in art, then,
there is no aesthetic or philosophy of art that can undo the link between art
and politics. In "Work of Art" and "Theories of German Fascism," Benjamin
interprets fascism's aesthetics of violence (indeed, with all its adornments
and spectacles, Nazism proved to be perhaps the most aesthetically self-
conscious regime in history) as the culmination of *l'art pour l'art*: "The most
rabidly decadent origins of this new theory of war," he writes, "are embla-
zoned on their foreheads: it is nothing other than an unrestrained transposi-
tion of the principle of *l'art pour l'art* to war itself" (*T* 121–22 / *GS* 3:240).[46]
Seeking a restoration of the aura within the framework of aesthetic auton-
omy, and originating as a reaction against the widespread commodification
of art, *l'art pour l'art* presents itself, within fascism's own efforts to stage the
nonpolitical essence of the political, as the truth of the political. Benjamin
responds to this situation by mobilizing the so-called forces of aesthetic pro-
duction toward political ends—something already at work within fascist pol-
itics—but also toward a politics whose infinitely mediated relations prevent
it from organizing itself around a particular form of instrumentality.
Whereas fascism aestheticizes politics, Benjamin wishes to politicize aesthet-
ics: "The concepts that are introduced below into the theory of art differ
from the more familiar ones in that they are completely useless for the pur-
poses of Fascism. Rather, they are useful for the formulation of revolutionary
demands in the politics of art" (*I* 218 / *GS* 1:473).

XIV.

D A N G E R. — It is because the question of reproducibility extends far be-
yond the realm of art that it raises the possibility of the democratization of
death. Not only does technical reproducibility change our relation to death,
but the incursion of the technical media into our everyday life introduces us
into what Jünger calls, speaking of technology in general, "a space of abso-
lute danger" ("On Danger," 30 / "Über die Gefahr," 15). This danger can be
registered, according to Benjamin, in the reproducibility that transforms us
into a recording apparatus. He makes this point when, in the "Work of Art"

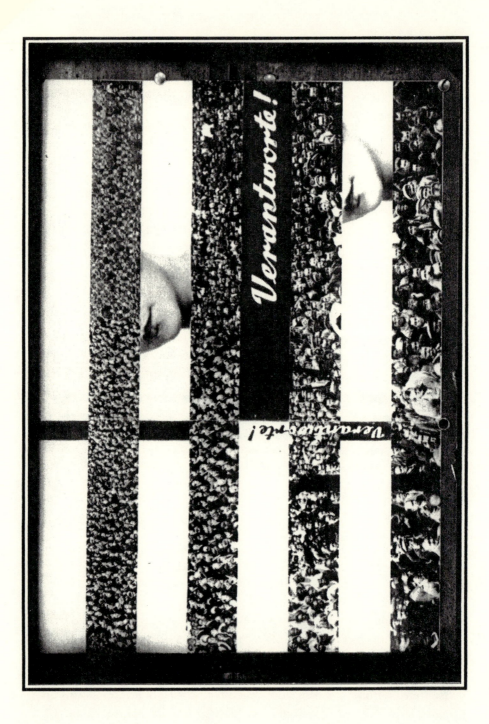

essay, he claims that "the violation of the masses, whom Fascism, with its Führer cult, forces to their knees, has its counterpart in the violation of an apparatus which is pressed into the production of ritual values" (*I* 241 / *GS* 1:506). This relation between the masses and the violence of technical reproduction can be read throughout Benjamin's essay—in his discussion of the breakdown of the traditional distinction between production and reproduction that he suggests occurred in the middle of the nineteenth century and that he associates with the introduction of first photography and then film, and also in his discussion of the disintegration of aura. As he explains, in a passage that associates these processes of breakdown and disintegration with the medium of film:

> *The technique of reproduction, to formulate generally, detaches what is reproduced from the realm of tradition. By multiplying the reproduction* [of the artwork, the techniques of reproduction] *replace its unique occurrence with one that is mass-like. And in permitting the reproduction to meet the receiver* [*dem Aufnehmenden:* the receiver, but also—as Weber reminds us—"the recorder, as a photographer, cameraman, recording engineer"[47]] *in his particular situation, it actualizes what is reproduced.* These two processes lead to a tremendous shattering of tradition which is the obverse of the contemporary crisis and renewal of mankind. Both processes are intimately connected with contemporary mass movements. Their most powerful agent is film. (221 / 477–78)

The techniques of reproduction, Benjamin suggests, disperse the unique occurrence of the artwork into a mass whose reproduction sets it into circulation and motion. No longer to be understood in terms of the traditional values of singularity and originality, this mass artwork now belongs to a network of unforeseeably mediated relations that, encountering a recording apparatus, comes to itself as a reproduced mass. It is associated within the movement of Benjamin's passage with the movement of the contemporary masses. What links the artwork to the masses—or the making of films to the formation of masses—is that both have their origins in techniques of reproduction. They are both produced, that is, according to the structure and operation of technological reproduction. This means that contemporary mass movements begin in their reproducibility: they belong to the production and reproduction of images. Benjamin's interest in the production techniques of film and photography corresponds to his conviction that what takes place on a film set or in a photography studio is related, if not identical, to

what takes place outside this same set or studio: the emergence or mobilization of images.[48] To put it another way: in the era of technological reproducibility, there is no space or time that is not involved in the reproductive inscription of images. This is why, Benjamin suggests, the techniques of reproduction increasingly can be said to replace living subjects with an "apparatus"—say, a camera—whose work of reinscription and recording (229 / 489) demonstrates that there can be no "apparatus-free aspect of reality" (233 / 495). It is here that we can begin to measure the relation and difference between Benjamin's sense of the transit between persons and the technical means of reproduction and that of Jünger, who in his essay "Über den Schmerz" (On pain)—comparing our contemporary gaze with that of the camera—claims that *technology is our uniform*" (174).

Jünger reads the pervasive violence of technology in the transformation of humanity into a new type of technologized, functionalistic human beings. The features of this transformation, he suggests, are legible in the increasing uniformity of social life, the technologizing of the everyday world, and the growing militarization of society. As he claimed in 1932, the mythic subject of this new humanity—the subject who embodies this social transformation—can be found in the *gestalt* [the form or figure] of *Der Arbeiter* (the worker). He had already made this argument two years earlier in "Die Totale Mobilmachung" (Total mobilization), which appeared in an anthology of essays entitled *Krieg und Krieger* (War and warrior) and which Benjamin reviewed in "Theories of German Fascism." Describing a world in which everything is stamped "in a martial medium" ("Total Mobilization," 129 / "Totale Mobilmachung," 129), in which the masses have all been touched by death (128 / 128), and human circumstances have become increasingly abstract (137 / 140), he defines the task of total mobilization as "an act which, as if through a single grasp of the control panel, conveys the extensively branched and densely veined power supply of modern life toward the great current of martial energy" (126–27 / 126). For him, war not only names the central experience of modernity; it also plays an essential role in our understanding of technological reproduction in general and of photography in particular. His interest in the technical media can be registered throughout his writings, but it is perhaps most visible in the many photography books that he either edited or to which he contributed articles and introductions. We can begin to trace this interest in the two photographic books on World War I that he edited in the early 1930s: *Das Antlitz des Weltkrieges: Fronter-*

lebnisse deutscher Soldaten (The face of the World War: Front experiences of German soldiers) in 1930 and *Hier Spricht der Feind: Kriegserlebnisse unserer Gegner* (The voice of the enemy: War experiences of our adversaries) in 1931.[49] As he tells us in his introduction to the first of these books:

> A war that is distinguished by the high level of technical precision required to wage it is bound to leave behind documents which are different from and more numerous than those of earlier times. It is the same intelligence, whose weapons of annihilation can locate the enemy to the exact second and meter, that labors to preserve the great historical event in fine detail. . . . Included among the documents of particular precision, which have only recently been at the disposal of human intelligence, are photographs, of which a large supply accumulated during the war. Day in and day out, optical lenses were pointed at the combat zones alongside the mouths of rifles and cannons. As instruments of technological consciousness, they preserved the image of these devastated landscapes. ("War and Photography," 24 / "Krieg und Lichtbild," 9)

Pointing to the mass of archival photographic material given to us by the war, Jünger evokes the relation that for him exists between war and photography. We could even say that, for this aesthetician of war, there can be no war without photography. This is why the entirety of his writings on photography can be read in relation to Paul Virilio's claim in *War and Cinema* that the German war of light and disaster illuminated the links between photographic technology and the techniques of modern warfare. While the English began equipping their bombers during World War I with photographic apparatuses, the German army flashed its death across the skies and landscape of Europe. Dividing night into night and day, it illumined the space of war. "What had taken place in the darkroom of Niepce and Daguerre," Virilio explains, "was now happening in the skies of England" (75). Like the camera flash that enables the emergence of an image, German and English bombers dropped incendiaries both to trace bombing areas and to light up nocturnal targets. Cities became subject to the glare of explosives and the blinding light of the searchlights whose skyward beams traced a kind of luminous cat's cradle in the night. To say that there could be no war without the production of images is to say that there could be no war without the flash of the camera. In the experience of the German light-wars, the technology of warfare comes together with the techniques of perception. As Jünger writes in his essay "On

Pain," "photography is a weapon employed by the modern type. For him, seeing is an act of aggression. . . . Today we already have guns equipped with optical cells, and even aerial and aquatic war machines with optical control systems" (in "Photography and the 'Second Consciousness,'" 208–9 / "Über den Schmerz,"182).

Linking war to photography and weapons to images, Jünger argues that modern technological warfare gives birth to a specifically modern form of perception organized around the experience of danger and shock. This is why, in his essay "On Danger"—written as an introduction to a 1931 collection of photographs and accounts of catastrophes and accidents entitled *Der gefährliche Augenblick* (The dangerous moment)—he notes that the moment of danger can no longer be restricted to the realm of war. Identifying the contemporary zone of danger with the realm of technology in general, he claims that a modern type is arising in response to "the increased incursion of danger into daily life" ("On Danger," 27 / "Über die Gefahr," 11), whose aim is to develop an anesthetized relation to danger: "If one were to try to describe the 'type' that is emerging today, one could say that its most striking characteristic is the possession of a 'second' consciousness. This second, colder consciousness is indicated by the ever more marked ability to see oneself as an object" ("Photography and the 'Second Consciousness,'" 207 / "Über den Schmerz," 181). Jünger associates the objectifying gaze of this cold consciousness with the "artificial eye" of photography. He writes:

> More instructive still, however, are the symbols which the second consciousness attempts to produce from within. Not only are we the first living creatures to operate with artificial limbs, but we are also in the process of creating strange realms in which the use of artificial organs of perception facilitates a high degree of typical accord. But this fact is closely connected with the objectification of our worldviews [*Weltbildes*] and thereby with our attitude toward pain.
>
> Attention is due first of all to the revolutionary fact of photography. The script of light is a kind of statement, which is accorded the character of a document. The World War was the first major occurrence to be recorded in this way, and since then there has been no significant event that has not been captured with the artificial eye. Our endeavor is to go further and peer into spaces that are inaccessible to the human eye. The artificial eye penetrates through the cloud banks, the atmospheric haze and the dark-

ness, overcoming the resistance of matter itself. . . . The act of taking a photograph stands outside the zone of sensibility. It has a telescopic character: one realizes that the event is seen by an impervious and invulnerable eye. It captures both the flight of the bullet and the man at the moment in which he is torn apart by an explosion. This, however, is our specific manner of seeing, and photography is nothing other than an instrument of this peculiarity. (208 / 181–82)

The technologies of perception, Jünger suggests, facilitate the reproduction of a kind of accord or consensus among the masses. This consensus signals the objectification of our views of the world, our transformation into things that can no longer experience pain. Like the artificial eye of the camera, whose gaze stands "outside the zone of sensibility," our manner of seeing neutralizes what it sees and thereby brings it under the understanding of photography. If photography is indeed a "revolutionary" fact, it is because it has transformed the entirety of the world into a photographable object. It has, in the words of Kracauer, given the world a "photographic face" ("Photography," 59). For Jünger, however, the technical media and photography are also means of disciplining the masses. "We are approaching a state of affairs," he explains, "in which each person needs to be made aware within minutes of a news report, a warning, a threat. Hidden behind the face of entertainment promoted by the all-encompassing media, are special forms of discipline" (cited in Kaes, "Cold Gaze," 115). In particular, the disciplinary function of the technical media works to distract or disperse the masses—to take them away from themselves in order to prevent them from experiencing pain directly. For example, Jünger notes, the impervious and invulnerable camera lens that increasingly mediates between us and the world alters our relation to pain: "As the process of objectification progresses, the amount of pain that can be endured grows as well. It almost seems as if man wished to create a space where, in a sense quite different from the one to which we are accustomed, pain can be regarded as an illusion" ("Photography and the 'Second Consciousness,'" 209–10 / "Über den Schmerz," 183–84).

This numbing effect of the media is linked in Benjamin and Kracauer to the distraction and dispersion that characterize our response to film. Kracauer analyzed these effects in his 1926 essay "The Cult of Distraction." There, referring to Berlin's large motion picture houses as "palaces of distraction," he describes the "optical fairylands" that he claims are "shaping the face of

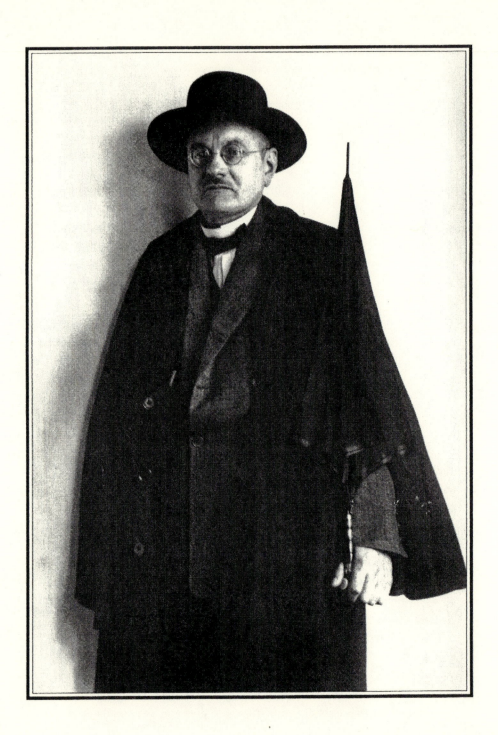

Berlin" (323). Pointing to the various visual and acoustic details that assault the senses of the masses, he evokes what he calls "the total artwork of effects" that, raising distraction to the level of culture, are "aimed at the masses" (324). "Rather than acknowledging the actual state of disintegration that such shows ought to represent," he writes, "the movie theaters glue the pieces back together after the fact and present them as organic creations" (328). Like the audiences who are fragmented and dispersed by the film that will also gather them together, Jünger's modern type is violated by technology—transformed into a kind of thing like everything else—in order to then be mobilized more easily under the laws of technical reproducibility. In other words, the same technology that works to disperse the masses also helps constitute them. This is why, in an age whose signature is total reproducibility, Jünger tries to envision an idea of a modern community, a return to the logic of togetherness inscribed within the values of *Gemeinschaft* that, remaining faithful to the new demands of this technological era, can be mobilized in order to give direction and form to the contemporary masses. A mode of organization that is effected primarily through film and photography, this work of mobilization "expresses the secret and inexorable claim to which our life in the age of masses and machines subjects us" ("Total Mobilization," 128 / "Totale Mobilmachung," 128) and, as a means of expression, works to name the gestalt of the masses.

For Benjamin, it is precisely this mobilization—one that, expressing the truth of the masses, gives them a figure or form—that lies behind the fascist mobilization of masses. In the epilogue to the "Work of Art" essay, for example, he explains that "the growing proletarianization" and the growing formation of the masses are "two sides of one and the same occurrence" (*I* 241 / *GS* 1:506). "Fascism," he says, "attempts to organize the growing proletarian masses without touching those property relations that these masses strive to eliminate. Fascism sees its salvation in giving these masses not their right, but instead a means of expressing themselves" (ibid.). If, following the logic of total mobilization, fascism offers the masses self-expression, this self-expression becomes a means for the masses to give themselves a face (or, as Jünger would have it, a gestalt) in which they can see themselves reproduced. As Benjamin explains in a discussion of the weekly newsreel:

> *Mass reproduction is aided especially by the reproduction of masses.* In big parades and monster rallies, in mass sporting events and in war, all of which today are conducted in front of cameras and sound equipment, the mass

looks itself in the face. This process, whose significance need not be stressed, is intimately connected with the development of the techniques of reproduction and photography. Mass movements are usually discerned more clearly by a camera than by the gaze. A bird's-eye view best captures gatherings of hundreds of thousands. And even though such a view may be as accessible to the human eye as it is to the camera, the image received by the eye cannot be enlarged the way a negative is enlarged. This means that mass movements, including war, represent a form of human behavior that particularly favors the apparatus. (251 / 506)

What makes a mass masslike, Benjamin explains, are the techniques of reproduction and photography that enable a mass to see itself in the face—to see itself looking at itself—as if it were looking into a mirror. If fascism works to allow the masses to view themselves according to the laws of self-reflection, if it wishes to give a face to the masses by means of the media, Benjamin claims that the masses can never be given a face. In his essay on Baudelaire, for example, he insists that the urban mass, of which Baudelaire is always aware, is never described as such (*I* 165 / *GS* 1:618). It can never reside in an image, even though its effects are nevertheless "imprinted on his creativity as a hidden figure" (ibid.). Or, as Benjamin puts it a little later, "The masses had become so much a part of Baudelaire that it is rare to find a description of them in his works. His most important subjects are hardly ever encountered in descriptive form" (167 / 621). For Benjamin, the masses can never be a signification. Unable to constitute a community, they are instead the name of a common dispersion.

The contrast between Jünger and Benjamin here could hardly be more striking. If Benjamin notes that Baudelaire's mass has neither a face nor a gaze with which it might see itself looking at itself, it is because he wishes to write against the fascist formation of masses. He wants to interrupt a mobilization of film and photography whose aim would be to give the dispersed and distracted masses not only a face but also a form and a voice. But it is film's capacity to give the masses this gestalt that has led Hans-Jürgen Syberberg to claim, in relation to the Nazi use of film, that

> Hitler understood the significance of film. Now we are just as used to regarding his interest in film pejoratively, as if he had only used it for propaganda purposes. We might even wonder whether he did not organize

> Nuremberg entirely for Leni Riefenstahl, it partially looks this way, and
> taking the argument a little further, whether the whole of the Second
> World War was not indeed produced as a big-budget war film for the
> evening newsreel screenings in his bunker. . . . The artistic organization of
> these mass ceremonies on celluloid, and even the organization of the final
> collapse, were part of the overall program of this movement. Hitler saw
> the war and its newsreel footage as his heroic epic. The newsreels of the
> war were the continuation of *Triumph of the Will* from Riefenstahl's
> Nuremberg.[50] (*Die freudlose Gesellschaft*, 74–75)

Claiming that Hitler worked to relaunch the war as a cinematic epic, Syber-
berg suggests that the varying potential of illumination and floodlighting was
mobilized in order to transform Europe into a movie screen. We could even
say, following his association of industrialized warfare with the cinema, that
there could not have been a Nazi movement without the artistic and cine-
matic representations that helped shape its meaning and organization. This
is why, for Syberberg, the total work of art is cinema.[51] It is also why he
asserts that Hitler was "the greatest filmmaker of all time" (*Hitler*, 109).

If the fascist approach to the masses demands an image in which they can
see themselves reflected and under which they can be reintegrated, Ben-
jamin's discussion of the aura—as a phenomenon that, always signaling the
appearance of a distance, implies that the gaze that the mass directs at itself
can only miss its target—offers an important alternative to what Weber has
called "the fascistic, aestheticizing use of aura." Within this discussion,
Weber adds, "what one 'sees' in the look of the other is not simply a repro-
duction of the same, but something else. [This is why] what is condemned,
in the age of technical reproducibility, is not the aura, but the aura of art as
a work of representation."[52] Although we could say that there are many
relays between Jünger's thoughts on photography and those of Benjamin—
they each claim that the experience of photography involves an encounter
with danger and shock, that technology in general has brought us nearer to
death, that every document of civilization is touched by a certain barba-
rism—Benjamin meets Jünger's desire for total mobilization with an insis-
tence on immobilization, his desire for expression with an interest in what
remains expressionless, his wish for community with the dispersion of com-
munity, the aura with the aura's disintegration, and the giving of a face with
what never has a face. That fascism names the filmic and photographic mobi-

lization of the identificatory mechanisms of the masses means that there can be no politicization of the human face that does not belong to an ideological combat zone. It is within this combat zone that Bloch, in a discussion of montage, states that in "the all-exploding, all-shattered Today ... human beings lack something, namely the main thing: their face and the world which contains it" (*Heritage of Our Times*, 228).

XV.

C A E S U R A. — History comes to a head in a moment of disaster, in the time of the disaster that structures the danger of history. In the almost-no-time of this breakdown, thinking comes to a standstill. It experiences itself as interruption. As Benjamin explains, historical thinking involves "not only the movements of thoughts, but their arrest as well" (*I* 262 / *GS* 1:702). The catastrophe of history—the catastrophe that is history—corresponds to history's efforts to arrest this arrest. In other words, the catastrophic is the insistence on an organic or progressive history. "That things just go on," Benjamin tells us, and have gone on this way, "this is the catastrophe": "Catastrophe is not what threatens to occur at any given moment but what is given at any given moment" (*CP* 50 / *GS* 1:683).[53] The head to which history comes during the time of the catastrophe of this catastrophe is, as he notes in his *Trauerspiel*, "a death's head" (*O* 166 / *GS* 1:343). It is the deadly head of Medusa. For Benjamin, there can be no history without the Medusa effect—without the capacity to arrest or immobilize historical movement, to isolate the detail of an event from the continuum of history. Adorno himself recognized this point when, in his 1955 portrait of Benjamin, he claimed that the glance of Benjamin's philosophy is "Medusan" ("Portrait of Walter Benjamin," 233).[54] The Medusa's gaze stalls history in the sphere of speculation. It short-circuits, and thereby suspends, the temporal continuity between a past and a present. This break from the present enables the rereading and rewriting of history, the performance of another mode of historical understanding, one that would be the suspension of both "history" and "understanding" (that is, the end of history and understanding as the directional and teleological paths we have always understood them to be). This other mode of historical understanding would be that of the historical materialist, of the one who "blasts the epoch

out of its reified *historical continuity*" (*OWS* 352 / *GS* 2:468). Whereas "histori-
cism presents the eternal image of the past," historical materialism offers "a
specific and unique experience with it. . . . The task of historical materialism
is to set in motion an experience with history original to every new present.
It has recourse to a consciousness of the present that shatters the continuum
of history. Historical materialism conceives historical understanding as an
afterlife of what is understood, whose pulses can still be felt in the present"
(ibid.).

Benjamin's sixteenth thesis claims that this leap out of a predetermined
history and into "true" history takes place in "a present which is not a transi-
tion, but in which time stands by and has come to a standstill" (*I* 262 / *GS*
1:702). Arguing according to the logic of the photographic image—that is,
negatively—Benjamin characterizes his position on history and historiogra-
phy against prevailing ones, and does so by affirming a movement of inter-
ruption that suspends the continuum of time. By retaining the traces of past
and future—a past and future it nonetheless transforms—the photograph
sustains the presence of movement, the pulses whose rhythm marks the
afterlife of what has been understood, within the movement it gorgonizes.
Only when the Medusan glance of either the historical materialist or the
camera has momentarily transfixed history can history *as* history appear in its
disappearance. Within this condensation of past and present, time is no
longer to be understood as continuous and linear, but rather as spatial, an
imagistic space that Benjamin calls a "constellation" or a "monad." "Where
thinking suddenly stops in a constellation saturated with tensions," Benjamin
writes, "it gives that constellation a shock, by which it [thinking] crystallizes
into a monad. The historical materialist approaches a historical subject only
where it confronts him as a monad" (262–63 / 702–3). If this break from the
present signals the taking over of a past (in theses VI and XIV, for example),
the arrest of thought in a constellation or monad "blasts" this past open—and
no less so because this constellation or monad itself consists of differences of
force and meaning, of heterogeneous inscriptions and transcriptions. This
blast solicits "a specific life out of the era, a specific work out of the lifework.
The benefit of [the historical materialist's] method is that *in* the work the
lifework is preserved and *aufgehoben*; in the lifework, the era; and *in* the era,
the entire course of history" (263 / 703). This blast "shatters the continuum
of history" and in so doing reveals the history hidden in any given work. It
discloses the breaks, within history, from which history emerges. Focusing

on what has been overlooked or hidden within history, on the transitoriness of events, on the relation between any given moment and all of history, the historical materialist seeks to delineate the contours of a history whose chance depends on overcoming the idea of history as the mere reproduction of a past.

The radical temporality of the photographic structure coincides with what Benjamin elsewhere calls "the caesura in the movement of thought" (*N* 67 / *GS* 5:595). It announces a point when "the past and the present moment flash into a constellation." The photographic image—like the image in general—is "dialectics at a standstill" (*N* 50 / *GS* 5:578). It interrupts history and opens up another possibility of history, one that spaces time and temporalizes space. A force of arrest, the image translates an aspect of time into something like a certain *space*, and does so without stopping time, or without preventing time from being time.[55] Within the photograph, time presents itself to us as this "spacing." What is spaced here—within what Benjamin elsewhere calls "the space of history" (*Geschichtsraum*; *N* 45 / *GS* 5:571)—are the always becoming and disappearing moments of time itself. It is precisely this continual process of becoming and disappearing that, for Benjamin, characterizes the movement of time. Speaking of Proust, in a passage that asks us to think about the relation between time and space, he writes: "The eternity that Proust opens to view is space-crossed time, not limitless time. His true interest concerns the passage of time in its most real, that is, its *space-crossed* figure" (*I* 211 / *GS* 2:320). The spacing of this *space-crossed* figure—which is, as Benjamin notes, a temporal operation: "the passage of time" (space and time are here intertwined, and to such a degree that they can no longer be distinguished)—opens a space for time itself, dispersing it from its continuous present. This is why he continues by claiming that this figure "nowhere prevails in a more undisguised form than in remembrance, within, and in aging, without" (ibid.). Looking both backward and forward, this figure marks a division within the present. Within the almost-no-time of the camera's click, we can say that something *happens*. For Benjamin, however, for something to happen does not mean that something occurs within the continuum of time, nor does it imply that something becomes present. Rather, the photographic event interrupts the present; it occurs *between* the present and itself, between the movement of time and itself. This is why nothing can occur in either the continuous movement of time or the pure present of any given moment. As Jean-Luc Nancy explains, "nothing can *take place*, because

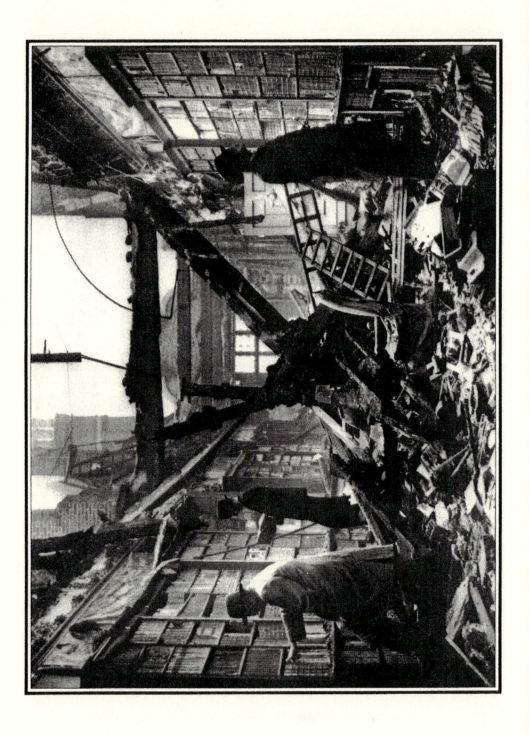

there is no place (no 'spacing') between the presents of time, nor between time and itself" ("Finite History," 156). For Benjamin, nothing can take place before the photograph, before the event of the photograph. Effecting a certain spacing of time, the photograph gives way to an occurrence. What the photograph inaugurates is history itself, and what takes place in this history is the emergence of the image.

The photograph is always related to something other than itself. Sealing the traces of the past within its space-crossed image, it also lets itself be (re)touched by its relation to the future. Related to both the future and the past, the photograph constitutes the present by means of this relation to what it is not. If a space must separate the present from what it is not in order for the present to be itself, this space must at the same time divide the present. In constituting itself, in dividing itself, this interval is what Benjamin calls *"space-crossed* time"—time-becoming-space and space-becoming-time.

From the very moment of the photographic event, the abbreviation that telescopes history into a moment—an abbreviation or miniaturization that tells us that history can end or break off—suggests that what inaugurates history is written into a context that history itself may never completely comprehend. This context—an isolated historical monad that contains "the whole course of history"—exceeds the limits of its representation. As Benjamin explains, "the events surrounding the historian and in which he takes part . . . underlie his presentation like a text written in invisible ink" (*N* 67 / *GS* 5:595). To write history is therefore not to represent some past or present presence. "To articulate the past historically," Benjamin writes, "does not mean to recognize it 'as it really was.' It means to seize a memory as it flashes up at a moment of danger" (*I* 255 / *GS* 1:695). History therefore begins where memory is endangered, during the flash that marks its emergence and disappearance. It begins where the domain of the historical cannot be defined by the concept of historicality—where representation ends. As Nancy puts it: "The historian's work—which is never a work of memory—is a work of representation in many senses, but it is representation with respect to something that is not representable, and that is history itself. History is unrepresentable, not in the sense that it would be some presence hidden behind the representations, but because it is the *coming* into presence, as event" ("Finite History," 166). For Benjamin, neither Medusa nor history can be viewed or comprehended directly[56]—not even in the technologically lit realm of the headlight.

XVI.

T R A C E S . — To say that history withdraws from sight or understanding is not to say that history is what is past, but rather that it passes away; not that it has disappeared, but rather that it "threatens to disappear"; it is always on the verge of disappearing, without disappearing. The possibility of history is bound to the survival of the traces of what is past and to our ability to read these traces as traces. That these traces are marked historically does not mean that they belong to a specific time—as Benjamin explains in his early essay on the *Trauerspiel* and tragedy, "the time of history is infinite in every direction and unfulfilled in every instant. This means that no single empirical event is conceivable that would have a necessary connection to the temporal situation in which it occurs" (*GS* 2:134). Rather, as he says of images in general, they only come to legibility at a specific time. This "coming to legibility" marks "a specific critical point of the movement within them" (*N* 50 / *GS* 5:577–78). This critical point is a moment of danger, a moment when historical meaning finds itself in crisis. "The image that is read," he writes, "meaning the image in the Now of recognizability, bears to the highest degree the stamp of the critical, dangerous movement that is the ground of all reading" (*N* 50–51 / *GS* 5:578). History is what such legibility comes to, and the place of this legibility is constructed by what Benjamin refers to as "now-time" (*Jetztzeit*). This time is to be understood according to the structure of photographic temporality, which conceives of the relationship between a past and a present as dialectical—that is, as imagistic. This image emerges in the now-time of reading:

> Every present is determined by those images that are synchronic with it: every now is the now of a specific recognizability. In it, truth is loaded to the bursting point with time (this bursting point is nothing other than the death of *intentio*, which accordingly coincides with the birth of authentic historical time, the time of truth). It isn't that the past casts its light on what is present or that what is present casts its light on what is past; rather, an image is that in which the Then and the Now come together, in a flash of lightning, into a constellation. In other words: an image is dialectics at a standstill. (ibid.)

"Historic" time is always *full,* even if, as Benjamin says, it is never fulfilled at any given moment. It is a time filled to the bursting point by its own *spacing,* by all of the images that are synchronic with it. As Benjamin writes elsewhere in the theses, "history is the object of a construction whose place is formed not by homogeneous, empty time, but rather by time filled by 'now-time' *(Jetztzeit)*" (*I* 261 / *GS* 1:701). History, according to this formulation, is still to come. It is what we come to, what is produced through an activity of construction, an activity whose place is in turn constituted by a temporal structure: the time of "now-time" (see Bahti, "History as Rhetorical Enactment," 11–12). Yet what is "now-time," and what does it mean to be filled by "now-time"? " 'Now-time' does not mean the present," Nancy suggests, "nor does it represent the present. 'Now-time' presents the present, or makes it *emerge.* . . . The present of 'now-time,' which is the present of an event, is never present. But 'now' (and not 'the now,' not a substantive, but 'now' as a performed word, as the utterance which can be ours) presents this lack of presence. A time full of 'now-time' is a time full of openness and heterogeneity" ("Finite History," 170).[57] The "now-time" of reading history "at once determines the readability of historical images and is determined by them." The truth of these images is neither timeless, because it is full of time, nor bound to the time of a historical subject, because it coincides with the death of intentionality (see Bahti, "History as Rhetorical Enactment," 12). It is instead written into the temporality of the photographic structure operating in every moment, determining the image's legibility. History is made in its being photographed. Yet, whenever the "coming to legibility" of the photograph is interrupted, as it must be, history, as a process of appropriation and self-realization, is all over.

For Benjamin, the activity of reading is charged with an explosive power that in no way preserves, but rather, in the interruption of its movement, tears the image to be read from its context. This tearing or breaking force is not an accidental predicate of reading; it belongs to its very structure. Only when reading undoes the context of an image is a text developed, like a photographic negative, toward its full historical significance (see Wohlfarth, "Walter Benjamin's Image," 89). The photographic image therefore comes only in the form of a coming, in the mode of a promise, within the messianism of its "event": photography promises that everything may be kept for history, but the everything that is kept is the everything that is always already

in the process of disappearing, that does not belong to sight. What is kept is only the promise, the event of the promise. As Benjamin puts it, "nothing that has ever happened should be regarded as lost for history" (*I* 254 / *GS* 1:694).

XVII.

NIGHTDREAMS. — The light of photography never arrives alone. It is always attended by darkness. We might even say that the relay between light and darkness that names photography also gives birth to it. Luminosity can only emerge in Benjamin from out of the coincidence of light and dark, day and night, waking and sleeping. As he wrote in an early poem he sent to Ernst Schoen in the fall of 1917: "Where waking does not part from sleeping / Luminousness makes its appearance" (*C* 96 / *B* 149). Suggesting that there is no moment of enlightenment or awakening that is not also a moment of darkness or sleep, Benjamin tells us that it is only when light is no longer light that it becomes light. A light that does not break with night, photography can be said to occur when the moment of awakening signals an instance of estrangement, a moment when awakening moves away from itself. This estrangement would mean that there is no interval between dreaming and waking. If there is such a thing as awakening, it can only happen within the night of our understanding, with the transit between light and darkness that prevents us from being awake, from being awake beings. To be awake means to be asleep.

Benjamin makes this point in an early fragment from the *Passagen-Werk*. There, in a passage that evokes the psychoanalytic deconstruction of the distinction between sleeping and waking, he writes:

> It is one of the unspoken assumptions of psychoanalysis that the antithetical contrast of sleeping and waking has no validity for the empirical form of human consciousness; rather it yields to an infinite variety of concrete states of consciousness, that are conditioned by all conceivable gradations of awakened-being. . . . The condition of the consciousness that is multiply patterned, checkered with sleep and waking, needs only to be transferred from the individual to the collective. (*GS* 5:492)

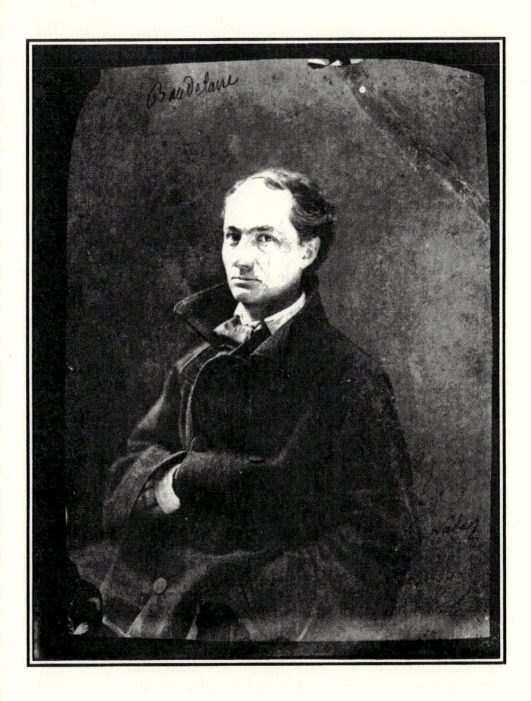

Awake neither to itself nor to others, human consciousness takes place within a spectrum of awakening without beginning or end. Consciousness is perhaps what it is only to the extent that it remains both awake and asleep at the same time. If sleep is inevitably inscribed within "all conceivable gradations of awakened-being," awakening means the impossibility of sleep within sleep. What is true for individual consciousness, moreover—that it is neither fully conscious nor individual—is also true collectively. This is why Benjamin understands the nineteenth century as a time and space of dreams, a *Zeitraum* in which "the collective consciousness plunges into an ever deeper sleep":

> As now the sleeper—resembling in this way the madman—undertakes through his body the macrocosmic voyage and the noises and feelings of his own interior which—for the healthy, awakened man coalesce into the surge of health, blood pressure, visceral movements, heartbeat, and muscular sensation—in his incredibly sharpened inner sensibility cause delirium or dream-image [*Traumbild*] . . . so is it with the dreaming collectivum, which in the passages becomes absorbed in its interior. We must investigate this, in order to interpret the nineteenth century . . . as the result of its dream visions. (491–92)

Like a photograph, the nineteenth century is both a space of time and a dream of time. It names a moment when dream-sleep falls over the eyes of Europe and thereby tells us what is true of every historical period: there is no era that is not constituted from such dream visions, that does not have its dream side (490). History is therefore a dream of time—a dream of time that affirms all time to be a time of dreams. This is why, for Benjamin, the historian must take on "the task of dream interpretation" (*N* 52 / *GS* 5:580). This is also why only a thinking that is dialectical can read history, can awaken us to history as he understands it. As he notes in relation to the dream spaces of modernity: "the arcades and interiors, the exhibition halls and panoramas . . . are residues of a dream world. The utilization of dream elements when waking up is the textbook example of dialectical thinking. For this reason dialectical thinking is the organ of historical awakening. After all each epoch not only dreams the next, but also, in dreaming, strives toward awakening" (*R* 162 / *GS* 5:59).

If Marx suggests that "the reformation of consciousness lies *solely* in the

awakening of the world . . . from its dreams about itself" (*GS* 5:570), Benjamin aims at awakening us to the impossibility of such an awakening.[58] If he nevertheless has recourse to a vocabulary of awakening in his discussions of dialectical historiography, he simultaneously undoes the opposition between waking and sleeping that enlightenment historiography assumes. His awakening hollows awakening out into another awakening, where there can be no question of waking, where awakening no longer implies our being awake. It is rather a moment that, linked to the unconscious world of remembrance, comes in the form of dream experience. Arguing against those who would want "to keep awakening away from the dream" (*GS* 5:1212), he suggests that, if we must "grasp all insight according to the schema of awakening," we must also understand that this awakening has "the structure of a dream" (1213). The dream that remains as the signature of modernity is in fact for Benjamin the "dream that one is awake" (496).

In a discussion of the relation between his dream rhetoric and that of surrealism, Benjamin furthers his sense of the relation between dreaming and waking by asking if awakening might be "the synthesis whose thesis is dream consciousness and whose antithesis is waking consciousness." If dreams are without end and waking is without beginning, he adds, "then the moment of awakening would be identical with the 'Now of recognizability' in which things put on their true—surrealist—face" (*N* 51–52 / *GS* 5:579).[59] That Benjamin elsewhere identifies this "true—surrealist—face" with "the face of an alarm clock that in each minute rings for sixty seconds" (*R* 192 / *GS* 2:310) suggests that the moment of awakening must be repeated endlessly because no one is ever fully awakened.[60] The face of surrealism here belongs to a "dialectical optic" (190 / 307) that registers both the wearing away of "the threshold between waking and sleeping" (178 / 296) and the spacing that prevents the now from being awake to itself. This optic implies a revolution in our view of awakening—as Benjamin tells us in his surrealism essay, "only revolt completely exposes its surrealist face" (182 / 300)—that, bringing the past into the present (and in a way that prevents either the past or the present from ever being themselves), takes place under the nonlight of a "profane illumination" (179 / 297).[61] It articulates the conditions of a mode of seeing in which nothing ever really comes to light. This is why, Benjamin explains, "the 'purity' of the gaze is not so much difficult as impossible to attain" (*N* 59 / *GS* 5:587).

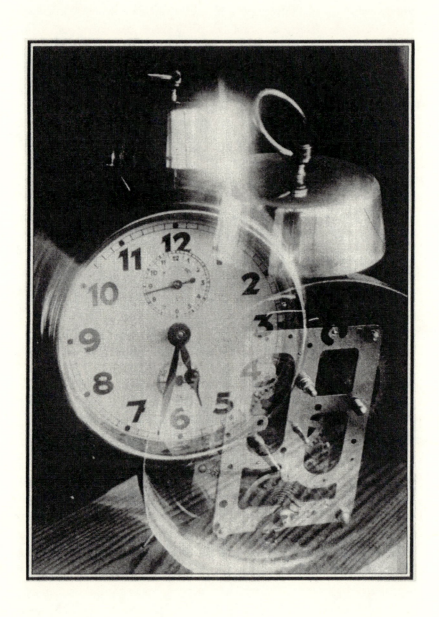

XVIII.

TWILIGHT. — The revolution in our view of awakening corresponds for Benjamin to a revolution in our view of history. He writes:

> The Copernican turn in the historical point of view is this: one used to take "the past" as the fixed point and saw the present as attempting to lead knowledge gropingly to this firm ground. Now this relation shall be reversed and the past should become the dialectical reversal, the sudden thought of an awakened consciousness. Politics is granted primacy over history. Facts become something that hit us just now; to establish [*festzustellen*] them is the task of memory. And, indeed, awakening is the exemplary case of remembering: the case in which we succeed in recalling the nearest, the most banal, the most obvious. What Proust means by the experimental rearrangement of furniture in the half-slumber of the morning, [what] Bloch understands as the darkness of the lived moment, is nothing other than what we should determine here, on the level of the historical, and collectively. There is a not-yet-conscious-knowledge of the past, whose furthering has the structure of awakening. (*GS* 5:490–91)

If the Copernican turn in Kantian philosophy signals a reversal in the relation between objects and thought—rather than thought conforming to objects, objects now conform to thought—the Copernican turn in Benjaminian historiography names an inversion of the relation between the past and the present.[62] The present no longer struggles to lead knowledge, as one would lead the blind, to the firm ground of a fixed past. Instead the past infuses the present and thereby requires the dissociation of the present from itself. In other words, the past—as both the condition and caesura of the present—strikes the present and, in so doing, exposes us to the nonpresence of the present. If it is no longer a matter of the past casting its light on the present or of the present casting its light on the past (*N* 50 / *GS* 5:578), it is because the past and the present deconstitute one another in their relation. The coincidence of this exposure and deconstitution defines a political event, but one that shatters our general understanding of the political. It tells us that politics can no longer be thought in terms of a model of vision. It can no longer be measured by the eye.

The past becomes "the dialectical reversal, the sudden thought of an awakened consciousness," because, suddenly infused into this awakened consciousness, it transforms this consciousness into something that is both awake and asleep, conscious and not-yet-conscious, at the same time. Exposing us to this "half-slumber," this "darkness of the lived moment," it exposes us to what is most near, most banal and obvious: the obscurity of our everyday experience (R 190 / GS 2:307). If awakening is the paradigm of remembering, it is because it recalls us to the condition of remembering, to the darkness that prevents us from knowing either the past or the present. It tells us that there is no awakening that is not at the same time a going to sleep—that is, an experience of forgetting. The memory that comes with forgetting—the memory that comes with what Benjamin calls "the Copernican turn of remembrance" (GS 2:490)—implies that the past is never before us as such. This is why the determination of facts remains a matter of memory rather than of perception. This is also why we are exposed to slumber and darkness: at a certain level, they constitute our experience in general—historically and collectively—even when we do not know it.

Benjamin here asks us to turn away from a historicism that presumes the truth of history to be present at all times. This historicism would assume that it is the task of the present to read or discover a "timeless truth" (N 51 / GS 5:578), a fixed, "'eternal' image of the past" (I 262 / GS 1:702). This truth and image would be, according to Ranke (whom Benjamin cites in his Theses), a knowledge of the past as it really was (255 / 695). Benjamin's writings on history work to break with this conception of historical truth. Against Gottfried Keller, who claims that the truth of history would never "run off and leave us" (ibid.), he suggests that history can only be history to the extent that it ceaselessly moves away from us. If it were not the disappearing trace of its own transience, history would in fact never "happen." Politics now "acquires primacy over history" because the axiomatics of a materialist historiography demand not only the mobilization of historical signification but an interruption of the optical imperative governing both political and historical understanding.[63]

For Benjamin, the truth of history does not involve the representation of an "eternal past" but rather the production—in relation to an agent and a present moment (even if neither the agent nor the present has a simple identity)—of an image. This truth of history is performed when we take the risk of making history rather than assuming it to belong only to the past. It

happens, in other words, when we understand historicity as a kind of per-
formance rather than as a story or a form of knowledge. As Nancy notes, "it
is precisely this question of beginning, of inaugurating and entering history,
that should constitute the core of the thinking of history. Historicism in
general is the way of thinking that presupposes that history has always al-
ready begun, and that therefore it always merely continues. Historicism *pre-
supposes* history, instead of taking it as what should be thought" ("Finite
History," 152). If the very concept of history has always been founded on the
possibility of meaning, on the past, present, or promised presence of meaning
and truth, then this Copernican turn in historiography tells us that historical
existence is never a matter of presence. History instead registers an event the
experience of which tells us that presence fails to arrive. What is at stake now
is the possibility of awakening to a history that does not give itself to sight,
that interrupts not only the present but also awakening itself. The possibility
of this other history is suggested, for Benjamin, by Proust and Bloch.

According to Benjamin, the moment of awakening in Proust marks the
"ultimate dialectical breaking point" of the whole of life because it occurs
only when life and death, waking and sleep, are understood to oscillate
within each other (*N* 52 / *GS* 5:579). If Proust begins his own *Recherche du
temps perdu* with a narrator who is falling asleep, it is in order to describe the
awakening that results from "the thought that it was time to go to sleep"
(*Remembrance of Things Past*, 1:3 / *Recherche du temps perdu*, 1:3). This coinci-
dence of sleeping and waking conjures the twilight state that throughout the
Recherche forms the matrix not only of a specific form of experience but of all
experience. This is why, for Benjamin, the awakening that comes with sleep
becomes the condition of writing any history. As he notes, writing of the
relation between awakening and history in Proust: "Just as Proust begins his
life story with the moment of awakening, so every presentation of history
must begin with awakening; in fact it actually must not deal with anything
else" (*N* 52 / *GS* 5:580). What Proust's narrator awakens to is an experience
that is neither lived or experienced, or rather is experienced as an encounter
with what is not experienced. The awakening of history implies an experi-
ence of history as what occurs without ever appearing before our eyes as
such.

What Marcel sees as he awakens, if he sees anything at all, is generally the
moving darkness around him: "I would fall asleep again," he writes, "and
thereafter would reawaken for short snatches only, just long enough . . . to

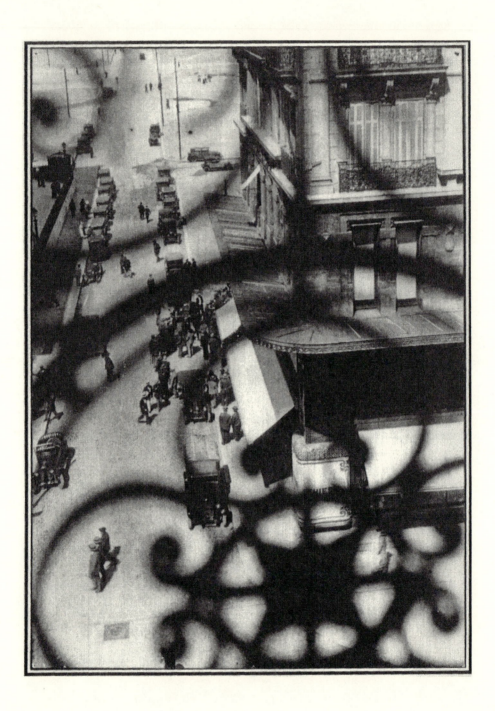

open my eyes in order to fix the shifting kaleidescope of darkness, to savour, in a momentary flash of consciousness, the sleep which lay heavy upon the furniture, the room, the whole of which I formed but an insignificant part and whose insensibility I should very soon return to share" (1:4 / 1:4). Like a night camera that works to arrest an image in the dark, Marcel's eyes open and, under the "momentary flash of consciousness," work to fix the "shifting kaleidescope of darkness" before him. Immobilizing the whirling darkness around him, he stares at the sleep that again will soon overtake him. If he orients himself at all, he does so only in relation to the darkness and sleep that keep him from registering who and where he is: "I lost all sense of the place in which I had gone to sleep, and when I awoke in the middle of the night, not knowing where I was, I could not even be sure at first who I was" (1:5 / 1:5).

The estrangement that characterizes Marcel's crepuscular states becomes the exemplary feature of the *Recherche*—and not only because of a darkness at the heart of experience. It occurs also because, in Proust, the possibility of sight and cognition, of memory and consciousness, is dependent less on the eyes than on the body. Benjamin registers this point more than once in relation to what he considers the "classic moment" in Proust—"awakening at night in a dark room" (*GS* 5:509):

> It always happened, when I would awaken like this, my mind struggling unsuccessfully to discover where I was, that everything would turn around me in the darkness: things, countries, years. My body, too heavy to move, would try, according to the form of its tiredness, to restore the position of its members in order to induce from that the direction of the wall, the place of the furniture, in order to restore and give a name to the house in which it lay. Its memory, the memory of its ribs, knees, shoulders, offered it in succession several of the rooms in which it had slept, while around it the invisible walls, changing positions according to the form of the imagined room, would whirl in the darkness. And even before my thought, which hesitated at the threshold of times and forms, had identified the house by bringing together the details, it—my body—would recall for each the type of the bed, the position of the doors, how the windows caught the light, the existence of a corridor, along with the thought that I had when I would fall asleep, and that I would find again when I would awaken. (*Remembrance of Things Past*, 1:5 / *Recherche du temps perdu*, 1:6)

Awakening in his dark room, Marcel finds himself in a photographic space.[64] What whirls before him in this dark space is not only the changing, unseen walls, the doors, the furniture, but also all the things, places, and years that remain written within his memory. Like a spectator in the dark projection hall of a cinema, he encounters a succession of images moving before him with a rapidity that, in bringing together the past and the present, prevents him from orienting himself in relation to either the image, the past, or the present. What is striking in the movement of the passage, however, is that Marcel's effort to orient himself is soon that of his body rather than of his mind. It is the memory of his body that works to discover where he is. Within the Proustian corpus it is the body that registers or records memories and impressions. An apparatus of memory, it finds itself, as Marcel says of the past, "encumbered with innumerable negatives" that, inscribed within it, remain undeveloped by the mind (2:1020 / 4:474). That cognition and perception are dependent upon the entirety of the corporeal sensorium means that memory and its negatives are irreducible to the operations of consciousness and therefore cannot be brought to light: to remember within the space of the remembering body is to remember without knowing anything. In other words, the body in Proust names a principle of articulation among writing, memory, and materiality that does not belong to the domain of knowledge. This is why Marcel's body can only "induce," construe or piece together a sense of where he is in order to name it. Indeed, that memory is written into Marcel's body means that this body is the darkened tomb of memory. Or, to be more precise, it is the sign of this tomb.

The materiality of this remembering body is therefore not that of a simple physical exteriority, even if we can say that it is the body or flesh of thought. The body that thinks and remembers with its "ribs, knees, [and] shoulders" is, like photography, an archive of memory.[65] As such, it describes an interiority devoted to the production of images. An "inside" in which images are formed and projected (at the level of sensation, perception, memory, or consciousness), the body is a kind of darkroom, what Proust elsewhere calls an "inner darkroom" (2:523 / 2:227). Like the magic lantern that will soon project its images upon the walls of Marcel's bedroom, the body projects images of the past into the darkness of a mind unable to identify where it is. These shifting images, however, are never present as such—either to Marcel or to themselves. In other words, the various rooms that flash cinematically before Marcel evoke and withdraw what we call "thoughts," but thoughts which are

thought from the point of departure of the body and its memories, its images. To say this is to say that thinking cannot "think" without at the same time touching on the body as its condition of possibility. The space in which thought and the body, memory and matter, come together is, as Benjamin tells us in his surrealism essay, the "image-space" (R 192 / GS 2:310). The flashing images produced by Marcel's body at the same time reveal it to be a kind of sign or image, a sign or image whose slightest movement alters the images it produces. As Bergson explains in *Matter and Memory*—a text that both Proust and Benjamin internalize within their own meditations on the relation between the body and images—"Here is a system of images which I term my perception . . . and which may be entirely altered by a very slight change in a certain privileged image—*my body*. This image occupies the center; by it all others are conditioned; at each of its movements everything changes, as though by a turn of a kaleidescope" (25). The radical discontinuity of the successive configurations that result from the body's kaleidescopic movements names a technology wherein body and image interpenetrate one another.[66] What this "technology of awakening" (GS 5:490) awakens is "a not-yet-conscious knowledge of the past" (N 45 / GS 5:572). It is because the body and image intersect that we encounter the darkness that conditions and interrupts the possibility of knowledge. The "advancement" of this darkness, of this "not-yet-conscious knowledge of the past," has "the structure of awakening" not because it defines a moment of awakening (it only has the structure of awakening) but because the movement of history belongs to the ceaseless reproducibility of this nonknowledge (GS 5:491). In other words, what gets furthered within the technology that joins our bodies with images is our relation to the darkness of experience in general.

If it is within the body that memory is given, it is because the body forms the aperture of Marcel's memory. What appears through the opening and closing of this aperture is memory's inability to appear to either itself or consciousness. This body of memory therefore names the body that is memory itself and the memory that comes in the form of the body. For both Benjamin and Proust—for Benjamin above all as a reader of Proust—memory is in the first place a *memory of the body* (CB 115n / GS 1:613).[67] According to Benjamin, Proust repeatedly concerns himself with what Freud referred to as those "other systems" that, different from consciousness, enable the transit between the past and the present. "Limbs," he writes, "are one of [Proust's] favorite representations of them, and he frequently speaks of the memory

images deposited in limbs—images that suddenly break into memory without any command from consciousness when a thigh, an arm, or a shoulder-blade happens to assume a position in bed that they had at some time earlier. The *mémoire involontaire des membres* is one of Proust's favorite subjects" (115n / 613). Linking the process of inscription to that of memory, the involuntary memory of Marcel's body parts flashes images of the past into the present and thereby produces an experience that does not belong to itself, that cannot appropriate experience. That memory is beyond consciousness means that the space of memory names a darkness, a kind of sleep at the heart of things.

This sleep and darkness—the conditions of the self's dissociation from itself—are what Bloch calls "the darkness of the lived moment." "We do not have an organ for the I or the we," he explains, "but we keep to ourselves in the blind spot, in the darkness of the lived moment, whose darkness is ultimately *our own darkness*, our being unknown, disguised, or lost, to ourselves" (*Geist der Utopie*, 371–72). Unable to discover who he is in the twilight of his awakening, Marcel awakens to the darkness that prevents him from knowing where he is, to the living present's inability to coincide with itself. At the same time it is through this darkness that we "keep to ourselves," that we come to ourselves as the ones who will never know who we are. Bloch registers the consequences of this same darkness when he explains that:

> Just as little as the eye can see at its blind spot, where the nerve enters the retina, is what has just been experienced perceived by any sense. This blind spot in the soul, this darkness of the lived moment, must nevertheless be thoroughly distinguished from the darkness of forgotten or past events. When past material is increasingly covered by night, this night can be lifted, memory helps out, sources and finds can be excavated, in fact historically past material, even if only patchily, is especially objectifiable precisely for contemplative consciousness. The darkness of the lived moment, on the other hand, stays in its sleeping-chamber. . . . Together with its content, the lived moment itself remains essentially invisible, and in fact all the more securely, the more energetically attention is directed toward it: at this root, in the lived In-itself, in punctual immediacy, all world is still dark. (*Principle of Hope*, 290)

Like Benjamin, Bloch suggests that the point at which experience touches us—at which we experience experience—is a blind spot. Neither the "punc-

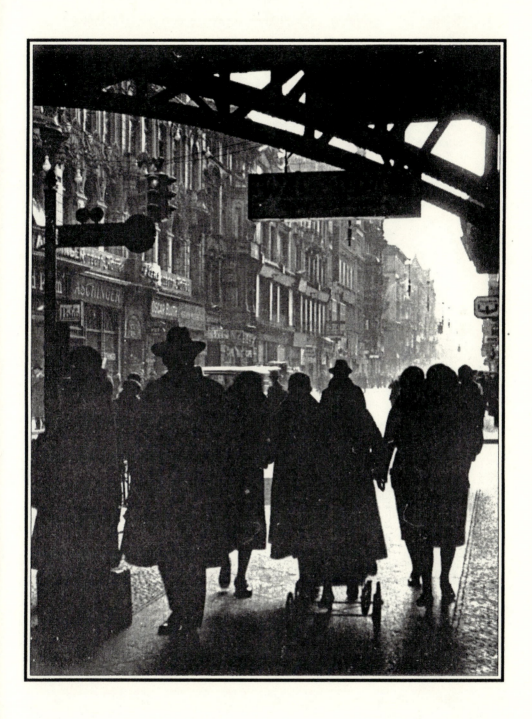

tual immediacy" of the present nor "the lived moment" is ever visible as such. The darkness of the lived moment—the noncontemporaneity of the present to itself—is darker than the darkness of forgotten or past events. It is a darkness that tells us, if it tells us anything at all, that we are never contemporaries of experience, that experience is what escapes the very possibility of experience. This is why the night that permeates the present "stays in its sleeping-chamber": it remains unreadable, hidden, even as it constitutes what Benjamin will elsewhere call "the darkroom of the lived moment" (_GS_ 2:1064). As Bloch notes, to awaken in this darkroom is not at all to awaken to the present:

> becoming aware only stretches to the point where the lived moment can in fact be experienced and characterized as dark. . . . Not the most distant therefore, the _nearest is still completely dark_, and precisely because it is the nearest and most immanent; _the knot of the riddle of existence is to be found in this nearest_. The life of the Now, the most genuinely intensive life, is not yet brought before itself, brought to itself as seen, as opened up; thus it is least of all being-here, let alone being-evident. The Now . . . is the most unexperienced thing that there is. (_Principle of Hope_, 292–93)

If we awaken at all, it is only to the darkness that, inhabiting all experience, tells us that we will never be sufficiently awake. What is in fact nearest to us, closest to what makes us what we are, is our relation to the auratic darkness of this "half-morning slumber." Or, put another way, what is nearest to us is the distance that keeps us from ourselves. This is why our experience is never an experience through which we live. "The Now . . . is the most unexperienced thing that there is" because it is never present—either to itself or to us. To experience this "Now" is to encounter a night that, even if it comes with day, can never know the day.

Cast in relief by the nonlight of a profane illumination, this night is the darkened space within which, according to Benjamin, we exist. It gives birth to a light that can never come to light in language. If language bears this night as it does its own movement, it is because it can neither name it nor overcome it. As he notes in a 1916 letter to Herbert Belmore:

> We are in the middle of the night. I once tried to combat it with words. . . . At that time I learned that whoever fights against the night must move its deepest darkness to deliver up _its_ light and that words are only a way

station in this major life struggle: and they can be the final station only where they are never the first. . . . Life must be sought in the spirit solely with all names, words and signs. For years, Hölderlin's light has shown down on me out of this night.

Everything is all too great to criticize. Everything is the night that bears the light. . . . Everything is also all too small to criticize, not there at all: even the dark, total darkness—even dignity alone—the gaze of anyone who attempts to behold it will grow dim. . . . To criticize is the concern of the outermost periphery of the circle of light around the head of every person, not the concern of language. . . . The chemical substance that attacks *spiritual* things in this way (diathetically) is the light. This does not appear in language. (*C* 83–84 / *B* 131–32)

XIX.

A W A K E N I N G. — Benjamin's efforts to analyze what he calls the "technology of awakening"—especially in its relation to the darkness and sleep that structure its movement—are at the same time directed, among other things, toward a critique of the central Nazi theme of national awakening. His performance of the relation between sleeping and waking articulates an "awakening" that he mobilizes against the "awakening" of National Socialism—not only the awakening that names its rise to power but also the motif of awakening sealed within such Nazi calls to responsibility as "Die Wacht am Rhein!" and "Deutschland, erwache!" Calls for the country and its people to keep watch over the Rhine, to awaken to the threats against their integrity, these two slogans not only served as rallying cries, as signs of alliance with the National Socialist movement, but also became political watchwords. "Deutschland, erwache!," for example, was perhaps the most widely circulated slogan of the Nazi regime. Derived from a poem by Dietrich Eckhart (to whom Hitler would dedicate *Mein Kampf*), it was, from 1923 on, a fighting song for the SS. The slogan for the SS weekly newspaper, *Der Stürmer*, it also closed every large National Socialist assembly, it was the first song in Nazi anthologies of poetry and literature, and, like a kind of seal, it was emblazoned on the square swastika flags carried in parades and adorning

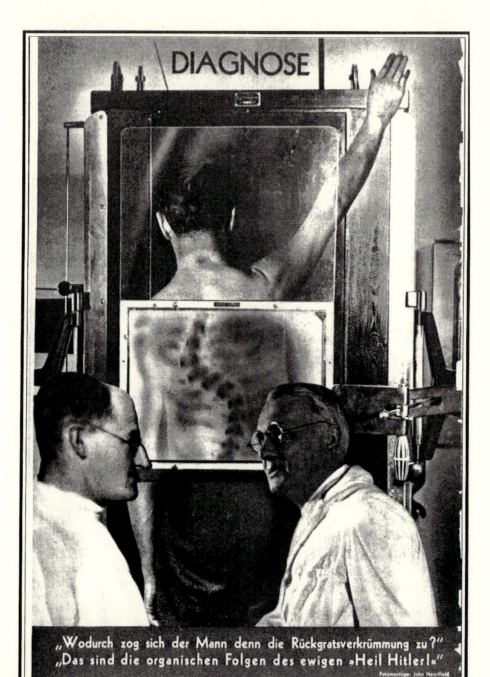

DIAGNOSE

„Wodurch zog sich der Mann denn die Rückgratsverkrümmung zu?"
„Das sind die organischen Folgen des ewigen »Heil Hitler!«"

Fotomontage: John Heartfield

the stages of the mass meetings. That Goebbels declared 4 March 1933, the day before the election, to be the "tag der erwachenden Nation," the "day of the awaking nation," and a few months later, a propagandistic tribute to Hitler and the SS, documenting their respective rise to power, was published under the title *Deutschland erwacht!*, reveals the centrality of this slogan to the formation of what Lacoue-Labarthe and Nancy have called "the Nazi myth" (see Lacoue-Labarthe and Nancy, *Nazi Myth*).

If the essential task for Benjamin is that of waking from the awakening by which National Socialism keeps Germany in its thrall, his awakening presupposes no clear distinction between sleeping and waking consciousness and therefore implies no final lucidity or self-control. As Bloch notes in relation to German fascism, "One definitely sees of course that there is no 'Germany Awake' whatsoever in it; Nazism rather forms a shelter for the contradictory unrest so that it should not awake" (*Heritage of Our Times*, 54). The Nazi rhetoric of emancipation and enlightenment is exposed as a means of intoxication.[68] If Benjamin and Bloch suggest that there can be no awakening, no enlightenment that is not simultaneously a moment of sleep and obscurity, they also imply that responsibility must be thought beginning from the presupposition that we always act and think with our eyes closed. This responsibility therefore calls forth a responsibility other than the one announced in the Nazi calls for a German "awakening." It can in fact take place only in the night of indetermination, in the twilight of our responsibility. This night and twilight name the blindness, the darkness of the lived moment, within which we are nevertheless obliged to respond and act. It is because this historical responsibility, this responsibility to history, is not necessarily linked to awareness, knowledge, or even the themes of history, that Benjamin can suggest that history cannot enter into any developmental history of enlightenment, knowledge, reflection, or meaning. His reflections on awakening in fact name the difficulties of having to respond, to decide and judge, without knowing how. We are obliged to respond while we are both awake and asleep at the same time. Benjamin makes this point in a letter of 3 March 1934 to Scholem. Almost exactly one year after Goebbel's day of the awaking nation, Benjamin writes not only of the sight that comes with night but also of the role of dreams and images in the history and politics of National Socialism: "In these times, when my imagination is preoccupied with the most humiliating problems during the day, I experience at night, more and

more often, its emancipation in dreams, which nearly always have a political subject. I would really like one day to be in a position to tell you about them. They represent a pictorial atlas of the secret history of National Socialism" (*CBS* 100 / *BW* 128).

XX.

L A N G U A G E. — Benjamin's use of the language of photography, in the *Theses* and elsewhere, coincides with his conviction that the image must be understood as historical, and also with his more radical suggestion that history be conceived as imagistic. History, in the sense of either "things as they are" or "things as they have been," can only be figured with and as an image. The movement of history therefore corresponds to what happens during the photographic event, or what happens when an image comes to pass. Benjamin's fifth thesis, for example, concerns the possibility of seizing the image of the past for and in the present, suggesting that the "true picture" of history intends the present: "For it is an irretrievable image of the past that threatens to disappear with every present that does not recognize itself as intended in it" (*I* 255 / *GS* 1:695). What "threatens to disappear" here is not the past, but an "irretrievable image of the past." While we might say that we can recognize ourselves in this image of the past only insofar as we are destined by it, the time of the truth of this picture of history coincides with an interruption of both recognition and intention: it is irretrievable, it can neither be recognized nor intentionally realized in the present. This is why what the image intends is the irretrievability of the present itself.

This image of the past—and of the irretrievable present it intends—may be "fleeting" and "flashing," but it is also susceptible to being held fast, even if what is seized is only the image in its disappearance. In other words, if "the true picture of the past flits by," it is not so much that we are unable to grasp the truth of the past, but rather that the *true* picture of the past is the one that is always in a state of passing away. If Benjamin suggests that a "true picture of the past" does not give us history—or rather, is the only thing of history we get—he still suggests that it can be viewed as true. Nevertheless, as we have seen, it is precisely this "correspondence theory of historical truth"—in which an image corresponds to an historical truth—that is the target of Ben-

jamin's critique (see Bahti, "History as Rhetorical Enactment," 10). To understand history as an image, as Benjamin does, is neither to assert that history is a myth nor to suggest that a certain "historical reality" remains hidden behind our images. Rather, it is always as if we were suspended between both: either something happens that we are unable to represent (in which case all we have are images that substitute for reality), or nothing happens but the production of historically marked fictional images. In either case, the image is a principle of articulation between language and history. This is why, Benjamin notes, we happen upon dialectical images—the only "genuine (i.e. not archaic) images"—in language (*N* 49 / *GS* 5:577). Articulating the intimate relation between vision and language, the principle of this encounter is indissociable from what, within the image, inaugurates history according to the laws of photography, the laws that determine—even as they are determined by—the involuntary emergence of the image. As Benjamin suggests in his notes to the *Theses*, "History in the strict sense is an image from involuntary memory, an image which suddenly occurs to the subject of history in the moment of danger. The historian's authority rests on a sharpened awareness of the crisis that the subject of history has entered at any given moment. . . . Historiography confronts this constellation of dangers. It has to test its presence of mind in relation to it" (*GS* 1:1243, 1242). For him, the laws of photography account not only for the force of images upon whatever we might call the "reality" of history but also for the essential imagism at work within the movement and constitution of history. Images are essentially involved in the historical acts of the production of meaning. Their links with knowledge give them their force, and hence their consequence within the domains of history and politics. This is why the materialism of Benjamin's theory of history can be allegorized in the photographic image. To the extent that the function of the camera is to make images, the historiography produced by the camera involves the construction of photographic structures that both produce and reconfigure historical understanding. Benjamin makes this point in his drafts to the *Theses*, in a passage that, understanding history as imagistic, as textual, links it to the citational structure of photography:

> If one wants to consider history as a text, then what a recent author says of literary texts would apply to it. The past has deposited in it images, which one could compare to those captured by a light-sensitive plate.

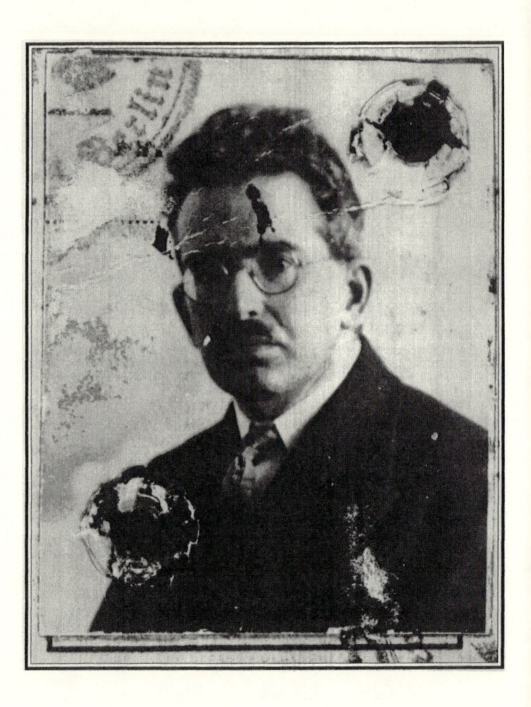

"Only the future has developers at its disposal which are strong enough to allow the image to come to light in all its details. Many a page in Marivaux or Rousseau reveals a secret sense, which the contemporary reader cannot have deciphered completely." The historical method is a philological one, whose foundation is the book of life. "To read what was never written," says Hofmannsthal. The reader to be thought of here is the true historian. (*GS* 1:1238)[69]

XXI.

MATTER. — The historicity of memory cannot be merely a qualification of either memory or the experience of memory: it is not enough to say that memory and experience are historically determined. Rather, the historicity of these two words and concepts must involve their transformation. This is why Benjamin's Baudelaire essay does not simply give us, among so many other things, a genealogy of a history of memory and experience that runs from Bergson to Proust to Freud and then to Baudelaire. Whatever history may be in Benjamin, it does not belong primarily to succession or causality. We could even say that some of the most difficult and enigmatic passages in Benjamin concern his attempt to describe the phenomenon of historical change. One such attempt occurs near the beginning of the Baudelaire essay. There, in a passage that tries to account for the increasingly negative reception of lyric poetry in terms of a change in the structure of experience, he writes:

> If conditions for a positive reception of lyric poetry have become less favorable, it is reasonable to assume that only in rare instances is lyric poetry in rapport with the experience of its readers. This may be due to a change in the structure of their experience. Even though one may approve of this development, one may be all the more hard put to say precisely in what respect there may have been a change. Thus one turns to philosophy for an answer, which brings one up against a strange situation. Since the end of the last century, philosophy has made a series of attempts to lay hold of the "true" experience as opposed to the kind that manifests itself in the stan-

dardized, denatured life of the civilized masses. It is customary to classify these efforts under the heading of a "philosophy of life." ... Towering above this literature is Bergson's early monumental work, *Matter and Memory*. More than the others, it preserves links with empirical research. It is oriented toward biology. The title suggests that it regards the structure of memory as decisive for the philosophical pattern of experience. Experience is indeed a matter of tradition, in collective existence as well as private life. It is less the product of facts firmly anchored in memory than of a convergence in memory of accumulated and frequently unconscious data. It is, however, not at all Bergson's intention to attach any specific historical label to memory. On the contrary, he rejects any historical determination of memory. He thus manages to stay clear of that experience from which his own philosophy evolved or, rather, in reaction to which it arose. It was the inhospitable, blinding age of big-scale industrialism. In shutting out this experience the eye perceives an experience of a complementary nature in the form of its spontaneous afterimage, as it were. Bergson's philosophy represents an attempt to give details of this afterimage and to fix it as a permanent record. His philosophy thus indirectly furnishes a clue to the experience which presented itself to Baudelaire's eyes in its undistorted version in the figure of his reader. (*CB* 110–11 / *GS* 1:608–9)

Wishing to account for a possible change in the structure of experience, Benjamin turns to the philosophical effort to articulate a "philosophy of life" and, in particular, the Bergsonian effort to define life in terms of memory. Describing in photographic terms how history is figured in the movement from Bergson's understanding of memory to Baudelaire's poetics of history, he suggests that the view of history that emerges in the movement between Bergson's philosophy and Baudelaire's reader follows the principles of a photographic apparatus.[70] This apparatus reveals the traces left by history on Bergson's philosophy in the very gesture through which he attempts to overcome them. The "blinding age" compels him to shut his eyes to the historical dimension of history. If, however, Bergson does not experience experience directly, this nonexperience "indirectly" lets us know what is possible for experience in this "blinding age." Experience now means the dissociation of experience from itself. In shutting his eyes, Bergson registers photographically the only possible experience left to experience: the experience of our

nonexperience, the nonexperience of our being blind to a blinding experience. As Elissa Marder notes, "because [Bergson] shuts his eyes to the blinding flash of history, his shut eyes perform the role of a photographic shutter: they retain the blotted image and allow it to be recorded (negatively) despite the fact that the recorded image was never seen directly" ("Flat Death," 138). This age, then, blinding us at the very moment it produces an afterimage of itself, does not so much figure what Bergson experiences when he shuts his eyes—although it does this, too—as it does the relation between what he turns away from and what he sees. It is in this oscillation between sight and blindness that the "spontaneous afterimage"—of Bergson's eyes as well as of the experiences he both sees and does not see—becomes visible not as something to be seen but rather as something to be read. If this afterimage signals, as Benjamin suggests elsewhere, that "the way in which human sense perception is organized—the medium in which it takes place—is not only conditioned naturally but also historically" (*I* 222 / *GS* 1:478), it still does not really tell us how such historical determination works: for determination implies historical causality while history in this passage shows itself to be a complex, even unstable network of causalities, none of which can be isolated from the other. The traces of such determination, however difficult to read, are nevertheless legible in the way in which Benjamin frames his discussion of Bergson within photographic language. Alerting us to the photographic dimension of Bergson's thought, this passage therefore tells us at least two things: (1) if the philosophical questioning of memory and experience before and outside of any particular context, "any specific historical label," is the name of a certain blindness, this blindness belongs to the structure of modernity; and (2) if Bergson's philosophy belongs to this structure, the traces of the age from which it evolved, "or, rather, in relation to which it arose," are readable in its own recourse to the language of photography. These two theses suggest the protocols for an entire rereading of the early Bergson.

This rereading would attend to the way in which Bergson's reflections upon the nature of perception and memory photographically affirm his relation to the very era to which he shuts his eyes. That his recourse to photographic language forms an essential part of the historical physiognomy of his philosophical texts can be read in his explicit discussions of photography as well as in his general interrogation of the relations among perception, memory, and representation.[71] In *Creative Evolution*, for example, Bergson

associates photography with the operations of both the mind and language. Emphasizing the movement inscribed within this "mental photography" (*Matter and Memory*, 87), that is, suggesting the genealogical connection between photography and cinema, he writes:

> We take snapshots, as it were, of the passing reality, and, as these are characteristic of this reality, we have only to string them on a becoming, abstract, uniform and invisible, situated at the back of the apparatus of knowledge, in order to imitate what there is that is characteristic in this becoming itself. Perception, intellection, and language proceed this way in general. Whether we would think becoming, or express it, or even perceive it, we hardly do anything else than set going a kind of cinematograph inside us. . . . *The mechanism of our ordinary knowledge is of a cinematographical kind.* (*Creative Evolution*, 322)

As he explains in *Matter and Memory*, we have not fully appreciated how photographic perception—and the world it is to perceive—really are:

> The whole difficulty of the problem that occupies us comes from the fact that we imagine perception to be a kind of photographic view of things, taken from a fixed point by that special apparatus which is called an organ of perception—a photography which would then be developed in the brain-matter by some unknown chemical and psychical process of elaboration. But is it not obvious that the photograph, if photograph there be, is already taken, already developed in the very heart of things and at all the points of space? No metaphysics, no physics even, can escape this conclusion. (*Matter and Memory*, 38)

That the photographed exists as a photograph even before the work of any camera means that perception and memory begin in photography. Indeed, for Bergson, there is no psychic process that does not have its origin in photography. It is because photography is older than perception that he can tell us, again in *Creative Evolution*, that, from the very moment that there is thought, there is photography, even if it is a photography before photography as we know it:

> The main laws of the doctrine that developed from Plato to Plotinus, passing through Aristotle (and even, in a certain measure, through the Stoics), have nothing accidental, nothing contingent, nothing that must be re-

garded as a philosophical fancy. They indicate the vision that a systematic intellect obtains in the universal becoming when regarding it by means of snapshots, taken at intervals, of its flowing. So that, even today, we shall philosophize in the manner of the Greeks, we shall rediscover, without needing to know them, such and such of their general conclusions, in the exact proportion that we trust in the cinematographical instinct of our thought. (*Creative Evolution*, 342–43)[72]

If Bergson persistently returns to analogies and metaphors drawn from the technical media of his own era and, in particular, from photography and film, it is also because his philosophy itself operates according to the principles of filmic perception. Like a camera, it works to seize and fix images as permanent records of the rapport between memory and experience (chapter four of *Matter and Memory* is in fact entitled "The Delimiting and Fixing of Images"). What complicates matters for Bergson is that the world he seeks to fix—a world comprised entirely of images (*Matter and Memory*, 18, 26)—has no other fixity than its incessant vanishing. This movement of disappearance, this ceaseless transformation cannot be grasped. It "remains absolutely foreign to the process of representation" (33). "Concentrate your mind on that sensation," he tells us, "and you will feel that the complete image is there, but evanescent, a phantasm that disappears just at the moment when motor activity tries to fix its outline" (86–87). Whenever we try to recover a recollection, to call up some period of our history in the form of an image—an activity that Bergson describes as "a work of adjustment, something like the focusing of a camera" (133–34)—the past to which we return remains "fugitive" (83). There is in Bergson no idea, no memory, no event, no sense of a world that does not leave us. If recollections may sometimes "flash out at intervals," they disappear "at the least movement of the voluntary memory." The very effort to recall the recollection "seems to drive the rest of the image out of [our] consciousness" (87). This is why, when the flash of a memory does reappear, "it produces on us the effect of a ghost [something like an afterimage] whose mysterious apparitions must be explained by special causes" (145). This is also why Bergson's texts, however much they rely on photographic language, also include a critique of photographic perception: neither photography nor perception can give us what is before the camera or the eye. They can only offer fragments that, even if "put end to end," are unable to "make even a beginning of the reconstruction of the whole, any

more than, by multiplying photographs of an object in a thousand different aspects" we can "reproduce the object" (*Creative Evolution*, 36).[73] "Past images," he explains in *Matter and Memory*, "reproduced exactly as they were, with all their details and even with their affective coloring, are the images of idle fancy or of dream" (*Matter and Memory*, 106).

Like Baudelaire before him, Bergson organizes his critique of photography around the way in which the camera's technical proficiency encourages the belief—here the idle fancy or dream—that photography can provide us with exact reproductions of the world, that it can give us a person, an object, or an event. For Baudelaire and Bergson, however, the photographic image can only translate or picture what is already a photograph. Like all photographs, it can only reproduce by condensing and immobilizing what it seeks to represent. Both matter and memory, object and representation, the image condenses "enormous periods of an infinitely diluted existence into a few more differentiated moments of an intenser life" and, in so doing, abbreviates "a very long history." What is seized in the activity of photographic perception is therefore not what is photographed or imaged, but "something which outruns perception itself" (*Matter and Memory*, 208). Like the remembrance it is supposed to maintain, a photographic image—and in the long run there is for Bergson no other kind of image—"is the representation of an absent object" (236). If photography does not give us the past, it tells us that perception must be thought in relation to what is no longer present, in relation to the structure of memory in general. To say this is to say that perception begins only at the moment when it begins to withdraw, when what is seen cannot be seen. In the words of Proust—Bergson's cousin-in-law—"a photograph acquires some of the dignity that it lacks when it ceases to be a reproduction of reality and shows us things that no longer exist" (*Remembrance of Things Past*, 1:578 / *Recherche du temps perdu*, 2:123).

XXII.

REFLECTIONS. — Photography and perception are analogous to one another in Bergson not so much because perception works like a camera to seize reality but rather because, working like a camera, it fails to seize reality. What photography and perception do not perceive they do not perceive for

reasons of principle. That is, it is because they are photography and percep-tion that they do not perceive. Rearticulating photography in terms of per-ception and perception in terms of photography, Bergson declines and ex-poses both of them in the direction of what has not yet been sufficiently recognized. In so doing, something happens in his texts that not only touches photography and perception but also alters all the concepts associated with them: memory, image, representation, time, space, and so forth. If Bergson's critique of photography does not become a reason for abandoning photogra-phy as a model for perception, it is because photography—another name for "matter and memory"—becomes a principle of articulation among percep-tion, memory, and representation that traces the conditions and features of these words and concepts.

In *Matter and Memory*, for example, we are told that, like photography, perception is also a matter of light and representation:

> When a ray of light passes from one medium into another, it usually tra-verses it with a change of direction. But the respective densities of two media may be such that, for a given angle of incidence, refraction is no longer possible. Then we have total reflection. The luminous point gives rise to a *virtual* image which symbolizes, so to speak, the fact that the luminous rays cannot pursue their way. Perception is just a phenomenon of the same kind. . . . Perception therefore resembles those phenomena of reflexion which result from an impeded refraction; it is like an effect of mirage. (*Matter and Memory*, 37)

Joining the etymological resources of the word "reflection"—especially its optical connotations—with a metaphorics of light, Bergson here links reflec-tion to the process whereby light is thrown back on reflecting surfaces. The passage he describes from the refraction of light to "total reflection" also traces the passage between two different ways of mediating light. However different these forms of mediation are, though, they each involve the deflec-tion of light, a deflection that is essential to the possibility of an image's emergence. Light can in fact only give way to an image when its path is impeded, when it is turned away from its course. In other words, to be what it is, to be revealed, light must be interrupted. As Bergson suggests, this moment of deflection and interruption also names the condition of percep-tion in general: like the light that would make it possible, perception can occur only to the extent that it is interrupted, that it cannot pursue its way.

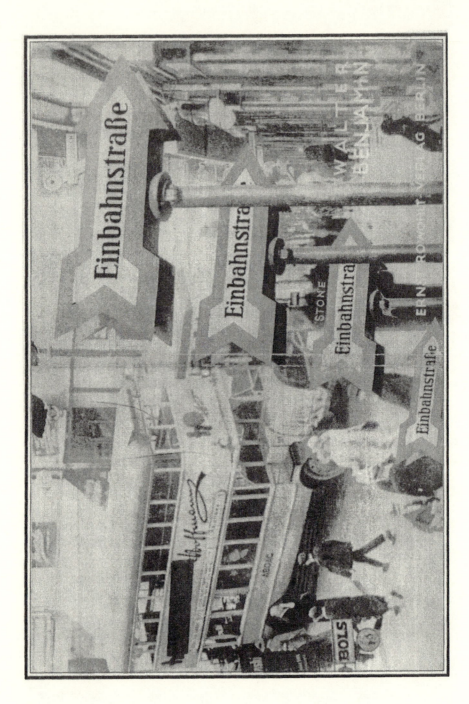

To perceive means: not to perceive. This is why the image that emerges from the luminous rays of perception is always only *virtual*. It is also why Bergson will later in the same text claim that "perception is only a true hallucination" (239).

Perception remains a "hallucination," a kind of "mirage," because it does not belong to the domain of knowledge. It is here that we can begin to measure the stakes of Bergson's philosophical efforts: *Matter and Memory* is written against an entire philosophical tradition organized around the belief that "to perceive means above all to know" (28). This tradition has, for Bergson, only worked to obscure the meaning of perception and, in particular, its relation to memory. A force of light or writing—he notes that perception has often been figured, on the one hand, as a kind of "phosphorescence that follows the movements of the mind and illuminates their track" and, on the other hand, as "an unwinding scroll within consciousness" (24)—perception emerges only with "the sudden interruption of optical continuity" (46). It *translates* "the state of our nervous system" (24) into an image or picture that, coming to pass at the intersection of vision and writing, figures what perception both sees and does not see at the same time. If what happens or comes to light oscillates between the ghostly and "the real," it is because there is no perception that is not haunted by the structure of memory, by its relation to a past that survives in the present. To perceive is always to perceive more than one perceives: "There is no perception that is not full of memories" (33). "However brief we suppose any perception to be," Bergson writes, "it always occupies a certain duration, and involves, consequently, an effort of memory which prolongs, one into another, a plurality of moments . . . in fact, there is for us nothing that is instantaneous. In all that goes by that name there is already some work of our memory" (34, 69). That there is a duration to perception means that the eye is always both open and closed. The snapshots of perception may never correspond to the punctuality of the instant. Always and never a snapshot, then, perception gives us not an instantaneous vision of the real but pictures, images, and photographs which in turn constitute whatever reality may be for Bergson. These pictures may bear the traces of their relation to the past but they do not give us the past. "Representation is there," he explains, "but always virtual—being neutralized, at the very moment when it might become actual. . . . To obtain this conversion from the virtual to the actual, it

would be necessary, not to throw more light on the object, but, on the contrary, to obscure some of its aspects, to diminish it by the greater part of itself, so that the remainder, instead of being encased in its surroundings as a *thing*, should detach itself from them as a *picture*" (36). The process of producing a picture here corresponds to a process of repression or forgetting that leads Bergson to claim that "to *picture* is not to *remember*" (135). If perception's photographs—and here we must understand photography as not only the consequence of perception but also its condition and medium—cannot reproduce the past, it is because the Bergsonian past has never been nor will ever be present, because perception and memory are entangled so thoroughly with one another that we can no longer distinguish between them. That neither one alone produces the other means that "we are condemned to an ignorance both of pure memory and of pure perception" (67). This is the lesson of *Matter and Memory*: photographs see and remember only when seeing and remembering are, strictly speaking, no longer possible. Bergson makes this point again in a remarkable passage that, drawing together the motifs of perception, memory, representation, and photography, evokes the afterimage of that to which, according to Benjamin, his entire philosophical effort was to have shut its eyes. Bergson and his philosophy shut their eyes, however, in order to register a blindness that reveals the truth of perception in the era of technological reproducibility:

> every *attentive* perception truly involves a *reflection*, in the etymological sense of the word, that is, the projection, outside ourselves, of an actively created image, identical with, or similar to, the object on which it comes to mold itself. If, after having gazed at any object, we turn our eyes abruptly away, we obtain an "afterimage" of it: must we not suppose that this image existed already while we were looking? . . . It is true that we are dealing here with images photographed upon the object itself, and with memories following immediately upon the perception of which they are but the echo. But, behind these images, which are identical with the object, there are others stored in memory, which merely resemble it, and others, finally, which are only more or less distantly akin to it. All these go out to meet the perception, and, feeding on its substance, acquire sufficient vigor and life to abide with it in space. . . . Any memory-image that

is capable of interpreting our actual perception inserts itself so thoroughly into it that we are no longer able to discern what is perception and what is memory. (102–3)

XXIII.

P S Y C H E S. — The emergence of photography concurs with the advent of psychoanalysis. Benjamin writes:

> It is after all another nature that speaks to the camera than to the eye, other primarily in the sense that a space informed by human consciousness gives way to a space informed by the unconscious. Whereas it is usual, for example, that someone gives himself an account of the way people walk, if only in general terms, he certainly no longer knows their position during the fraction of the second of "stepping out." Photography, with its devices of slow motion and enlargement, reveals it to him. It is through photography that he first discovers the existence of the optical unconscious, just as he discovers the instinctual unconscious through psychoanalysis. (*OWS* 243 / *GS* 2:371)

With its devices of slow motion and enlargement, photography reveals what sight cannot see, what makes sight impossible. The photograph tells us that when we *see* we are unconscious of what our seeing cannot see. In linking, through the photographic event, the possibility of sight to what he calls "the optical unconscious," to what prevents sight from being immediate and present, Benjamin follows Freud, who, in his own efforts to trace the transit between the unconscious and the conscious, often returns to analogies drawn from the technical media, and in particular from photography (see Rickels, *Aberrations of Mourning,* and Ronell, *The Telephone Book*). In "A Note on the Unconscious in Psychoanalysis," for example, Freud sees photography as corresponding to the relation between unconscious and conscious thought: since every photograph must, in order to become developed, pass through the negative process, and since only certain negatives are selected for positive development, the photograph can represent the relation of conscious thought to the unconscious. He elaborates upon the analogy, not only

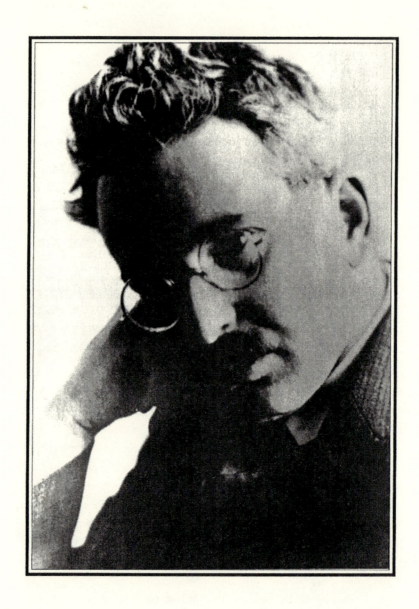

in *Interpretation of Dreams* and *Moses and Monotheism* but also in his *General Theory of the Neuroses*, where, in a discussion of the resistance and repression that attend our experience of "some vicissitude," he writes:

> In order to form a picture of this vicissitude, let us assume that every mental process . . . exists to begin with in an unconscious stage or phase and that it is only from there that the process passes over into the conscious phase, just as a photographic picture begins as a negative and only becomes a picture after being formed into a positive. Not every negative, however, necessarily becomes a positive; nor is it necessary that every unconscious mental process should turn into a conscious one. This may be advantageously expressed by saying that an individual process belongs to begin with to the system of the unconscious and can then, in certain circumstances, pass over into the system of the conscious. (*SE* 16:294–95)

What links the laws of photography to those of psychoanalysis is that both require a thinking of the way in which this passage between the unconscious and the conscious, the invisible and the visible, takes place. Both photography and psychoanalysis oblige us to think of the temporal and rhetorical process whereby an image comes to pass, comes into consciousness, and does so at a moment of danger. The emergence of an image, however— within either the psyche or photography—does not mean that the image is the transcription of the unconscious into the conscious. For both Benjamin and Freud, neither the unconscious nor the conscious can be thought independently of one another—there can be no passage between them without there already being relays or paths that would facilitate such a passage. As Freud explains in the final chapter of *The Interpretation of Dreams*, in a discussion of the way in which an unconscious thought seeks to convey itself into the preconscious in order then to force its way into consciousness: "What we have in mind here is not the forming of a second thought situated in a new place, like a transcription which continues to exist alongside the original; the notion of forcing a way through into consciousness must be kept carefully free from any idea of a change of locality" (5:610). In other words, the unconscious, strictly speaking, is never simply the unconscious, is never simply elsewhere waiting to be transposed or transported. It is already a weave of traces—traces which have never been perceived, whose meaning has never been lived in the present, has never been lived consciously. The unconscious

tells us that we may never experience our experience directly, and that every-thing begins with reproduction.[74]

This is why the structure of the psychical apparatus can be represented by a camera and why psychical content can be represented by a photograph: there can be no psychic operation without the transit between light and writing we call photography. The question is not whether or not the camera or the photograph are successful figures for the work of the psyche, not whether or not the psyche is indeed a kind of photograph, but rather what is a photograph, and what is the psyche if it can be represented by a photo-graph. For if there can be no camera or photograph that does not have a psychic origin—and this seems to be what Benjamin and Freud think—then there can be no psyche without photography, without a process of writing and reproduction. To say that everything within the psyche begins with writing and reproduction is to say that the psyche begins with photography. If the psyche and photography are machines for the production of images, however, what is produced is not simply any image, but an image of our-selves. And we are most ourselves when, not ourselves, we are an image or a photograph—an image or photograph we may never see "before our gaze."[75] As Benjamin writes in his 1932 speech on Proust:

> Concerning the *mémoire involontaire*: its images do not only come without being called up; rather, they are images which we have never seen before we remember them. This can be seen most distinctly in those images in which—just like in some dreams—we ourselves can be seen. We stand in front of ourselves, the way we might have stood somewhere in a prehistoric past, but never before our gaze. And it is in fact the most important images, those developed in the darkroom of the lived moment, that we get to see. One might say that our most profound moments have been furnished, like those cigarette packages, with a little image, a photograph of ourselves. And that "whole life" which, as we often hear, passes before the dying or people in danger of dying, is composed precisely of those tiny images. (GS 2:1064)[76]

This photograph of ourselves registers our lived experience and points to our absence in the face of that experience. The self-portrait that emerges from what we remember of our past tells us that what once took place may never be given to us in the present, may never be brought before our gaze. We can neither see nor remember anything before the photographic image that brings forth both our sight and our memory.

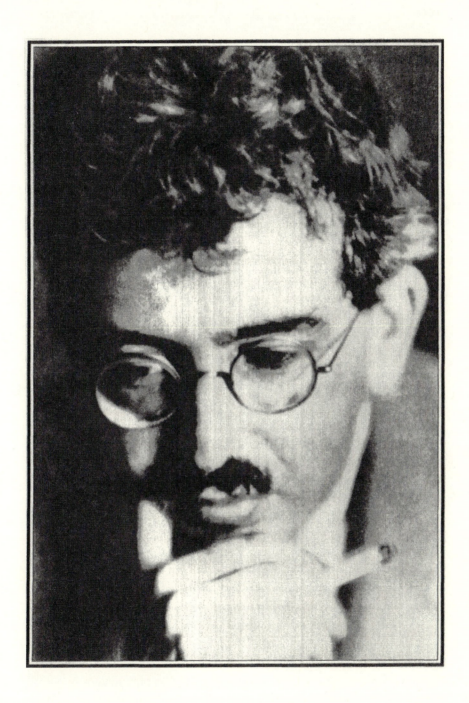

XXIV.

SHOCKS. — In Benjamin's etiology, shock characterizes our experience. While linked to a particular experience—an experience of danger and bereavement—it exemplifies, in the words of Miriam Hansen, "the catastrophic and dislocating impact of auratic experience in general" ("Benjamin, Cinema, and Experience," 211). The advent of shock experience as an elemental force in everyday life in the mid–nineteenth century, Benjamin suggests, transforms the entire structure of human existence. While Benjamin identifies this process of transformation with technologies that have "subjected the human sensorium to a complex kind of training," and that include the invention of the match and of the telephone, the technical transmission of information through newspapers and advertisements, and our bombardment in traffic and crowds, he singles out photography and film as media that—in their techniques of rapid cutting, multiple camera angles, instantaneous shifts in time and place—raise the experience of shock to a formal principle: "Of the countless movements of switching, inserting, pressing, and the like," he explains, "the 'snapping' of the photographer has had the greatest consequences. A touch of the finger now sufficed to fix an event for an unlimited period of time. The camera gave the moment a posthumous shock, as it were" (*I* 174–75 / *GS* 1:630). In linking the experience of shock to the structure of delay built into the photographic event, Benjamin evokes Freud's own discussions of the latency of experience, discussions that are themselves often organized in terms of the language of photography. In *Moses and Monotheism*, for example, Freud claims that "the strongest compulsive influence arises from impressions which impinge upon a child at a time when we would have to regard his psychical apparatus as not yet completely receptive. The fact itself cannot be doubted; but it is so puzzling that we may make it more comprehensible by comparing it with a photographic exposure which can be developed after any interval of time and transformed into a picture" (*SE* 23:126). Freud goes on to suggest that the delay of the shock experience is due on the one hand to the remoteness of the period concerned and on the other hand to the process whereby the event is met, our reaction to it.

Freud links the event's remoteness not simply to the remoteness in time of the events of our childhood, but more importantly to the distance between an event and our experience or understanding of it—a distance that

tells us that we experience an event indirectly, through our mediated and defensive reaction to it. Confronted by an event that paralyzes us by the magnitude of its demand, an event that we recognize as a danger, we fend off the danger through the process of repression: the danger is in some way inhibited, and its precipitating cause—the event, with its attendant perceptions and ideas—is forgotten. Not entirely effaced, however, the danger of the event renews its demand and opens another path for itself, emerging, symptomatically, as an image of what has happened—as a return of what was to have departed—without our acquiescence or understanding. What characterizes this process, a process whereby a moment of danger, a state of emergency, corresponds to the involuntary emergence of a symptom or image, is "the far-reaching distortion to which the returning material has been subjected as compared with the original" (23:127). As in Benjamin, what characterizes experience in general—experience understood in its strict sense as the traversal of a danger, the passage through a peril[77]—is that it retains no trace of itself: experience experiences itself as the vertigo of memory, as an experience whereby what is experienced is not experienced. For both Freud and Benjamin, consciousness emerges as memory begins to withdraw.

It is here that we can begin to register the possibility of a history which is no longer founded on traditional models of experience and reference. The notion of shock—of a posthumous shock that coincides with the photographic event—in fact requires that history emerge where understanding or experience cannot:

> The greater the share of the moment of shock in particular impressions, the more incessantly consciousness has to be present as a screen against stimuli, the more successfully it operates, the less these impressions enter *Erfahrung*; rather, they fulfill the concept of *Erlebnis*. Perhaps the peculiar achievement of shock defense may in the end be seen in its function of assigning to an incident a precise point in time in consciousness at the cost of the integrity of its [the incident's] contents. (*I* 163 / *GS* 1:615)

The experience of shock, "the fact of latency," as Cathy Caruth has recently argued in regard to Freud, "would seem to consist, not in the forgetting of a reality that can hence never be fully known; but in a latency inherent to the experience itself." The historical power of shock, she goes on to explain, "is not just that the experience is repeated after its forgetting, but that it is only

in and through its inherent forgetting that it is first experienced at all" ("Unclaimed Experience," 187). "Only what has not been experienced explicitly and consciously," Benjamin writes, "what has not happened to the subject as an experience [*Erlebnis*], can become a component of the *mémoire involontaire*" (*I* 160–61 / *GS* 1:613). It is what is not experienced in an event that paradoxically accounts for the belated and posthumous shock of historical experience. If history is to be a history of this "posthumous shock," it can only be referential to the extent that, in its occurrence, it is neither perceived nor experienced directly. As Benjamin suggests elsewhere, "The dialectical image is one that flashes. Thus—as an image that flashes in the now of recognizability [*Erkennbarkeit*]—the image of the past is . . . to be held fast. The recovery that is accomplished in this manner and only in this manner always lets itself be won only as what irretrievably loses itself in the course of perception" (*CP* 49 / *GS* 1:682). For Benjamin, history can be grasped only in its disappearance. This is why, as he explains in his Proust essay, it is not what is experienced that "plays the main role for the remembering author, but rather the weaving of his remembrance, the Penelope work of memory" with "a Penelope work of forgetting" (*I* 202 / *GS* 2:311; see Jacobs, "Walter Benjamin"). This is the lesson that Benjamin offers, not only in his writings on photography, but also in a passage from his memoirs of his childhood in Berlin, a lesson itself framed within the language and temporality of photography:

> Anyone can see that the duration for which we are exposed to impressions has no bearing on their fate in memory. Nothing prevents our keeping rooms where we spent twenty-four hours more or less clearly in our memory, and forgetting entirely where we passed months. Thus it is certainly not owing to an all too short exposure time if no image appears on the plate of remembrance. More frequent, perhaps, are the cases when the twilight of habit denies the plate the necessary light for years, until one day, from alien sources, it flashes as if from burning magnesium powder, and now a snapshot transfixes the room's image onto the plate. But it is always we ourselves who stand at the center of these rare images. And this is not so enigmatic, since such moments of sudden exposure are at the same time moments when we are beside ourselves, and while our waking, habitual, everyday (*taggerechtes*) self involves itself actively or passively in what is happening, our deeper self rests in another place and is touched by shock,

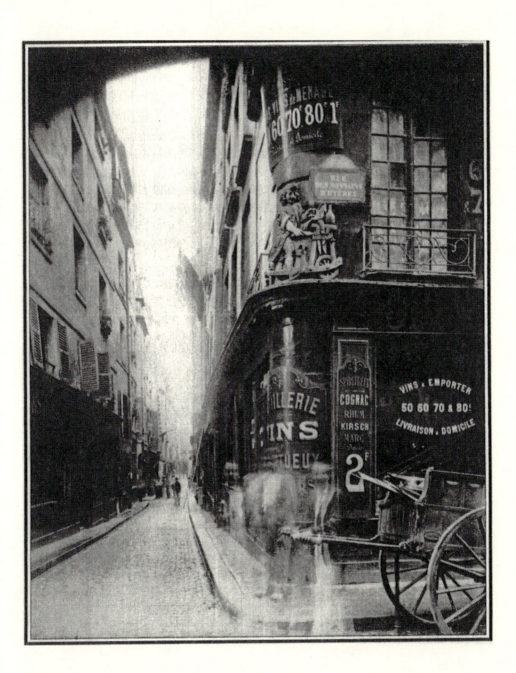

> like the little heap of magnesium powder by the flame of the match. It is
> to this sacrifice of our deepest self in shock that our memory owes its most
> indelible images. (R 56–57 / GS 6:516)

During the flash of the mind's camera—a moment when, beside ourselves,
we are no longer ourselves—we experience the shock of an experience that
tells us that memory, all remembrance of things past, registers, if it registers
anything, its own incapacity, our own immolation.

XXV.

SIMILARITY. — That the space of photography is a site of the self's
sacrifice means that whoever or whatever enters this space is always some-
thing else. Benjamin makes this point in an extraordinary passage from the
"Mummerehlen" section of his 1934 *Berliner Kindheit um Neunzehnhundert*.
There, situating the self between language and photography, he suggests the
self's essential relation to alterity. He claims that he first encounters this
alterity—an alterity that strangely compels him to be like another—in his
relation to language. Not knowing the word "Muhme," for example, he
transforms the figure in an old children's verse, Muhme Rehlen, into "a
spirit" called the "Mummerehlen" (GS 4:260–61). Such misunderstandings,
Benjamin notes, may dissemble a world to the child but they nevertheless
reveal to him "the ways that led into the world's interior." More particularly,
the distortions of language that characterize his encounter with the world
lead him to the interior of language. What makes language language, he
discovers, is its capacity for distortion. He soon learns to wrap himself in
words that are at the same time "clouds."[78] Distorting the words he does not
understand, he articulates a relation between these words and the things and
persons that make up his world. This work of dissemblance, Benjamin goes
on to suggest, dissembles not only words but also the world and everything
in it. As he notes later, the "entire distorted world of childhood" (262) finds
its place within this activity of dissemblance, disguise, *mummen*. The child
cloaks himself in a series of cloudy words, all of which are organized around
the word *mummen*: there is for the child nothing but *mummen*. It is what
compels him to become like something else:

The gift of recognizing similarities is really nothing but a feeble vestige of the old compulsion to be and act in a like manner. Words exercised such power over me. Not those which served me as models of proper behavior, but those which made me resemble apartments, furniture, clothes. (261)

The movement of *mummen* at the heart of language demands that the child, in order to be who he is, become like an other. The words that compel him to become like a thing—for example, like an apartment, like furniture or clothing—at the same time tell him that he can never be himself. Or rather that, in order to be himself, he must always depart from himself. Nevertheless, the one thing to which he can never bear witness is his becoming a thing. This is why, Benjamin explains, he can never resemble his own image: such a coincidence would name the moment of his death. He exhibits this law of death and disguise in a description of his visit to a photography studio at the age of ten. There, he not only gives us an example of his capacity for transformation but he also explains why he can always only be himself as an other. It is in fact because he can never reside in his "own image" that he becomes perplexed when a "likeness" [*Ähnlichkeit*] of himself is demanded of him. He writes:

That was at the photographer's. Wherever I looked, I saw myself surrounded by screens, cushions, pedestals which lusted for my image like the shades of Hades for the blood of the sacrificial animal. Finally I was presented before a coarsely painted Alpine view and my right hand, which had to hold up a goatee hat, cast its shadow upon the clouds and glacier-snow of the backdrop. Yet the tortured smile around the mouth of the young mountaineer is not as saddening as the gaze that sinks into me from the child's face in the shadow of the household palm. It belongs to one of those studios that, with their stools and tripods, tapestries and easels, partake of both the boudoir and the torture chamber. I'm standing bareheaded, holding in my left hand a mighty sombrero, which I allow to hang down with studied grace. The right hand is occupied with a staff whose lowered handle is visible in the foreground, while its end is hidden in the bundle of ostrich plumes, which flow forward off a garden table. Entirely off to the side, next to the door curtain, the mother stood rigid, in a tight bodice. Like a mannequin she gazes at my velvet suit, which for its part, seems overloaded with trimmings and cut from a fashion magazine. But I am disfig-

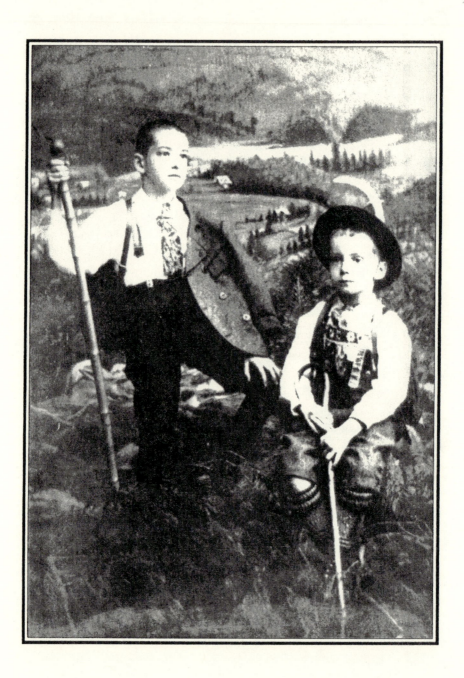

ured by my similarity to everything around me here. I dwelt in the nine-
teenth century as a mollusk dwells in its shell, and the century now lies
hollow before me like an empty shell. I hold it to my ear. (261)

From the very first moment that Benjamin enters the photography studio, he
leaves himself. Wherever he looks, he says—and it is no accident that his first
act is an act of the eye—he witnesses a double of himself surrounded by
photographic props. This distance between his gaze and a double is repeated
in various forms throughout the passage but in each instance it marks a
moment when, experiencing himself as another self, he is no longer himself.

He registers his anxiety over this loss of self in his presentiment that the
screens, cushions, and pedestals that furnish the studio lust for his image "like
the shades of Hades for the blood of the sacrificial animal." If these furnish-
ings wish to appropriate his image to themselves, it is perhaps because they
seek to present themselves. Existing only in order to be in a photograph, they
can only be what they are when a self is sacrificed to its image, when a self
enters a photograph and not only becomes, like them, a thing, but also en-
ables them to become, like it, more than a thing.[79] That the furnishings lust
at all means that what is at issue here is the movement between the conver-
sion of things into persons and of persons into things—that is to say, both the
appearance of something as something else and the question of presentation
in general. These accessories in fact lust for Benjamin's image "like the
shades of Hades for the blood of the sacrificial animal" because there too it
is a matter of presentation. In book ii of *The Odyssey*, Odysseus goes to Hades
in order to speak with Tiresias. Discovering that he can only speak with the
ghosts of the underworld if they first drink the blood of a sacrificed animal—
they can only present themselves after drinking the blood of a dead other—
he orders his men to sacrifice a number of young lambs. The first to drink the
blood of the dead lambs, Tiresias addresses Odysseus, telling him that "any
dead man whom you allow to enter where the blood is will speak to you and
speak the truth" (189). That the screens and cushions lust for Benjamin's
image therefore means that—dead until they exist in an image—they seek to
speak (through an image) and, in particular, to speak the truth. Elsewhere, in
the "Epistemo-Critical Prologue" to his *Trauerspiel* book, Benjamin explains
that to speak the truth means to be moved to presentation, to a "presenta-
tional moment" (*darstellende Moment*; *O* 31 / *GS* 1:211) that, occurring in lan-
guage, works to imprint or trace the essence of phenomena.[80] Moved to

present themselves in a kind of language, the studio's furnishings are destined to become an imprint, an image or photograph. We might even say that in lusting after Benjamin's image they express their desire to present themselves photographically. Wishing to belong to a photograph, they desire the sacrifice of a living other. Once this other enters a photograph he will no longer be distinguishable from the screens, cushions, and pedestals that seek his image. Benjamin suggests that it is only when the living other has become a thing, and things have taken on a kind of life, that commodities can speak the truth.[81] Only then can they say: "persons are like us, they too are thinglike." Like language, which for Benjamin can only communicate itself and not some signified content (R 316 / GS 2:142), the props of the studio can only communicate themselves as props, as signs of things within a kind of imprint, within a photograph. Benjamin already had emphasized the photographic dimension of the empirical realm in the *Trauerspiel* book, explaining that "Truth is not an intention that finds its determination in the empirical, but rather consists as the initial imprinting power of the essence of the empirical" (O 36 / GS 1:216). The impulse toward photography, he suggests, is already written into the world of things. It names an inaugural force of inscription that, like the process whereby an imprint is left upon a photographic plate, defines the movement of history. What is at stake for both Benjamin and the accessories that make up the phantasmagoric world of photography is the possibility of exhibiting themselves, of presenting themselves to be "seen." If Benjamin expresses his anxiety over this possibility it is because it implies not only that there can be no self that is not exhibited, imaged, or photographed but also that the self that is exhibited in this way is not a self. It cannot be understood as a self.

Raising the question of presentation in general, Benjamin addresses the issue of whether or not the self, whatever it may be, can present itself as such, can appear in its own element. He suggests not only that presenting itself as such, appearing in its own element, may mean ultimately not presenting itself or appearing at all but also, because of this, that some form of manifestation is always necessary. If there is no possible revelation of the self without some kind of loss, it is because, for a presentation or an appearance to occur, it is necessary, in the words of Lacoue-Labarthe, that what "must 'present' itself not present *itself*, not appear *as* itself." Instead it must "differentiate itself, alienate itself, externalize itself, transport itself, give itself (to be 'seen' and thought, to be *theorized*), and, by giving itself, lose itself" ("Unpresent-

able," 143). In other words, the presentation of the self always entails its loss. Like the ghost of Tiresias that speaks, and speaks the truth, Benjamin speaks the truth of the self's disappearance in a series of transitions from one double of himself to another—from the double in the studio to the young mountaineer to Kafka to Kafka's mother to a mollusk and finally to its shell. These figures of his self continually dissolve before any one of them has a chance to assert itself. They are evoked only to be quickly replaced by other figures. Each new figure not only covers over and refracts the one before it but also moves progressively further away from Benjamin. Like the distortions in language that bring the child to the interior of language, however, this multiple concealment of the self brings us closer to the continual distortions and displacements from which the Benjaminian self emerges but always as an other.

This doubling of the self happens again when, along with his brother Georg, the ten-year old Benjamin is presented, like an offering (he says he is *dargebracht*), to the rough reproduction of an Alpine landscape to which he will soon belong.[82] Wrapped in his mountaineer outfit like the child wrapped in cloudy words, he is quickly surrounded by the painted backdrop of clouds and ice. He disguises himself as an alpine youth in preparation for the camera and, as if already anticipating the moment of his sacrifice, he falls, as Bernd Witte notes, "into a deathly rigidity even before being captured on the photographic plate" (*Walter Benjamin*, 13). Worried that he is about to become an image, that he is about to be killed, he freezes into what he will soon become: a petrified image. The more he enters the studio's artificial surroundings the more he is disfigured, the more he is estranged from his "own image." In presenting him as an other, the photograph in fact transforms him into a thing in an image. What he sees in the young mountaineer is not simply a reproduction of himself—since the mountaineer is already a reproduction of sorts—but a something else that takes him further away from himself. In other words, if he sees another double of himself, this double is without self. That he will soon become something other than even this double, however, can already be read in his tortured smile. As he explains elsewhere, smiles are not only bearers of a mimetic process but also signals of the passage from one figure to another. Whenever we extend a greeting, he notes, even a shadowy one, there is a smile in our physiognomy which reveals the "secret agreement of a willingness to become like the one to whom it is directed" (*GS* 6:194). Our smile registers our willingness to take

on elements of the other and to make them our own. The one at whom we smile, he goes on to say, is elevated to a "Vorbild" (ibid.), a model of the other self to come.[83] This is precisely what happens when Benjamin directs his tortured smile to another childhood image of "himself."

This second image belongs to a space situated between private repose and trauma. It is from within this ambivalent space that the child in the image casts its saddening gaze toward Benjamin. Benjamin's attribution of a gaze to the imaged child—that is, to the inanimate figure sealed within the borders of this second photograph—should be understood in terms of his conception of the auratic experience. As he writes in his study of Baudelaire, "the experience of aura thus rests upon the transfer of a form of reaction that is current in human society to the relation human beings have with the inanimate or with nature. The person who is looked at, or the person who believes himself looked at, looks up [*den Blick aufschlagen*]. To experience the aura of an appearance means to endow that appearance with the ability to look up" (*I* 188 / *GS* 1:646–47). Again it is a matter of the relation or similarity between persons and things (as Marx explains, in a passage that Benjamin cites elsewhere, "in a practical sense, I can behave in a human way toward an object only when the object behaves in a human way toward human beings" [*GS* 5:277]). But it is also a question of a gaze that, opening without looking at anything in particular, introduces an atmosphere of distance and death into the encounter between Benjamin and this other image. What is perhaps most troubling, in fact, is that Benjamin's attribution seems to work in reverse. The one to whom the gaze is given comes to threaten the other—in this case "Benjamin"—with a certain thinglike quality of death. The second image begins to take on a life of its own even as it orients the young mountaineer toward death—and even as the child and his gaze remain fixed within its frame. While something of this process would be at work in the reciprocal exchange of human and inhuman traits, "the chiasmus or crossing of terms hardly produces a harmonious, dialectical totality,"[84] and not only because the authorial self is already doubled throughout the *Berliner Kindheit*: he is both at the beginning of his life and in the moment of his writing, both the child and the writer. But also because once the two images encounter one another neither remains the same: they experience instead what Benjamin elsewhere refers to as the "sudden paradoxical change of one form of observance into the other (regardless of which direction)" (*C* 300 / *B* 425). Even when the aura is understood in a positive light—which is not always the

case—it is experienced primarily in its withdrawal or destruction. This is why the aura is always a matter of ghosts and specters. As Ian Balfour has noted, "not only is the inanimate endowed with a kind of life in the fleeting moment of its disappearance, [but] that very movement raises the specter of the subject's own disappearance, the prospect of the subject as a thing" (645).

That Benjamin is in fact disappearing here is confirmed in his next few sentences, when this second photograph of "himself" turns out to be the image of someone else: Franz Kafka.[85] Two years before the drafting of the autobiographical text, in his 1931 "A Short History of Photography," Benjamin had already described this early image of the five-year old Kafka in almost identical language.[86] Engaging in what he calls the art of citation without quotation marks (N 45 / GS 5:572), he simultaneously conceals and reveals his identification with Kafka. Nevertheless, his self-portrait turns out to be a portrait of Kafka. He encounters himself in relation to a text (a quotation), and as an other (Kafka): that is, in both instances, as not himself. The figure he describes is both like Kafka and like Benjamin, since it is in this figure of the other (the photographed double of the little Kafka) as the other (Kafka) that Benjamin encounters himself.[87] This is not exactly to say that Benjamin rediscovers himself, nor that he recognizes himself in the other. Rather, in experiencing the other's alterity, in experiencing alterity in the other, he experiences the alteration that, "in him," infinitely displaces and delimits his singularity. If Benjamin's self is exposed in this scene, it is because it is posed according to an exteriority that traverses the very intimacy of his being. Being like the image that is like Kafka therefore means no longer having a substantial identity. What Benjamin encounters in this self-portrait is therefore his infinite strangeness. Likening himself to the image of Kafka means that what is brought closer to him is itself already a reproduction— and as such separated both from Kafka and him. This is why the closer this image comes to Benjamin, the more distant it is from him. This doubled movement can be registered not only in images that are, from the very beginning, constituted as reproductions. It can also be read in relation to those to whom such images are addressed: Benjamin is already an image, whether it be the image of a young mountaineer or that of one of the many doubles whom he witnesses within this photographic space.

Every photograph, every self-portrait answers to this structure. It is the structure of photography in general and it names the loss of identity that attends the entrance into the space of photography. As Barthes explains, "the

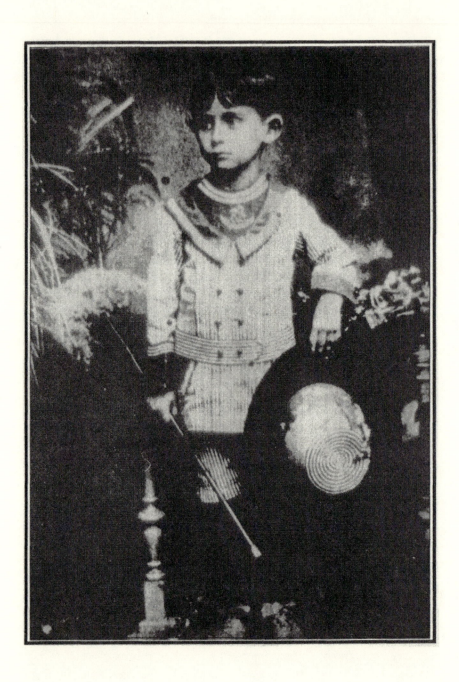

photograph is the advent of myself as other" (*Camera Lucida*, 12). This is why every photograph is a photograph of someone dead. This is also why the two figures here—but are they really two different figures?—do not work recipro- cally to constitute an "I." Instead they deconstitute one another in their rela- tion. It is in fact their relation that traces the withdrawal of their identity. Neither Kafka nor Benjamin returns to himself because the other is already in him. If these sentences condense a doctrine of mimesis, it is, as Benjamin suggests in relation to his reading of Baudelaire's poetry, "a kind of mimesis of death" (*CB* 83 / *GS* 1:587). That they are alike means that neither Benjamin nor Kafka remain wholly alive. Like the shades of Hades that come to speak, and to speak the truth, the ghosts of these two figures come to speak of the deadly mimesis that makes them, and prevents them from being, what they are: "I speak in the name of what is most mine, the otherness that makes me not me."

XXVI.

PETRIFICATION. — This exchange between Benjamin and Kafka, this relation that prevents either one from signing in their own name, can also be read throughout Benjamin's 1934 essay on Kafka. The very title of the essay, "Franz Kafka: On the Tenth Return of His Death," can refer not only to Benjamin's effort to write about Kafka on the anniversary of his death but also to the possibility that Kafka himself has returned from his death in order to write on the topic of this particular return of his death. In this instance, it would be Kafka who, writing from beyond the grave, writes of his death but only after his death—or rather, only after the death of his death. The essay can therefore be said to be written by Kafka in the name of Benjamin or, assuming the first possibility, by Benjamin in the name of Kafka. In either case, what seems to get staged here is the necessity that each sign in the name of the other or of oneself as other. This necessity is again evident in the first section of the essay, which is entitled "Potemkin." The section recounts a little fable which "Benjamin" later says heralds the entirety of Kafka's enig- matic achievement. In the story, Chancellor Potemkin has fallen into one of his longer periods of depression, retreated to his room, and refused to sign, or even consider, any official documents. This refusal has left the court of

Catherine the Great in great disarray and practically paralyzed the operations of government. Upon hearing the complaints and distress of the heads of state assembled in the anteroom of the Chancellor's palace, an insignificant clerk named Shuvalkin claims that he will take care of the matter if they merely entrust him with the papers that need to be signed. The councillors, having nothing to lose, give him the documents and he sets out for Potemkin's bedroom with the sheaf of documents under his arm. Without announcing himself, he enters Potemkin's darkened chamber, finding him in his nightshirt biting his nails. As Benjamin tells the rest of the story:

> Shuvalkin stepped up to the writing desk, dipped a pen in ink, and without saying a word pressed it into Potemkin's hand while putting one of the documents on his knees. Potemkin gave the intruder a vacant stare; then, as though in his sleep, he started to sign—first one paper, then a second, finally all of them. When the last signature had been affixed, Shuvalkin took the papers under his arm and left the room without further ado, just as he had entered it. Waving the papers triumphantly, he stepped into the anteroom. The councillors of state rushed toward him and tore the documents out of his hands. Breathlessly they bent over them. No one spoke a word; the whole group stood rigid. Again Shuvalkin came closer and solicitously inquired as to the gentlemen's consternation. At that point his gaze too fell upon the signature. One document after another was signed Shuvalkin, Shuvalkin, Shuvalkin. (*I* 111–12 / *GS* 1:409–10)

To say, as Benjamin does, that the enigma that clouds this story over is Kafka's enigma is to say that Kafka's world is a world in which one never signs in one's own name. Like the Benjamin who can never coincide with his own image—the Benjamin who, when asked for a likeness of himself, presents himself as an other—Potemkin signs with the name of the other who not only demands his signature but who also countersigns with him.[88] This enigmatic world of disguise, distortion, displacement, and *mummen*—whose space, like that of photography, consists of "dark rooms" (112 / 410)—raises the questions of identity and signature in all of their philosophical and political registers.[89] If it suggests that the authority of a signature depends on its capacity to be repeated and reproduced, even when the signatory is absent or, as is the case here, when the signatory (with his vacant stare and in his trancelike state) is neither entirely conscious nor present to himself, it also

implies that this reproducibility works to detach the signature from the singularity that makes it what it is.[90] In other words, it is because Potemkin is asked to multiply and reproduce his signature that it has to take another form. Binding reproduction to alterity, "Benjamin's" opening fable describes a world in which the structure of the signature implies both identity and difference—a world in which, like the photograph that both reproduces and alters the photographed, the signature identifies not only the signatory but also the other in whose name it appears. That this alterity is inscribed within every signature means that every signature is also another name for death.

This is why, like Potemkin, neither Kafka nor Benjamin can present himself as himself: neither one can develop before dissolving into the other. We should therefore not be surprised when the next few sentences of the *Berliner Kindheit* passage with which we began turn to yet another figure. Like the books which, when opened earlier in the text, lead Benjamin "into the midst of the womb" (*GS* 4:275), the photographs of Benjamin and Kafka here lead to the figure of the mother. She enters the passage as a kind of phantom that, although in neither of the two images that Benjamin describes, nevertheless hovers in the distance. She is positioned at the threshold of Benjamin's description—"entirely off to the side, next to the door curtain"—and she stands frozen, as if already caught within the frame of a photograph, as if already a kind of thing. We can perhaps get an idea of the camera that seizes her by taking a closer look at the image of the five-year old Kafka. His saddening eyes are not directed toward the photographer and his camera but rather off to the right side of his image.[91] Within the scenario that Benjamin imagines, it is possible that it is in fact Kafka's gaze that, viewing the mother off to the side of the photographic space, registers her petrification. Like the Medusa that gorgonizes whoever looks at her, Kafka petrifies the mother whom he says gazes at his velvet suit.[92] We could even say that his gaze works like a kind of camera to fix the image of the thinglike ghost of the mother (in his notes to his 1934 essay on Kafka, Benjamin, citing Rosenzweig, tells us that "all spirit must be thinglike, to have a place and to have the right to existence here" [*GS* 2:1198]). Kafka himself had already identified the perspective of his writings with that of the camera in his conversations with Gustav Janouch. There, he states that "we photograph things in order to drive them out of our minds." "My stories," he goes on to say, "are a way of shutting my eyes" (*Gespräche mit Kafka*, 54). Likening the movement of his eyes to that of the

camera's shutter, he suggests the photographic dimension of his corpus.[93] If Benjamin identifies Kafka with the medusalike gaze of the camera, though, he also suggests that the mother bears a likeness to what threatens her. That she is near the curtain that serves to delimit the photographic space means that she is associated further with the condition of the possibility of the image in general. A kind of ghostly apparatus that gives way to images, the mother is in fact also a camera. Like the gorgon who, according to Rainer Nägele, brings together "the staring eye and the petrified object" (*Theater, Theory, Speculation*, 123), the mother's mannequinlike gaze suggests that death and rigidity are born in the eye (as Benjamin writes, *die Mutter starr*). If the mother intervenes here as another medusalike figure, it is because she is the petrifying caesura, the material support that enables the process of figuration to go on. She is not only the medium of Benjamin's projection, but a mechanism for reproduction. Or, to be more precise, as both mannequin and mother, she is already a reproduction of what makes reproduction possible. The hinge around which the motif of petrification turns, moreover, hers is the gaze that returns Kafka into stone, the limit that again turns him into a thing. She gazes at his velvet suit which, "overloaded with trimmings" and looking as though it were "cut from a fashion page," reveals Kafka himself to be a kind of mannequin. Like the Benjamin who displays his alpine outfit, the little Kafka exhibits the velvet and trimmings that, like bits of curtain, identify him not only with the mother but also with the cushions and screens that surround the little Benjamin.[94]

Although Kafka and the mother both receive and send out a gaze, this does not mean that this gaze has any consciousness nor that it can be defined in terms of any simple symmetry or reciprocity. Rather, like the deadly eye of the camera, the two figures gaze at one another without exactly returning the gaze that is directed to them. Even if "the gaze carries the expectation that it will be returned by that to which it gives itself," as Benjamin notes in his Baudelaire essay, this expectation is never met absolutely. Elaborating this point within the specific example of the relation between a camera and its subject, he suggests that "what in the daguerreotypes must have been felt to be inhuman, even lethal, was the (prolonged, by the way) staring into the camera, since after all the camera takes a person's picture without returning his gaze" (*I* 188 / *GS* 1:646). The distance that is opened up within the camera's gaze—a gaze which, not that different from the eyes that in Baudelaire have lost the capacity to have a gaze, can no longer meet the gaze of an other

(189 / 648)—again names the condition for experiencing the other's aura. This distance can be read in the fact that the mother directs her gaze at the suit that signals Kafka's transformation into a mannequin (thereby recording his likeness to her but without gazing directly at him) and that Kafka's gaze seems to be directed toward the mother rather than to Benjamin, who first endows him with a gaze. To the extent that in Benjamin the experience of aura is always also an experience of its disintegration—a disintegration in which photography is implicated—we might say that this distance is written into a kind of rhythm or oscillation between a gaze that can return the gaze of an other and one that cannot, between a thing that is becoming a person and a person that is becoming a thing. In other words, what is at stake here is the possibility of our understanding a gaze that both returns and does not return the gaze that comes to it from elsewhere, the process whereby persons and things are both like and different from one another at the same time. We are asked to understand a distance that remains—at least at this point—as a kind of signature for the relation between the mother and Kafka, no matter how closely related they may seem to be. This distance becomes a measure of the force of the auratic experience shared and divided between them. As Benjamin explains, again in his Baudelaire essay, "Gazes might be all the more compelling the deeper the looker's absence that was overcome in them. In mirroring eyes, it remains undiminished. Therefore these eyes know nothing of distance" (190 / 648). To suggest, as he does here, that the more absent the looker is, the more compelling the gaze, is to suggest why the most compelling gazes belong to the dead, to the most remote and thinglike beings. It is also to explain why the mother—who is entirely off to the side, absent from both of Benjamin's photographs—bears the most deadly, the most spellbinding gaze. There is perhaps no other human figure that can approach the degree of thingliness that she can—which is why in the long run she becomes the medium of every representation, another name for the incunabula of images. If, as Benjamin tells us in his hashish notebook, the "essence of the mother" is "to undo the past" (GS 6:614), it is because, as the condition of representation, she names a mechanism of reproduction that reproduces, not the same thing, but something else: she gives way to the emergence of an image and, in so doing, marks the irruption of an historical event. This point is reinforced in a rather striking way when we register that, within the logic of the passage with which we are concerned, Kafka's gaze

actually is shared by both the mother and Benjamin. It may be directed at the petrified eye and body of the mother but, as Benjamin has already told us, it is at the same time directed to him. He is already in its line of sight: it even "sinks" into him. No longer simply a double of himself, a young mountaineer or the young Kafka, he is also the mother—perhaps even Kafka's mother. That is to say, he identifies himself with the mother who here stands as the "transparent glass" through which Kafka gazes at Benjamin and upon which he leaves the traces of his reflections.[95]

Inserting himself within the relay between Kafka's gaze and that of the mother not only accelerates the vertiginous whirl of disfiguration already at work in the passage but also prevents us from identifying who is speaking its last three sentences. This movement of disfiguration—linked to the chiasmic plurality of the passage's interwoven figures—makes it impossible to say whether the voice that speaks here belongs to Kafka or to Benjamin—or even by implication to the mother who is associated with both Kafka and Benjamin: "But I am disfigured by my similarity to everything around me here. I dwelt in the nineteenth century as a mollusk dwells in its shell, and the century now lies hollow before me like an empty shell. I hold it to my ear." The semantic potential and significance of these sentences, like that of the encounters between the various figures, is extended in relation to all the ghosts that haunt their permeable contours. Where everything is alike—for example, in the aleatory, ghostly space of photography—nothing is ever itself. It is always the *Vexierbild*, the picture-puzzle of something else, which is why it never resides in its own image. It is also why whoever or whatever speaks by the passage's end has "dwelt in the nineteenth century as a mollusk dwells in its shell."[96]

But to say this is not yet to understand fully what makes this analogy possible. Even if the appearance of this "as" separates the I who speaks from its image and, in so doing, indicates the self's nonpresence to itself, the mollusk in its shell is not simply to be associated with the various figures that, within the passage, emerge as something different than themselves. In sealing and encrypting a series of references to the processes of disfiguration and petrification that motivate the very movement of the passage, this figure is also haunted by what generates its appearance—and even its disappearance (as the "speaker" admits, "the century now lies hollow before me like an empty shell"). In other words, if Benjamin closes his paragraph with this

figure, it is because many paths cross there, the relations among an entire network of motifs: subjectivity, the relation between self and other, disfiguration, translation, petrification, historical context, and death—all of which raise fundamental questions about who we are in relation to what we call "photography." The figure of the mollusk in its shell is itself a kind of shell that shelters and encrypts something like its own mollusk, which is to say that the shell "itself" is linked to what it shelters, is like what it is unlike. It encloses what can at the same time be read in it, even if in a translated form. This is why this strange figureless figure—this mollusk in its shell—resembles an image. As something that is completely formless, the mollusk secretes the shell that will serve as its frame, that will give it its shape, and, when filled with fluid, it expands until its formless figure inhabits its frame, like the mother in her tight bodice. This shell-frame appears as the petrification of life—dead matter, a thing, it continues to grow as long as the mollusk is alive. Like a slow-motion, time lapse camera it in fact records every second of the mollusk's life.[97] The perfect autobiographical form, it registers, inscribes and imprints every moment of the process whereby what is living becomes petrified. Along with its shell, the mollusk therefore names a kind of rhythm of the transit between life and death. Living in the domain of photography—the shell around it forms a kind of dark room—the mollusk participates in the chemical process whereby it is translated into its image, its afterlife. To have lived in the nineteenth century as a mollusk in its shell is therefore to have lived in a space of photography, a space in which it is necessary to understand what takes place under the names light, darkness, technology, capital, thing, reproduction, language, and death.

If the mollusk and its shell are at once a kind of camera, a developer, and a photographic dark room, however—all of which together work to seal and deliver their "initial imprinting power"—there is a point or a moment when the image is interrupted. At a certain point, a difference interrupts the two spaces of the mollusk's structure—emerging between the surface of the shell and the mollusk, it tells us that these two spaces no longer belong to the same element. At a certain point, that is, the mollusk is translated into its shell. Like the Benjamin who is unable to be presented in his own image, the mollusk and the shell become incommensurable within the very relation they continue to maintain. Both alike and different from one another, they also belong, even if they cannot be reduced, to the processes of disfiguration that throughout the passage work to enact and perform a certain theory of

resemblance—one that can no longer be understood in terms of the resemblance between two separate and distinct things.

Elsewhere Benjamin associates this "Lehre vom Ähnlichen" with the superimposition of one figure upon another. It is because figures are always haunted by other figures—are always bearing the traces of the other—that they are always themselves and not themselves at the same time. In other words, the experience of a resemblance, because it experiences a likeness and not an identity, encounters a distance at the heart of resemblance. Adhering to resemblance like a mollusk to its shell, this distance or disymmetry is, according to Benjamin, what makes likeness both possible and impossible. His emphasis on distance not only helps to account for the process of figuration and disfiguration at work here—the giving and taking away of faces— but it also suggests a method of writing that performs at the level of its sentences and words what it wants us to understand. The writing that would remain faithful to this theory of similarity and superimposition would be, as we have seen, a writing that shifts from one figure to another and, in the process of this movement, takes on the characteristics of these altering figures. Benjamin elaborates this point in a remarkable passage from the *Passagen-Werk* that not only links the practice of his writing to the unlimited substitution of one figure for another, but also touches on the auratic experience of words in general.[98] He writes:

> The phenomena of superposition, of overlay, that appear with hashish should be included within the concept of similarity. When we say that a face is similar to another, that means that certain features of this second face appear to us in the first, without the first ceasing to be what it was. But the possibilities of apparition that are offered in this way are not submitted to any criterion and are therefore unlimited. The category of similarity, which for the awake consciousness only has a very limited significance, acquires in the world of hashish an unlimited one. For, everything is in it: face, everything has the degree of physical presence, that enables, as in a face, the search for the apparition of traits. Under these circumstances even a sentence acquires a face (not to speak of a word) and this face is like that of the sentence opposed to it. In this way each truth evidently points to its contrary and from this state of things doubt can be explained. Truth becomes something living; it lives only in the rhythm, in which sentence and countersentence displace themselves in order to think themselves. (GS 5:526)[99]

If this passage helps us understand the various forms of disfiguration that occur in the relation between the two photographs to which Benjamin refers, it also tells us that, like photography, language is a medium of likeness. In language, as in photography, all things, persons, places, and experiences can correspond with one another. They can turn into one another, and in fact they do so whenever they enter into its movement. That this movement consists in the giving and taking of faces means that it corresponds to the movement of prosopopeia. Like the rhythm "in which sentence and countersentence displace themselves in order to think themselves," prosopopeia names the movement of effacement whereby a figure—in particular, a face or a mask—emerges only in order to withdraw in its disfiguration.[100] It is another name for photography. Telling us that there is no thing, person, or event that does not participate in the experience of language, it conjures the figures whose disfiguration enables them to resemble every other figure, fleetingly and in a flash.

That this passage can also be read as a formula for understanding Benjamin's experience of the relation between language and things in general means that it gives us access to the linguistic gesture of his writings, a gesture in which the movement of his language inscribes the lessons he wishes us to learn. In regard to the *Berliner Kindheit*, this gesture can be read in the resemblance between the echolalia, the paronomasia that often motivates the movement of his language and the faces and figures of the persons and things that come to be like one another. This is why, and here we return to Benjamin's photography studio, little Benjamin's ability to be like another or even like others means that he is never like himself. It is only because he does not resemble himself that everyone else can be like him (but again everyone else only to the extent that they too are not themselves).[101]

To say that Benjamin can never correspond to his own image is to say that he can never correspond to his own death. We can read this noncorrespondence in the figure of the empty shell toward which this entire photographic scene is oriented. We could even say that this empty shell forms the nucleus of the passage. What it tells us is what we have already seen: that the virtually infinite relations that are condensed within a name, a face, or a figure, enter into a complex that is without a relation to itself—and therefore touched by death. This is why whoever or whatever speaks these last few lines—and does so while viewing the empty shell in which it lived—is already dead, is

REGISTRO CIVIL DE | DISTRITO DE

Número *25.–*

NOMBRE Y APELLIDOS

Walter Dr.
Benjamin

En *Port-Bou, provincia de* (1)
Gerona , a las *catorce* y *quince*
minutos del *veintisiete* de *Septiembre* de mil
novecientos *cuarenta* , ante D. *Fernando Pastor*
Nieto Juez municipal , y D. *José*
Reiré Broté , Secretario ,
se procede a inscribir la defunción de D. *Benjamín*
Walter Dr. de edad *cuarenta y ocho*
años , natural de (3) *Berlín (Alemania)*
, hijo de D.
y de Doña
, domiciliado en de
núm. , piso , de profesión *Dr.*
y de estado (5) *casado con Dora Kellner*

falleció en *Fonda de Francia, de esta* (9) el día *veintiséis*
del actual , a las *veintidós horas* minutos, a
consecuencia de (8) *hemorragia cerebral*
según resulta de *la certificación facultativa*
y reconocimiento practicado, y su cadáver habrá de recibir sepultura en el
Cementerio de *esta localidad*

Esta inscripción se practica en virtud de *diligencias pre-*
ventivas de abintestato

consignándose además (12) *si había otorgado testamento*
se ignora
habiéndola presenciado como testigos, D. *Santiago Sanz*
Sanz y D. *Julio Oliver Campos*
mayores de edad y vecinos de *esta localidad*

Leída esta acta, se sella con el del Juzgado y la firman el señor Juez, los
testigos (1)
de que certifico. (14)

speaking from beyond death. Like the mollusk who can only leave its shell by dying, the various figures sealed within the figure of the shell—among others, Benjamin, Kafka, the mother, and the mollusk—here encounter their disappearance. That we are left with a kind of funereal monument means that the sentences of this passage become, by enacting what they describe and by describing what they enact, "Benjamin's" epitaph. The *Berliner Kindheit*, in other words, presents itself as an epitaph for the "one" who, now dead, still speaks. As we have already seen, however, this one who crosses the conditions of death and of life is never just one.

If, according to the "Work of Art" essay, "the prying of an object from its shell [*Hülle*], the destruction of the aura, is the signature of a perception whose 'sense of the sameness in the world' has increased to such a degree that it extracts it even from the unique by means of reproduction" (*I* 223 / *GS* 1:479–80), it is no accident that the singular, but labyrinthine ear to which the empty shell is held ("I hold it to *my* ear") is related to another ear, which it has already encrypted—the ear of the little reproduced Kafka. In the "Childhood Photograph" section of Benjamin's essay on Kafka, at the end of a description of the photograph of the five-year-old Kafka that is nearly identical to that in the *Berliner Kindheit*, we again find the mournful gaze, the shell, the ear, and this time even the shell of an ear. As Benjamin tells us, Kafka's "immeasurably sad eyes dominate the landscape predetermined for them, into which the auricle [*Ohrmuschel*] of a big ear listens" (*I* 118–19 / *GS* 2:416). In other words, the "I" who holds the empty shell to his ear at the same time listens with the auricle, literally the shell-ear, of another.[102] His ear is also that of the other.[103] Still, these two ears are never quite the same ear—the one has a shell held to it while the other is formed like a shell, the one listens into a shell while the other, already formed by that into which the first one listens, listens to a landscape, the one has a shell directed toward it while the other directs the shell that it is toward a landscape. To say that the "I" listens with the other's ear—whether it is the ear that Kafka lends him or the ear that he lends himself in writing—is to say that the speaker enters into a relation with himself as an other.

If this relation involves the superposition of one ear upon another, what is at stake here is our learning how to listen to the other who always hears in us before us, the one who always signs in our place. This is why the ear to which Benjamin's "I" holds the shell is an ear in which, as he notes later in

the *Berliner Kindheit*, "everything struck my ear as a repetition ... every sound and moment approached me as the double of itself" (*GS* 4:301). It is because nothing within this ear is ever itself—it hears what we have already discovered in this visit to the photographer's studio—that Benjamin is left with a question that, he suggests, remains "in the folds of the curtain" that hung in front of his door "in order to guard against the noise": "why is there anything in the world? why is the world? I was struck with amazement that nothing in the world could make me think the world. Its non-being would have appeared to me in no way more questionable than its being, which seemed to blink at its non-being" (ibid.). Asking us to think of the rhythm between likeness and unlikeness, being and nonbeing, seeing and not seeing, the question registers the rhythms at the heart of photography. As we have seen, the one who is photographed—the one who is like himself but not himself—blinks at his nonbeing. We could even say that this is the lesson of "Mummerehlen"'s discussion of photography's relation to the question of resemblance. If Benjamin can never enter his own image, it is because, inhabiting the nineteenth century in the twentieth century, he lives in an intersection between the past and the present that, like his relations to others, prevents him from ever coinciding with himself. Benjamin reinforces this lesson in a passage from the *Passagen-Werk* that points to the vertiginous effects of the mirrors in the Parisian arcades—which are themselves formed like shells—and evokes the shifting resemblances that both govern and limit the relations among what he calls the "whisper of gazes":

> One view upon the ambiguity of arcades: their wealth in mirrors, which magically extends the spaces and renders orientation more difficult. For even if this world of mirrors has several significations [*mehrdeutig*], even an infinite number of significations [*unendlich vieldeutig*], it still remains ambiguous [*zweideutig*]. It blinks—it is always this One and never Nothing, from which something else immediately ascends the space that changes and does so in the lap of Nothingness.... Gaze whisper [*Blickwispern*] fills the passages. There is not a thing, that does not look up, and then down squintingly where one least expects it, but if you look closer it has disappeared. Space lends its echo to this whisper of gazes. "What may have happened inside me," he says, squinting. We hesitate. "Yes, so what may have happened inside you," we softly ask him back. (*GS* 5:672)

XXVII.

DEATH. — Death, both the word and the event, is a photograph that photographs itself—a photograph that comes as the suspension of reality and its referents. As Benjamin suggests in "Central Park," the photograph, like the souvenir, is the corpse of an experience (*CP* 49 / *GS* 1:681). A photograph therefore speaks *as* death, as the trace of what passes into history. I, the photograph, the spaced out limit between life and death, am death. Yet, speaking as death, the photograph can be neither death nor itself. At once dead and alive, it opens the possibility of our being in time.[104]

This is why the event of photography is necessarily anterior to any history of photography—photography does not belong to history; it offers history. It delivers history to its destiny. It tells us that the truth of history is to this day nothing but photography. Nevertheless, the photograph—as what is never itself and therefore always passing into history—asks us to think the remains of what cannot come under a present. How can an event that appears only in its disappearance leave something behind that opens history? How can the photographed guard a trace of itself and inaugurate a history? To pass through these questions is not only to think what is incomprehensible about photography but also what makes photography photography. This consideration imposes itself at the heart of any history of photography, in terms of the many ways in which history finds itself exposed to the danger of having understood photography. We could even say that photography escapes history when history orients itself toward a "history of photography" rather than a "photography of history." For Benjamin, history happens when something becomes present in passing away, when something lives in its death. "Living means leaving traces" (*CB* 169 / *GS* 5:53). History happens with photography. *After life.*

XXVIII.

EPITAPHS. — Gershom Scholem closes his memoirs of his friendship with Benjamin with an account that evokes the relations among photography, death, and cemeteries, and does so in relation to the death of Benjamin

himself. Whatever the strangeness and sorrow that touch the account, it remains in faithful memory of Benjamin. That is to say, it holds to *his* memory, to his thinking on the subject of memory and on the relation between memory and death:

> I learned about Benjamin's death on November 8th in a brief letter—dated October 21st, 1940—from Hannah Arendt, who was then still in the south of France. When she arrived at Port Bou months later, she sought Benjamin's grave in vain. "It was not to be found; his name was not written anywhere." Yet Frau Gurland had, according to her report, bought a grave for him in September for five years. Hannah Arendt described the place: "The cemetery faces a small bay directly overlooking the Mediterranean; it is carved in stone in terraces; the coffins are also pushed into such stone walls. It is by far one of the most fantastic and most beautiful spots I have seen in my life." Many years later, in the cemetery that Hannah Arendt had seen, a grave with Benjamin's name scrawled on the wooden enclosure was being shown to visitors. The photographs before me clearly indicate that this grave, which is completely isolated and utterly separate from the actual burial places, is an invention of the cemetery attendants, who in consideration of the number of inquiries wanted to assure themselves of a tip. Visitors who were there have told me that they had the same impression. Certainly the spot is beautiful, but the grave is apocryphal. (*Walter Benjamin*, 226)

In telling us of the absence of the inscription that would identify the place of Benjamin's burial, of any marker that might serve to memorialize Benjamin's death, Scholem reveals what Benjamin has already told us: death may never be a referent—even if it is always referred to. If Benjamin is without an epitaph, and perhaps in no need of an epitaph, it is because he has already written that epitaph in the form of his corpus. Not only is this corpus characterized by an insistent reflection on mourning, a reflection in which bereavement and memory are indelibly inscribed, but it is also the prosopopeia that he addresses to us from a death that becomes all the more legible precisely because it remains unmarked. Beyond the grave and its funereal inscriptions, Benjamin's voice speaks through the tomb that is his writing. Benjamin already had presaged this tomb of writing near the conclusion of his most extensive treatise on death and mourning, the *Trauerspiel* book. Citing a passage from Johann Christian Hallmann's *Leichreden* (Corpse

speeches) that identifies our being with images of death, Benjamin has his text envelop within itself a thought of death and thereby makes his writing a work of mourning—a work of mourning that foresees, in however an encrypted manner, the Germany within and against which he so often wrote, the Germany that would eventually drive him to suicide. He writes, borrowing the words of Hallmann:

> if we consider the innumerable corpses with which, partly, the ravages of the plague and, partly, weapons of war, have filled not only our Germany, but almost the whole of Europe, then we must admit that our roses have been transformed into thorns, our lilies into nettles, our paradises into cemeteries, indeed our whole being into an image of death. It is therefore my hope that it will not be held against me that in this general theater of death I have not foreborne to set up my own paper graveyard. (*O* 231 / *GS* 1:405)

Benjamin's "paper graveyard"—what I have wanted to call a photograph— tells us, if it tells us anything, that we must *regard* death. And it is there, in death, that Benjamin experienced what he had already experienced in life— death. The shock of his death—breaking in upon his own history and giving it, in this way, an end and a future—corresponds to the terrifying lucidity of his corpus. Death, corpse, decay, ruin, history, mourning, memory, photography—these are the words Benjamin has left for us to learn to read. These are the words that prevent his other words from being organized into a system, that prevent his writings and readings from being crystallized and frozen into a merely negative method. Words of light, they correspond to the cremation of his work, a cremation in which the form of the work—its suicidal character—reaches its most brilliant illumination, immolated in the flame of his own criticism.

Notes

PREFACE

1. Cited in Schaaf, *Out of the Shadows*, 65.

2. For an extended analysis of the relation between memory and archivization in particular and of the archive in general, see Derrida, *Mal d'archive*.

3. Benjamin's friend, Theodor Adorno, brings together thought, grasping, and photography in his review of Ernst Bloch's *Geist der Utopie*. There, he claims that "thought uses a hand-held camera" ("The Handle, the Pot, and Early Experience," 216).

4. I am indebted in this discussion of Benjamin's personal relation to the practice of photography to Lehning, "Walter Benjamin and *i10*." For Benjamin's review of Freund's book, see *GS* 3:542.

5. On the importance of this structure of arrest to Benjamin's thinking on history in general, see Balfour, "Reversal, Quotation (Benjamin's History)," 646.

6. I am grateful to Gerhard Richter for having directed me to this passage. For a discussion of Nadar's aeronautical photography, see Rouillé, "*When I Was a Photographer*," 108–12. See also Nadar's own account in his autobiography, *Quand j'étais photographe*, 75–97.

7. See especially Ronell, *Telephone Book*, "*Differends* of Man," "Support Our Tropes," and "Trauma TV."

8. In his brief essay "Über die Gefahr" (On danger), written as an introduction to a collection of photographs published under the title *Der gefährliche Augenblick* (The dangerous moment) in 1931, Jünger notes that "the history of inventions poses the increasingly pressing question whether . . . the final hidden goal of technology may be a space of absolute danger" (15). Suggesting the urgency of a consideration of technology in general and of photography in particular, he names the danger that motivates Benjamin's analyses of the politics of the technical media.

9. As Hitler declared in *Mein Kampf*, Nazism is above all the "construction and conformation of its vision of the world" (*Mein Kampf* 1940: 881 / *Mein Kampf* 1938: 680). There was even an official Bureau of the *Weltanschauung* set up in order to ensure the installation of this vision. For an analysis of the relation between fascism and modernity's effort to "conquer the world as image," see Heidegger's "The Age of the World Picture" (134 / *Holzwege*, 92).

10. There is no revolutionary discourse or situation, on the left or on the right (and, as Derrida has noted, "from 1921, in Germany, there were many of these that resembled each other in a troubling way, Benjamin often finding himself between

the two" ["Force of Law," 991]), that does not have recourse to technology, to the technical media, often in the name of progress. This is why so many of Benjamin's writings are directed against the rhetoric of progress, technological or otherwise. It is also why it is often difficult to distinguish between one revolution and another. As Jean-Luc Nancy notes, that "Fascism and Nazism were also revolutions, as were Leninism and Stalinism" means that "it is therefore also a question of revolutionizing revolutions. . . . This requires something on the order of a revolution in thinking" (*Experience of Freedom*, 164). In the instance of technology, it requires a manner of thinking that emphasizes the unforeseeably mediated relations that prevent the meaning of an event from ever being present.

11. See Nancy, *Inoperative Community*, especially chapter 1.

12. I am indebted for this formulation to Weber, "The Media and the War," 22.

13. This passage has been discussed in the context of Heidegger's relation to the question of technology in general by Ronell in *Telephone Book*, 197–201. See also Dienst, *Still Life in Real Time*, 106–10.

14. Weber, "Mass Mediauras," 88.

15. Barthes makes a similar point in his *Camera Lucida*, 64–65.

16. I am indebted here to Derrida's discussion of a politics of death in *Aporias*, 61.

17. The citations are from Moholy-Nagy, "Unprecedented Photography," 85, and Passuth, *Moholy-Nagy*, 328. In order to address the importance of being photography-literate, Moholy-Nagy claims elsewhere that "there ought to be an Academy of Light." He continues: "the forming of such an academy could be justified on economic grounds alone by reference to the changes in the economic situation, the new forms of appeal to the public—press photos, book illustrations, theatrical lighting, advertising of films and illuminated advertising, to say nothing of the developments the future may bring and all that would be directly born of such a center devoted to the theoretical and practical study of the uses of light" ("Light Painting," 343).

WORDS OF LIGHT

1. Cf. this point with Hamacher's analysis of the "logic" of such realism—as it appears in Sartre's "Qu'est-ce qu'un collaborateur" and Paul de Man's wartime writings—in his "Journals, Politics."

2. See Lacoue-Labarthe, *Heidegger, Art and Politics*, 62–70. For another recent analysis of the relationship between the political project of National Socialism and aestheticism, see Hamacher's "Journals, Politics."

3. That Benjamin saw his attempt to rethink the status and nature of the work of art as a means to combat fascism is well known. See Wolin, *Walter Benjamin*, especially 183–98, and Düttmann, "Tradition and Destruction." On the political stakes of his thinking on photography, see Puppe, "Walter Benjamin on Photography." For three excellent analyses on the role of art and the technical media within the political

agenda of National Socialism, see Syberberg, *Hitler*; Virilio, *War and Cinema*; and more recently, Ronell, *Telephone Book* and "*Differends* of Man" (especially 266).

4. Although today we may understand the importance and relevance of these reflections, it is no longer simply a question of crisis. Everything happens as if we understood and shared the discretion, everything happens as if we all acknowledged the massive role that photographic technologies—their productions, diffusion, and manipulation—have in what we call "our historical reality." Indeed, no single instant of our life is not touched by the technological reproduction of images: here we could consider a vast array of ideological forms—fashion, cinema, newspaper illustrations, televisual representations, advertising, political campaigns, and so on. We need only recall the tragedy of what we now refer to as the "War in the Gulf." If this war taught us anything, it taught us what has been true of all wars—there can be no war that does not depend on technologies of representation. This was a war whose entire operation depended on the technologies of sight: satellite and aerial photography, light-enhancing television cameras, infrared flashes and sighting devices, thermographic images, and even cameras on warheads. The war machine was in every way a photographic machine. To think what made the Gulf War possible would at some level involve a thinking of the relation between photographic technologies and what Virilio has called "the logistics of military perception" (*War and Cinema*, 1).

5. Benjamin is not the first to suggest the urgent necessity of thinking photography and history together. Kracauer, in his 1927 essay "Photography" (an essay to which Benjamin's own essay on photography refers; see *OWS* 245 / *GS* 2:373), had already seen photography as a means for reconsidering the relation between history and historicism. Early in the essay, he claims that historicism "emerged at about the same time as modern photographic technology" (49). Questioning the historicist assumption that history is linear and sequential, he attempts to transform both the concept of history and a thinking of photography by emphasizing what for him is their interruptive, even dangerous character: "The turn to photography," he writes, "is the life and death game [*Vabanque-Spiel*] of the historical process" (61).

Kracauer reiterates this point in his introduction to his *History: The Last Things before the Last*. There, in a statement about the trajectory of his previous writing that is itself articulated in the language of photography, he notes: "I realized in a flash the many existing parallels between history and the photographic media, historical reality and camera-reality" (3–4; I am grateful to Thomas Levin for directing me to this passage). For both Benjamin and Kracauer, what gives thinking history to think about is photography.

6. See Villiers de l'Isle-Adam, *Tomorrow's Eve*, especially the section entitled "Snapshots of World History." For an excellent reading of the novel that focuses on the relations among light, technology, and the production of images, see Gasché, "Stelliferous Fold." See also Bellour, "Ideal Hadaly."

7. Paul Valéry elaborates this point on the occasion of the centenary of photography, claiming that there are "very intimate and very ancient affinities between light and Philosophy." "Philosophers in every age," he goes on to say, "theorists of knowl-

edge as well as mystic authors, have shown a rather remarkable predilection for the most commonly known phenomena of optics, which they have often exploited—sometimes in the most subtle manner—in order to figure the relations between consciousness and its objects, or to describe the illusions or illuminations of the mind" ("Centenary of Photography," 197 / "Centenaire de la Photographie," 104). Derrida reinforces this point when he suggests that the metaphor of darkness and light is "the founding metaphor of Western philosophy": "the founding metaphor not only because it is a photological one—and in this respect the entire history of our philosophy is a photology, the name given to a history of, or treatise on, light—but because it is a metaphor" ("Force and Signification," 27). In relation to Benjamin in particular, Norbert Bolz's essay, "Der Fotoapparat der Erkenntnis" confirms that photography is Benjamin's metaphor for historical knowledge in general (21–22).

8. For a discussion of the relation between the weather and perception in Benjamin, see Hamacher, "Word *Wolke*—If It Is One."

9. Mac Orlan elaborated this correspondence between photography and death again in his 1929 essay "Elements of a Social Fantastic." He writes, "What is utterly mysterious for man is, unarguably, death. To be able to create the death of things and creatures, if only for a second, is a force of revelation which, without explanation (which is useless), fixes the essential character of what must constitute a fine anxiety, one rich in forms, fragrances, dislikes, and, naturally, the association of ideas. It is thanks to this incomparable power to create death for a second that photography will become a great art" (32).

10. Benjamin does not identify the specific photograph to which he refers here. Nevertheless, of the many calotypes that Hill made at Greyfriars, there is a series of shots taken at three different tombs, each of which fits Benjamin's description. The most likely candidates are a group of calotypes made at the Dennistoun monument (one in particular, entitled "The Artist and the Gravedigger," appears as plate number 57 in Heinrich Schwarz's *David Octavius Hill*, to which Benjamin refers in his essay on photography), but those taken at the Byrnes monument and at the Naismyth monument are also possible. What is most striking in all of these is indeed how closely the tombs resemble fireplaces. See Stevenson, *David Octavius Hill and Robert Adamson*, 191–94.

11. In his discussion of the baroque mourning play, Benjamin insists that life is always judged from the perspective of death. "From the point of view of death," he writes, "life is the production of the corpse" (*O* 218 / *GS* 1:392). On the relation in general between death and photography, see, in addition to the above, Derrida's essays "The Deaths of Roland Barthes" and "The Right to Inspection." See also Amelunxen, "Skiagraphia" and "Ein Eindruck der Vergängnis," 6–7, and Stiegler, "Mémoires gauches" and *La technique et le temps*, 269–70.

12. This formulation is indebted to Heidegger's discussion of the relation between death and language in *On the Way to Language*. See *On the Way to Language*, 107, and *Unterwegs zur Sprache*, 215. Heidegger explicitly discusses the relationship between

death and photography in his analysis of the Kantian notions of image and schema. Suggesting that what links death and photography is their capacity to reveal the process of appearance in general, he writes:

> The photograph of the death mask, as copy of a likeness, is itself an image—but this is only because it gives the "image" of the dead person, shows how the dead person appears, or rather how it appeared. . . .
>
> Now the photograph, however, can also show how something like a death mask appears in general. In turn, the death mask can show in general how something like the face of a dead human being appears. But an individual corpse itself can also show this. And similiarly, the mask itself can also show how a death mask in general appears, just as the photograph shows not only how what is photographed, but also how a photograph in general appears.
>
> But what do these "looks" (images in the broadest sense) of this corpse, this mask, this photograph, etc., now show? Which "appearance" (*eidos, idéa*) do they now give? What do they now make sensible? In the one which applies to the many, they show how something appears "in general." (*Kant and the Problem of Metaphysics*, 64)

13. On this point, see Derrida, "Deaths of Roland Barthes," 281–82.

14. Giving an account of the ghostly dimension of early photography, Tom Gunning has noted that, while "photography emerged as the material support for a new positivism, it was also experienced as an uncanny phenomenon, one which seemed to undermine the unique identity of objects and people, endlessly reproducing the appearances of objects, creating a parallel world of phantasmatic doubles" ("Phantom Images and Modern Manifestations," 42–43). In other words, if the invention of photography was a turning point in the history of the process of identification—as Benjamin reminds us, "photography made it possible for the first time to preserve permanent and unmistakable traces of a human being" (*CB* 48 / *GS* 1:550)—it was also understood as a technological means of capturing and reproducing specters. Nadar makes this point in his autobiography (a book that Benjamin read and cites repeatedly in the *Passagen-Werk*) by evoking Balzac's theory of the ghostly character of both photography and life in general:

> According to Balzac's theory, all physical bodies are made up entirely of layers of ghostlike images, an infinite number of leaflike skins laid one on top of the other. Since Balzac believed man was incapable of making something material from an apparition, from something impalpable—that is, creating something from nothing—he concluded that every time someone had his photograph taken, one of the spectral layers was removed from the body and transferred to the photograph. Repeated exposures entailed the unavoidable loss of subsequent layers, that is, the very essence of life. ("My Life as a Photographer," 9)

For Balzac, photography is another name for the production of ghostly images. Or, as Benjamin would have it, the ghost is the residue of technological reproduction.

For a genealogy of the role of ghosts within the early understanding of photography and film, see Gunning, "Phantom Images and Modern Manifestations."

15. I am indebted here to Hamacher's formulation of the relation between history and citation in Paul Valéry's *La jeune parque*, in his "History, Teary," 84–85.

16. Cf. on this point what Derrida says about the power of the name in *Mémoires*, 49 and in "Signature Event Context," 7–8. On the suggestion that the deadly power of the image "does not wait for death, but is marked out in everything—and for everything—that awaits death," see his "By Force of Mourning," 180–81.

17. It may also correspond to the gesture that gives birth to myth in general. According to Scholem, Benjamin early on thought that a "spectral" age of organic unity with nature had preceded the age of myth and that "the real content of myth was the enormous revolution that polemicized against the spectral and brought its age to an end" (*Walter Benjamin*, 61). We can make two remarks here: first, the effort to efface the photograph's ghostly character can be situated before the birth of photography, as we generally conceive it, and second, the growing conviction in the realism of the photograph (as Benjamin describes it) can be understood to belong to the world of myth.

18. Benjamin here seems to be following Heinrich Schwarz's formulation in his *David Octavius Hill*. There, describing Hill's work, Schwarz writes: "Hill remained true to his primitive mechanical equipment, even when an advanced optics had already mastered instruments that completely vanquish darkness and that delineate phenomena as does a mirror." It is important to register the degree to which Benjamin's "Short History of Photography" recirculates—the way one passes around photos—the arguments of the photographic books he lists in his notes: the Bossert and Guttmann collection of photographs from 1840 to 1870 (1930), the Schwarz book on Hill (1931), Karl Blossfeldt's photographs of plants (1930), Atget's photographs (1931), and Sander's photographs (1929). To a large degree the essay is itself a series of snapshots or photos of the arguments presented in these books. There is much work to do here, but Price's chapter on Benjamin in *The Photograph* provides an excellent start in this direction (see especially 37–61).

19. It is no accident that Benjamin refers to both the language of photography and the fleeting character of the image in his discussion of the perception of similarity. In "The Doctrine of the Similar," he writes: "The perception of similarity is in every case bound to a flashing up [*Aufblitzen*]. It flits by, may perhaps be won again, but, unlike other perceptions, can never really be held fast. It offers itself to the eye as fleetingly, transitorily as a star constellation" (*D* 66 / *GS* 2:206–7).

20. For readings of Benjamin's translation essay that trace the consequences of his discussion of the essential disjunction between an original and its translation, see de Man, "'Conclusions,'" and Jacobs, "Monstrosity of Translation."

21. Samuel Weber, "Theater, Technics, and Writing," 18. I am indebted to Weber for much of this discussion of Benjamin's *Trauerspiel* book.

22. Beyond its association with photography and writing, lightning is also understood by Benjamin as an "emblem of the descending technological age" (*GS* 5:212).

23. This inability is stated more strongly as a refusal to be photographed in *One-Way Street*: "the truth refuses (like a child or woman who does not love us), facing the lens of writing while we crouch under the black cloth, to keep still and look amiable" (95 / GS 4:138).

24. For an extended and complementary reading of this passage, see Bahti, *Allegories of History*, 245–48.

25. Learning to die is what Montaigne understands as the endless task of philosophy in general. As Nancy reminds us, "Montaigne has fixed once and for all, at the threshold of the epoch of desire, the *exemplum* of this endless task—and this is also why he attributes the end of philosophy to our 'learning to die,' that is, for him, to our learning to accept the infinite distance between us and our signification (or better still: to our learning that the final signification is the arrest of signification)" (*L'oubli de la philosophie*, 48).

26. Menke makes a similar point in her reading of "Lehre vom Ähnlichen." See *Sprachfiguren*, 288–92.

27. Responding to Adorno's own understanding of the image as a constellation, Benjamin linked the dialectical image to the figure of the constellation in a letter of 16 August 1935 to Gretel Adorno:

> How apt W.'s definition of the dialectical image as a "constellation" seems to me, and how undisputed certain elements of this constellation, to which I referred, nevertheless appear to me: namely, the dream figures. The dialectical image does not draw a copy of the dream—it was never my intention to assert this. But it does seem to me to contain the instances, the moment of the irruption of awakening, and indeed to produce its likeness only from these passages just as an astral image emerges from luminous points. (*C* 510 / *B* 688)

28. Stéphane Moses makes this point in "Ideas, Names, Stars," 184. He also notes that the theme of stars returns in the *Passagen-Werk* within one of Benjamin's discussions of the effects of technology on urban space. There, Benjamin links the destruction of aura to the absence of stars: "The metropolis does not know the true twilight. Artificial lighting in any case deprives it of its transition to night. The same circumstance causes the stars to fade in the city sky. Their rising is noticed least of all. Kant's depiction of the sublime as 'the moral law within myself and the starry heavens above me' could not have been conceived in this way by a city dweller" (*GS* 5:433).

29. It is perhaps also why Benjamin more than once notes that stars never appear in the writings of Baudelaire—or if they do, that they are always in the process of fading or disappearing. There is much to be said about the importance of stars in this reading of Baudelaire. We could even say that such a reading is organized around an understanding of the role the stars play in the poet's various allegories of history. Benjamin suggests their importance when, in the section of the *Passagen-Werk* devoted to Baudelaire, he provides us with a list of what he calls "the principal passages concerning the stars in Baudelaire . . . : 'How you would please me, O night! without these stars / whose light speaks a known language / For I seek silence, the night, and

nothingness!' 'Obsession' . . .—the final stanza of 'The Promises of a Face' . . . ! that 'enormous head of hair / . . . which in darkness rivals you, / O starless night, obscure night!'—'No star anywhere, no vestiges / Of the sun, not even at the horizon' 'Parisian Dream' . . .—'What if the heavens and the sea are black as ink' 'The Traveler' . . .—Cf. on the contrary, 'The Eyes of Berthe,' the only significant exception and, at most, the combination of stars with ether, such as it appears . . . in 'Le Voyage.' On the other hand, it is highly characteristic that 'The Twilight of the Evening' does not make any mention of stars" (GS 5:342–43). Benjamin reinforces this relation between Baudelaire and the question of stars in several passages from this same section of the Passagen-Werk, of which I offer only a few:

> (1) "Hugo to Baudelaire, 30 August 1857. He acknowledges having received a copy of Fleurs du Mal. 'Art is like azure, it is an infinite field: you have just proven it. Your Fleurs du Mal sparkle and shine like the stars.' " (361)

> (2) "We will find the decisive text on the confrontation between Baudelaire and Hugo in a letter that the latter wrote on 17 November 1859 to Villemain: 'I sometimes pass entire nights dreaming about my fate in the presence of the abyss . . . and I can do nothing more than cry out: stars! stars! stars!' Cited in Claudius Guillet, Victor Hugo spirite, Lyon-Paris, 1929, p. 100." (371)

> (3) "Baudelaire: the melancholic whose star points him to distance. But he has not followed it." (402)

> (4) "That the stars are missing [ausfallen] in Baudelaire provides us with the most exact concept of the tendency proper to his lyric poetry—shinelessness [Scheinlosigkeit]." (421)

> (5) "Stars represent in Baudelaire the picture-puzzle [Vexierbild] of the commodity. They are the always-again-the-same [Immerwiedergleiche] in great masses." (429; see also GS 1:660)

It is not surprising that Benjamin closes his essay on Baudelaire with the figure of the star. Suggesting that the law of Baudelaire's poetry corresponds to "the disintegration of the aura in the experience of shock," he states that it nevertheless "shines in the sky of the Second Empire as 'a star without atmosphere'" (I 194 / GS 1:653).

30. Cited in Fenves, Peculiar Fate, 13.

31. Benjamin specifies this movement a bit further in the "Epistemo-Critical Prologue" to his Trauerspiel book. He suggests that what returns is always the endless and auratic interplay between "singularity and repetition" (O 46 / GS 1:226). As he explains in his Passagen-Werk, "Life under the magical spell of the eternal return grants an existence that does not step out of the auratic" (GS 5:177).

32. On the concept of the eternal return, see Nietzsche, Will to Power, 544–50. See also Blanchot, Infinite Conversation, 148–50 and 272–78, and Deleuze, Nietzsche and Philosophy, 47–49.

33. It is important to note, however, that what is repeated in Benjamin's understanding of this concept is the enigma of the commodity (its "picture-puzzle") and not some readable "always-again-the-same" that still could be inscribed within the

rhetoric of progress. If, as Wohlfarth has suggested, progress can be understood to progress "the way capital capitalizes itself" ("Measure of the Possible," 14), then there is a form of the eternal return that paradoxically would remain compatible with progress. As Benjamin notes:

> Belief in progress, in endless perfectibility—an unending moral task—and the presentation of the eternal return are complementary. They are ineluctable antinomies, in the face of which the dialectical presentation of historical time needs to be developed. Against this dialectical presentation, the eternal return emerges as precisely that "flat rationalism" of which the belief in progress is accused, and this latter belongs to the mythical mode of thinking just as much as does the presentation of the eternal return. (*GS* 5:178)

This is why Benjamin emphasizes the enigmatic character of an eternal return that, remaining unreadable, could interrupt the clarity, the "flat rationalism," of the progress of progress. That the concept of the eternal return can be used both to question and to support the notion of progress points to the difficulties involved in distinguishing between different political positions. This is why Benjamin so often suggests that the fetishistic myth of progress can be found to be at work in both the right and the left: in this, he bears witness to the necessity of a vigilance whose aim is "to drive out any trace of 'development' from the image of history," to overcome "the ideology of progress . . . in all its aspects" (*GS* 5:1013, 1026).

34. In the *Theses*, Benjamin mobilizes the name of Blanqui specifically against the Social Democratic rhetoric of progress. He writes of the Social Democrats: "Within three decades they managed virtually to erase the name of Blanqui, though it had been the rallying cry that had reverberated through the preceding century" (*I* 260 / *GS* 1:700).

35. Benjamin cites this passage in the *Passagen-Werk*, *GS* 5:76 and 171–72. The relation between Benjamin and Blanqui has received little attention, even though many critics state the importance of Blanqui in Benjamin's reading of Baudelaire. For discussions of this relation, see Jennings, *Dialectical Images*, 60–61; Buck-Morss, *Dialectics of Seeing*, 106–7; and Mehlman, *Walter Benjamin for Children*, 43–45. The most extensive reading of Benjamin's interest in Blanqui can be found in Rella, "Benjamin e Blanqui."

36. It should also be pointed out that Blanqui's writings—written in the name of liberty, equality, and revolution—are organized primarily around a metaphorics of light and darkness, of sight and blindness. The revolutionary for him is the one who leads with light, works to enlighten a humanity that marches with a band over its eyes, and flashes a revolutionary light on the darkness that inhabits the relation between work and capital. That governments do not fall by themselves means that they need to be pushed and exposed. They need to be brought into a light that not only reveals their machinations but also works to hold them responsible for these actions. Addressing the government's recourse to secret trials, for example, he writes, "How do they dare, these daughters of darkness, to face the light of the day?

... The secret trial is the night, the night of horror! The public debate is the joyful sun!" (*Oeuvres*, 549). His recourse to a language of flashes and blindness can be registered throughout his writings; see especially *Oeuvres*, 63, 76, 251, 293, 445, 625, and 636.

37. Buck-Morss makes a similar point in *Dialectics of Seeing*, 106.

38. Blanchot associates the advent of modern technology with the transformation of man into stars in *The Infinite Conversation*. He writes:

> Today the event we are encountering bears an elementary character: that of the impersonal powers represented by the intervention of mass phenomena, by the supremacy of a machinelike play of these forces, and by the seizure of the constitutive forces of matter. These three factors are named by a single term: modern technology. For the latter includes collective organization on a planetary scale for the purpose of establishing calculated planning, mechanization and automation, and, finally, atomic energy—a key term. What up to now only the stars could do, man does. Man has become a star. The astral era that is beginning no longer belongs to the bounds of history. (266)

See also his effort to associate a break from the order of stars with disaster in general in his *Writing of Disaster*, 48–75.

39. This identification between the *Trauerspiel* and a principle of repetition that is at the same time a means of transformation can be read in Benjamin's early essay "Trauerspiel and Tragedy." There he tells us that "the law of the Trauerspiel" rests on repetition (*GS* 2:136). "The universality of its time," he says, "is spectral" (ibid.). If this mourning play is characterized by a concept of time that is organized around a ghostly repetition, it is also marked by a language that is essentially in permanent transformation. As he explains in his essay "The Signification of Language in the Trauerspiel and Tragedy," "the word in transformation is the linguistic principle of the Trauerspiel" (138). Gathering together the motifs of mourning, repetition, specters, transformation, and the play of language, these two essays provide a context within which we can understand further Benjamin's interest in Blanqui's text. For a discussion of the importance of this essay to an interpretation of Benjamin's reflections on the relation between naming and mourning, see Düttmann, *La parole donnée*, 135–41.

40. That phantoms belong to the medium of light through which vision is both possible and impossible can be confirmed within the movement of what Blanqui calls "the obscurity of language" (*L'éternité par les astres*, 46). It is there that the *spectre solaire* oscillates in its meaning between the solar spectrum and the solar specter or phantom. As the figure of what is both dead and alive at the same time, the ghost belongs to the essence of Blanqui's universe. It helps account not only for why "simple bodies" cannot be seen (43), but also for the universe's incomprehensibility (6). To see in Blanqui means to see through ghosts—which means not to see at all. As he puts it, "We have seen nothing, it is true, but because we cannot see anything" (43).

41. For a historical discussion of the Blanquists and their politics of commemoration, see Hutton, *Cult of the Revolutionary Tradition*, especially 11–21.

42. I would like to emphasize this point: it would be a mistake to read this text solely as the hallucinatory madness of an aging revolutionary who, imprisoned in the twilight of his life, looks to the stars for refuge and consolation, or who, like the society against which he fought, throws his projections on the sky. The first thing we can say is that Blanqui's interest in cosmology can be said to have begun as early as 1841 and that it remained a permanent interest throughout his life. Dommanget has documented Blanqui's readings in astronomy and probability theory and, in particular, traced his readings in Laplace's *Exposition du système du monde* (Blanqui, 147–49). In addition, we can begin to read Blanqui's accusations against the society that has hidden him away in prison not only in his encrypted references to his own imprisonment (74) but in his references to Haussmannization (53) (this massive program to renovate the topography of Paris, designed in part to make revolution more difficult, was organized around l'Arc de Triomphe, which is located in la place de l'Étoile), to our capacity to interfere with the physical laws of the universe and thereby overthrow nations and empires (63), and to the relays between revolutions in the sky and those on the earth (34–35). Blanqui's entire text should be read in terms of its engagement with the field of politics—an engagement that revises the terms in which we generally speak of politics. If, as Benjamin puts it, the text seems to register Blanqui's surrender to a "social order that [he] had to recognize as victorious over him in the last years of his life," he still "kneels down before it with such violence that its throne is shaken" (*C* 549 / *B* 2:741 and *GS* 5:168).

43. Baudelaire's sketch is reproduced in Soupault's critical biography of Baudelaire (*Baudelaire*, 15).

44. Cf. here Derrida's formulation concerning the relation between the question of technology and that of writing in *Of Grammatology*, 8.

45. See Düttmann, "Tradition and Destruction," 532. This link between the domain of the political and the reproduction of images is made explicit in Benjamin's essay "*Surrealism*: The Last Snapshot of the European Intelligentsia." There he describes the sphere of political action as "a space reserved one hundred percent for images" (*R* 191 / *GS* 2:309).

46. Benjamin makes a similar point in the appendix to his artwork essay. There, he writes, "All efforts to render politics aesthetic culminate in one thing—war" (*I* 241 / *GS* 1:506).

47. Weber makes this point in his essay "Mass Mediauras," 83.

48. On this point, see ibid., 89. This essay has been very helpful to me in framing my discussion of the relation between Jünger and Benjamin. Although Weber does not write directly about Jünger, his attention to the ambivalences inscribed within Benjamin's relation to the technical media makes his essay an important lever for any discussion of these two theorists of photography.

49. For an excellent discussion of Jünger's historical and theoretical relations to the question of photography, see Werneburg, "Ernst Jünger and the Transformed World." (I am indebted to this essay throughout my comments on Jünger.) See also Huyssen, "Fortifying the Heart," and Kaes, "Cold Gaze."

50. Riefenstahl confirms that the Nuremberg congress was staged to be photographed in *Hinter den Kulissen des Reichs-Parteitag-Films*. She writes: "Preparations for the congress were fixed in conjunction with preliminary work on the film—that is to say, the event was organized in the manner of a theatrical performance, not only as a popular rally, but also to provide the *material* for a propaganda film. . . . *Everything was decided by reference to the camera*" (cited in Virilio, *War and Cinema*, 55).

51. Lacoue-Labarthe makes this point in *Heidegger, Art and Politics*, 64.

52. On this point, see Weber, "Mass Mediauras," 107.

53. For a parallel passage, see *N* 64 / *GS* 5:592: "The concept of progress should be grounded on the idea of catastrophe. That things 'just keep on going' *is* the catastrophe. Not something that is impending at any particular time ahead, but something that is always given. Thus, Strindberg—in 'To Damascus'?—: Hell is not something that lies ahead of us, but this very life, here and now."

Benjamin's discussion of catastrophe has significant connections with the messianic dimension of his writings on history, and touches on the Judaic conception of messianism as it is described by Scholem himself. "Jewish Messianism," Scholem writes, "is in its origins and by its nature—this cannot be sufficiently emphasized—a theory of catastrophe." See "Understanding of the Messianic Idea," 7; see also Wolfharth, "Messianic Structure." It is within this discussion of catastrophe, here and elsewhere, that one could begin to trace in Benjamin a notion of a finite messianism—a messianism that is neither outside time nor in the future, but rather what is given in time. The messianic in Benjamin belongs to the structure of what he calls *Jetztzeit, now-time*. It is both what is exposed to time and what exposes time. This is why it is the task of the historical materialist to establish "a conception of the present as the 'Jetztzeit' which is shot through with chips of Messianic time" (*I* 263 / *GS* 1:704). The messianic is finite—that is to say, marked historically and temporally—not only because it emerges in fragmentary form but also because its essence is not in itself. The messianic involves neither a negation of time nor a cessation of time in a present, but rather a differential structure of time. For Benjamin, the messianic is what happens in and as history.

54. Bloch had already made this point in his 1928 review of Benjamin's *One Way Street*. He notes that the "same glance that decays causes the diverse flow to freeze at the same time, consolidates it (with the exception of its direction), Eleaticizes even the imagination of the most variant intertwining; this makes this philosophizing uniformly Medusan, in accordance with the definition of Medusa in Gottfried Keller as the 'petrified image of unrest'" (*Heritage of Our Times*, 336–37).

55. This discussion of the relation between space and time is itself a fragmentary, photographic montage of Nancy's essay, "Finite History." See also Derrida's "Differánce." For a genealogy of Benjamin's notion of the dialectical image, see Jennings.

56. For a reading of the relation between the figure of Medusa and Benjamin's reflections on history, see Abbas, "On Fascination," 57.

57. Except for the second-to-last "now" in Nancy's passage, I have substituted "now-time" for "now" in order to emphasize that the "now" is filled with time, as well as to get closer to Benjamin's *Jetztzeit*.

58. Benjamin found this passage in a September 1843 letter from Marx to Ruge. He uses it as one of his two epigraphs to the *Passagen-Werk*'s "Konvolut 'N.'"

59. Benjamin makes this point again when he writes that "the Now of recognizability is the moment of awakening" (*GS* 5:608). On Benjamin's relation to surrealism, see Fürnkäs, *Surrealismus als Erkenntnis*, and Cohen, *Profane Illumination*.

60. As Benjamin explains in the *Passagen-Werk*, alluding to the same "alarm clock" [*Wecker*], "The first waking-stimuli [*Weckreize*] deepen the sleep" (*GS* 5:494).

61. Adorno reinforces Benjamin's identification of surrealism with the photographic elements of its concept of awakening in his 1956 essay "Looking Back on Surrealism." There, he writes: "As a freezing of the moment of awakening, Surrealism is akin to photography" (89). On the relation between surrealism and photography in general, see Krauss, "Corpus Delecti," "Photographic Conditions of Surrealism," and "Photography in the Service of Surrealism."

62. As in Benjamin, the "Copernican revolution" in Kant is also cast in optical figures. It is "a change in point of view," Kant writes, such that "our representation of things, as they are given, does not conform to these things as they are in themselves, but that these objects as appearances, conform to our mode of representation" (*Critique of Pure Reason*, 24).

63. The link between history and seeing is written into the word *history*. As Giorgio Agamben has noted, "Like the word indicating the act of knowledge [*eidénai*], so too the word *historia* derives from the root *id-*, which means to see. *Histor* is in origin the eyewitness, the one who has seen" (*Infancy and History*, 94).

64. In his essay on Proust—an essay organized around the "image" of Proust—Benjamin suggests that the space of Proust's writing is always that of the photographic darkroom. Within a discussion of the relation between memory and forgetting, he writes: "This is why Proust finally turned his days into nights, devoting all his hours to undisturbed work in his darkened room with artificial illumination, so that none of those intricate arabesques [of the *mémoire involontaire*] might escape him" (*I* 202 / *GS* 2:311).

65. Proust refers to photography as an archive of memory in the last fragment of *Jean Santeuil*. There, writing of the involuntary memory that emerges when one hears a particular piece of music, he notes: "And the photography of all of this had taken its place within the archives of his memory, archives so vast that he would never look into most of them, unless they were reopened by chance, as happened with the shock of the pianist this evening" (cited in Chevrier, *Écrit sur l'image*, 21–22). He takes this phrase from Baudelaire, who, in his *Salon of 1859*, in the section called "The Modern Public and Photography," uses it to distinguish photography from art. As Baudelaire writes, speaking of photography: "If she saves from oblivion the crumbling ruins, books, engravings, and manuscripts that time devours, the precious

things whose form will disappear and which demand a place in the archives of our memory, she will deserve our thanks and applause" ("Salon of 1859," 297).

66. At the end of his essay on surrealism, Benjamin suggests that it is only through a technology that brings together the body and image, matter and psyche, that we can begin to understand the revolutionary potential of images. He writes of the image sphere "in which political materialism and physical nature share the inner man, the psyche, the individual, or whatever else we wish to throw to them, with dialectical justice, so that no limb remains unrent." "Nevertheless," he continues,

> indeed, precisely after such dialectical annihilation—this will still be an image-space and, more concretely, a body-space. . . . The collective is a body, too. And the *physis* that is being organized for it in technology can, for all its political and factual reality, only be produced in that image-space in which profane illumination makes us feel at home. Only when in technology body- and image-space so interpenetrate that all revolutionary tension becomes bodily collective innervation, and all the bodily innervations of the collective become revolutionary discharge, has reality transcended itself to the extent demanded by the *Communist Manifesto*. (R 192 / GS 2:309–10)

67. On this point, see Comay, "Benjamin's Endgame," 255.

68. Soon after his appointment as minister for propaganda in March 1933, in a speech to representatives of the press, Goebbels confirms Bloch's suggestion that, despite its rhetoric of awakening, Nazism favored a kind of intoxication or addiction over enlightenment:

> We cannot be satisfied with just telling people what we want and enlightening them as to how we are doing it. We must replace this enlightenment with an active government propaganda that aims at winning people over. It is not enough to reconcile people more or less to our regime, to move them toward a position of neutrality toward us, we would rather work on people until they are addicted to us. (Cited in Welch, *Third Reich*, 24)

Welch includes the entire text of Goebbels' speech in the appendix to his book, 136–46. Goebbels refers later in the same speech to the propagandistic basis of the slogan "Germany Awake." He states:

> The art of propaganda is to gather completely confused, complex and composite ideas into a single catch slogan and then to instill this into the people as a whole. I must once more cite as proof a precedent from our own propaganda past, namely the Day of the Awakening Nation on 4 March. No one, either friend or foe, can have any doubts that this day was the greatest propaganda achievement realized in Germany within living memory. But this achievement was only made possible because for a whole week we abandoned all other work and focused the popular vision as if by hypnosis on this *one* event. (144–45)

69. For a reading of the relation in general in Benjamin between citation and history, see Balfour, "Reversal, Quotation (Benjamin's History)."

70. I am indebted here to Elissa Marder's discussion of this passage in "Flat Death," 138.

71. Jay's *Downcast Eyes*, 192–203, and Deleuze's *Cinema I* offer a general account of Bergson's recourse to the language of film and photography.

72. In a figure that would later be mobilized within contemporary film theory, Valéry also suggests that we can find the resources for a discussion of film already at work in the Greeks. He notes on the occasion of the centenary of the invention of photography: "What is Plato's famous cave, if not a *camera obscura*—the largest, I think, that has ever been realized? If Plato had reduced the mouth of his grotto to a tiny hole and applied a sensitized coat to the wall that served as his screen, by developing the rear of the cave he could have obtained a gigantic film; and heaven knows what surprising conclusions he might have left regarding the nature of our knowledge and the essence of our ideas" ("Centenary of Photography," 197 / "Centenaire de la photographie," 106).

73. For a condensed account of Bergson's critique of photography and cinematography, see *Creative Evolution*, 339–46.

74. I am indebted here to Derrida's analysis of the relation between the unconscious and techniques of reproduction in "Freud and the Scene of Writing."

75. A similar point is made by Jacques Lacan in his discussion of the role of the other's gaze in the constitution of our self as a photograph. He writes:

> I must, to begin with, insist on the following: in the scopic field, the gaze is outside, I am looked at, that is to say, I am a picture. . . . It is through the gaze that I enter light and it is from the gaze that I receive its effects. Hence it comes about that the gaze is the instrument through which light is embodied and through which—if you will allow me to use a word, as I often do, in a fragmented form—I am photographed. (106)

For a discussion of the photographic resources to be found in Lacan's concept of the gaze, see Silverman, "What Is a Camera?"

76. Benjamin links these images to a kind of cinematic movement, stating that "they present a quick sequence, like the small leaflets, precursors of the cinema, in which we, as children, could admire a boxer, a swimmer, or a tennis player during his activities" (*GS* 2:1064). He associates this cinematic image with the moment of dying at least two more times: once in the last paragraph of the *Berliner Kindheit* (4:304), and again at the end of his discussion of the motif of death in the tenth section of "The Storyteller" (*I* 94 / *GS* 2:449–50).

77. The word "experience" derives, as Roger Munier has noted, "from the latin *experiri*, to undergo. The radical is *periri*, which we find again in *periculum*, peril, danger." This etymological link between traversing and danger is kept in the German *Erfahrung*, experience, which itself derives from the old high German *fara*, danger, from which we get *Gefahr*, danger, and *gefährden*, to endanger. To experience some-

thing—and here we may recognize the strict sense that Benjamin gives the word *Erfahrung*—is to put oneself in danger, to exist within a permanent state of danger and emergency. For a fuller discussion of the etymology of "experience" see Munier's "réponse à une enquête sur l'expérience," in *Mise en page* 1 (May 1972), cited in Lacoue-Labarthe, *La poésie comme expérience*, 30–31.

78. On the relation between words and clouds in the *Berliner Kindheit*, see Hamacher, "Word *Wolke*—If It Is One." Although Hamacher does not address directly the photographic elements of "The Mummerehlen," I have found his concern with the issues of language and mimesis in this section to be closely related to my own discussion of Benjamin's photographic self-portraits.

79. In her history of nineteenth-century photography, Gisèle Freund (to whom Benjamin owes many of his thoughts on photography) reinforces this point when she notes that, within the space of the photographic studio, "the sitter seems to be nothing more than a prop in the studio" (*Photography and Society*, 61). In the effort to reproduce a replica of the bourgeois interior, the photographic studio becomes the means whereby the photographed becomes a corpse. Benjamin makes this point in relation to the late-nineteenth-century interior in *One-Way Street*. There, he writes:

> The bourgeois interior of the 1860s to the 1890s, with its gigantic sideboards distended with carvings, the sunless corners where palms stand, the bay window embattled behind its balustrade, and the long corridors with their singing gas flames, fittingly houses only the corpse. "On this sofa the aunt cannot but be murdered." The soulless luxuriance of the furnishings becomes true comfort only in the presence of a dead body. (*OWS* 48–49 / *GS* 4:89)

80. On the relation between language and the inscription of phenomena, see Fynsk, "Claim of History," 118–19.

81. If, as Benjamin suggests elsewhere, "a hell rages in the commodity soul" (*GS* 5:466), it is because of the multiple, shifting uses to which a commodity can be put—that is, because of its shifting significations. If this hell is interrupted at all it is only through an abstraction, a ghost—in this instance a ghost that, drinking the blood of the sacrificial animal, is now able to speak, and to speak the truth. The truth of this ghost names the dissimulation at the interior of the process of capital itself. Capital in fact requires that there be *mummen*. As Thomas Keenan notes, wherever "the capitalist mode of production prevails, something (economic) shows itself by hiding itself, by announcing itself as something else in another form" ("Point Is to (Ex)Change It," 157). It would be necessary here to trace the manner in which Benjamin mobilizes the language of disguise against the disguise he understands to be central to the progress of capital. Such an analysis might begin with his discussion of the relations and differences between allegory and the commodity in "Central Park."

82. In his 1902 "Tagebuch von Wengen," Benjamin describes his trip to the Alps with his mother and brother in terms that present, in miniature, many of the details

of this photographic scene from the *Berliner Kindheit*. See especially his description of the *Genrebild* that furnish many of Wengen's hotels (*GS* 6:235–42).

83. Benjamin's claim here goes a long way toward an account of why we are always asked to "smile" at the very moment when our photograph is about to be taken: we are being asked to prepare ourselves to become something else.

84. Balfour makes this point in a discussion of the relation in Benjamin between personification and reification ("Reversal, Quotation (Benjamin's History)," 645).

85. The necessity that Benjamin appear as another, that his sentences begin to refer elsewhere, is already written into his image of Kafka. In his notes to the Kafka essay, he writes: "Kafka leaves no process undistorted. In other words, everything that he describes makes statements about something other than itself. The continuous visionary presence of the disfigured things corresponds to the inconsolable seriousness, the despair in the gaze of the author himself" (*GS* 2:1204).

86. The passage in "Short History of Photography" reads as follows:

> This was the period of those studios which, with their draperies and palm trees, their tapestries and easels, occupied so ambiguous a place between execution and representation, between torture chamber and throne room, and to which an early portrait of Kafka bears distressing witness. There the boy stands, perhaps six years old, dressed up in a tight, almost humiliating child's suit overloaded with trimmings, in a kind of winter garden landscape. Palm fronds stand staring in the background. And as if to make these upholstered tropics still more sultry and oppressive, the subject holds in his left hand an oversized, broad-brimmed hat, such as Spaniards wear. He would surely be lost in this setting were it not for the immensely sad eyes, which dominate this landscape predetermined for them. (*OWS* 247 / *GS* 2:375)

Benjamin reworked the passage in a version closer to that of the *Berliner Kindheit* in his 1934 essay on Kafka. There, in "A Childhood Photograph," the passage reads as a kind of *Vorbild* of the *Berliner Kindheit* passage, especially in its last image:

> There is a childhood image of Kafka. Rarely has the "poor, brief childhood" been so movingly imaged. It was probably made in one of those nineteenth-century studios that, with their draperies and palm trees, tapestries and easels, stood so ambivalently between a torture chamber and a throne room. At the age of approximately six the boy is presented in a kind of winter garden landscape, wearing a tight, almost humiliating child's suit, overloaded with trimmings. Palm fronds stand staring in the background. And as if to make these upholstered tropics still more sultry and oppressive, the model holds in his left hand an oversized, broad-brimmed hat of the type worn by Spaniards. Immensely sad eyes dominate the landscape predetermined for them, into which the auricle [the shell] of a big ear listens. (*I* 118–19 / *GS* 2:416)

To my knowledge, Anna Stüssi is the first critic to register Benjamin's identification with Kafka here. See her *Erinnerung an die Zukunst*, especially pages 189–92, which are entitled "Photoatelier—die Folter-Kammer." Witte also makes this identification,

but he restricts his understanding of the relation primarily to the "social construction" of individuals "growing up among the Jewish upper bourgeoisie before the turn of the century" (*Walter Benjamin*, 14). Reading these two photographs in terms of Rimbaud's statement "I am an other," Amelunxen, in "Ein Eindruck der Vergängnis," 5–6, also conjures photography's relation to the questions of death and allegory in general. Finally, for a general discussion of Benjamin's identification with Kafka, see Corngold and Jennings, "Walter Benjamin/Gershom Scholem."

87. The uncanny relation here between Benjamin and Kafka perhaps can be understood best in relation to Freud's essay "The Uncanny." There, Freud links the motifs of repetition and the double to the media of film and photography. As Gunning reminds us:

> His discussion of the double proceeds from Otto Rank's classic essay on the theme [of "the constant recurrence of the same thing"], which—as Freud notes—began with a consideration of a film: the Hanns Heinz Ewers-Stellan and Rye-Paul Wegener 1913 production of *The Student of Prague*. This early classic of the German uncanny cinema portrayed its unearthly double through the old photographic trick of multiple exposure.... While both Freud and Rank demonstrate that the double has a long lineage (from archaic beliefs in detachable souls to the romantic Doppelgänger) that predates photography, nonetheless photography furnished a technology which would summon up an uncanny visual experience of doubling. ("Phantom Images and Modern Manifestations," 45)

This association between the process of doubling and that of technological reproduction helps explain why Benjamin—this student of Prague—presents himself as Kafka in the photography studio.

88. The name Potemkin is "itself" another name for *mummen*. Best known for the cardboard villages that he erected in order to deceive Catherine the Great on her tour of inspection in 1787, Potemkin has, at least since the writings of Jean Paul, entered the German language as a figure for disguise, for facades and dissimulation.

89. That Benjamin sees a significant association between this fable and the question of the signature in general is evidenced in his decision to retell the story under the title "Die Unterschrift," (The signature) (*GS* 4:758–59). According to Tiedemann, he first seems to have read the story in a collection of anecdotes about Russian history by Alexander Pushkin, published in Munich in 1924 (see *GS* 2:1271). His version follows Pushkin's quite closely, except in his substitution of the name Shuvalkin for the clerk whom Pushkin calls Petukov. This substitution helps Benjamin generalize the lesson of the fable beyond the particular example of Potemkin: there is no signature that is not that of an other. This is also the lesson of Bloch's retelling of the story in his "Potemkins Unterschrift," even though he stays with Pushkin's Petukov. In the brief analysis that he includes after his own rendition of the story—in which he links the questions of identity and the gaze to that of melancholy—he suggests that Pushkin has:

not only related the most uncanny document on melancholy to that endlessly self-questioning brooding that gropes in the fog, to the head in the nameless twilight that takes the name Petukov, because at least something stirs there, to the head that, in the light of bile, can still make all names grey, Petukov or Potemkin, same thing. But also, as the story of the *Prince Potemkin*, the happiest and favorite man, insofar as the happy, in general (not only the despots), at the height of their life, easily become melancholic (the still ambitious and the dreamers of glory are more easily manic), it shows how little height there often is above the fog, that is man, how his name and character often only stand like an island in it, one maybe more firmly elevated than Potemkin's but always one that can be darkened and hebrides-like. Indeed in what one calls heaven, even if it is painted according to the measure of the happiest time, for some, all the time, what matters is that it still might be only a nursery school for gazes, which are only a little out of the fog of being, the mourning of fulfillment. (*Werkausgabe*, 118–19)

90. I am indebted in this discussion of the signature to Derrida's "Signature Event Context," "Limited Inc.," and "Otobiographies."

91. If Benjamin suggests that this look to the side, this "askance gaze" (*scheele Blick*), is "the most characteristic thing about Kafka" (*GS* 2:1199), Adorno associates this gaze to that of the camera. As Benjamin writes, citing Adorno's note, "an old idea of Wiesengrund: Kafka: 'a photograph of earthly life from the perception of the redeemed one, of which nothing appears but a corner of the black cloth while the horribly twisted Optics of the image is none other than the one of the camera set askew'" (1251). Benjamin himself often identifies Kafka with the technical media in general and with film and photography in particular. In his essay on Kafka, for example, he writes: "The invention of film and the phonograph came in an age of maximum alienation of men from one another, of unforeseeably mediated relationships which have become their only ones. Experiments have proven that a man does not recognize his own gait on the screen or his own voice on the phonograph. The situation of the subject in such experiments is Kafka's situation" (*I* 137–38 / *GS* 2:436). See also *GS* 2:1256–57, where Benjamin compares the work of distortion at the heart of Kafka's writings to that of Chaplin's films, suggesting that Kafka's prose constitutes one of the last connections to the silent movies. It is no accident that the ghost of Kafka emerges within Benjamin's visit to the photography studio.

92. This is not the only time Benjamin identifies Kafka with Medusa. In a note that he recorded during one of his hashish trances, he allegorizes the process of reading by suggesting that, when we read, what we actually do is assimilate a statue of the writer to ourselves. When he reads Kafka's *Betrachtung*, for example, he claims to incorporate a stone image of Kafka into his body. At the same time, he says, it was "as if I were fleeing from Kafka's ghost and now, at the moment when he touched me, I turned into stone" (*GS* 6:565). If Benjamin first petrifies Kafka's book into a stone image of its author, this Medusa-like act of reading in turn transforms Benjamin into the same material from which Kafka's reproduction is made.

93. Kafka reinforces the optical character of his writings, again in his conversations with Janouch, in a passage that points to the rapid, interruptive quality of cinematic images. He notes: "It [the cinema] is a marvelous toy. But I dislike it because I am too optically disposed. I am an optical person. The cinema disturbs perception. The rapidity of movements and the rapid change of images compels the viewer to engage in a constant surfeit of viewing. The gaze does not control the images, but, on the contrary, the latter assume control of the gaze. They overwhelm consciousness" (cited in Janouch, *Gespräche mit Kafka*, 100). Benjamin makes a similar point in his "Work of Art" essay in a discussion of the shock experienced by film audiences:

> Let us compare the screen on which a film unfolds with the canvas of a painting. The latter invites the spectator to contemplation . . . before it he can abandon himself to his associations. Before the film frame [*Filmaufnahme*] he cannot do so. No sooner has his eye grasped a scene than it is already changed. It cannot be fixed. Duhamel, who dislikes film and knows nothing of its significance, though something of its structure, notes this circumstance as follows: "I can no longer think what I want to think. My thoughts have been replaced by moving images." The process of association, in view of these images, is immediately interrupted by their alteration. This constitutes the shock effect of the film which, like every shock effect, should be arrested by heightened presence of mind. (*I* 238 / *GS* 1:503)

94. The relation to death exhibited by both the mother and Kafka is mediated and reinforced by their relation to the realm of fashion. As Angelika Rauch has suggested, "fashion cannot emerge independently. It needs a willing but dead body, a thing, which it can disguise. The ideal support for fashion is therefore the mannequin" ("*Trauerspiel* of the Prostituted Body," 84). Or, in the wording of Benjamin, "fashion has never been anything other than a parody of the colorful corpse, a provocation of death through the woman," and "fashion exercises the rights of the corpse over the living" (*GS* 5:111, 130).

95. In his notes to his essay on Kafka, Benjamin claims that "when Proust in his *Recherche du temps perdu*, when Kafka, in his diaries, says 'I,' it is always the same transparent I, made of glass" (*GS* 2:1221).

96. My thinking on what it might mean to dwell within the shell of a mollusk is in part indebted to a reading of Francis Ponge, "The Mollusc," written between 1929 and 1932. There, Ponge writes: "The mollusc is a *being—almost a—quality*. It has no need of any frame— / work but only of a bulwark, something like the color in a tube. / Nature in this instance renounces the presentation of plasma formally. / She shows only that she prizes it by carefully sheltering it, in a jewelbox / whose inner face is most beautiful. / It isn't then a simple bit of spit, but a most precious reality. / The mollusc is endowed with a mighty energy for keeping itself shut / up. It is only to be truthful a muscle, a hinge, a blount and its door. / The blount having secreted its door. Two doors slightly concave con- / stitute its entire dwelling. / First and last dwelling. It lodges there until after its death. / No way to pull it out alive. / The least

cell of the human body clings so, and with this force, to / speech,—and recipro-
cally. / But at times another being comes to desecrate this tomb, once it is all / done,
and settles there in place of the defunct constructor. / This is the case of the pa-
gurian" (*Things*, 30). I am indebted to Elissa Marder for having directed me to this
poem and for her insights about its relation to Benjamin.

97. In a fragment, Benjamin discusses what he calls "the mysterious power of
memory to create closeness." Claiming that the rooms in which we live are closer to
us than to any visitor—"this is what is homely in the home," he says—he suggests
that the walls of children's rooms are in fact nearer than in reality. This is why, he
says, "their image tears us apart because we have attached ourselves to the wall" (*GS*
6:203). Like the photographic image that sets before us what is no longer there, the
image that comes to us in memory severs our relation to the walls in which we no
longer live. Like the mollusk, which can only be detached from its shell by dying, we
can only be detached from the walls of our memory by experiencing simultaneously
its loss and our death.

98. In his essay on Karl Kraus, Benjamin points to the auratic character of lan-
guage in general. Citing one of Kraus's aphorisms, he writes: "The more closely you
look at a word, the more distantly it looks back" (*R* 267 / *GS* 2:362). That Benjamin's
writing moves according to the auratic interplay between distance and proximity,
similarity and superimposition, and singularity and reproduction can be seen in his
various formulations of the theory of aura. These formulations not only repeat each
other, even as they say very different things, but they also reproduce texts by writers
with whom Benjamin shares a certain intimacy. We can find a remarkable instance
of such reproduction in the auratic scene that Benjamin offers in his "Short History
of Photography" (a scene that he later reproduces in altered form in his "Work of
Art" essay [*I* 222–23 / *GS* 1:479]). He writes: "What is the aura, actually? A Strange
weave of space and time: the unique appearance or semblance of a distance, no
matter how close the object may be. On a summer afternoon, resting, to follow a
chain of mountains on the horizon or a branch casting its shadow on the person
resting, until the moment or the hour becomes part of their appearance—that is
what it means to breathe in the aura of these mountains, of this branch" (*OWS*
250 / *GS* 2:378). What is remarkable here is something that to my knowledge has
never been noticed: Benjamin's description reproduces a scene near the end of
Proust's *Remembrance of Things Past*. In other words, Benjamin's definition of aura is
already a kind of citation. In a passage that brings together distance, mountains,
breath, and "a strange weave of space and time," Marcel writes:

> Yes, if the remembered image, thanks to forgetting, has been unable to contract any
> link, to forge any connection between itself and the present moment, if it has
> remained in its place, in its time, if it has kept its distance, its isolation in the hollow
> of a valley or at the summit of a mountain, it suddenly makes us breathe a fresh air,
> precisely because it is an air which we have breathed before—that purer air which
> the poets have vainly tried to establish in Paradise, and which could not convey that

profound sensation of renewal if it had not already been breathed, for the true
paradises are the paradises that we have lost. (*Remembrance of Things Past*, 2:994 /
Recherche du temps perdu, 4:449)

Linking singularity to repetition, the echolalia between these two passages tells us
that the auratic experience that Benjamin associates with the "unique appearance of
a distance, no matter how close the object may be" also appears as a mode of repro-
duction. The very passage that defines aura defines it by withdrawing from itself
toward another passage and, in so doing, stages the movement of distancing and
separation in which the auratic experience takes place. If the singularity of a work of
art is linked to its inscription within a tradition, this passage suggests that the singu-
larity of the auratic experience is inseparable from a process of reproduction and
repetition. This is why, for Benjamin, the disintegration or decline of the aura never
names the loss of the aura but rather what is always already repeated in the very
experience of aura.

99. Well aware of Proust's own obsessions with the questions of photography and
resemblance, Benjamin would have known the following passage from *Within the
Budding Grove* (one of the volumes of the *Recherche* that he and Hessel translated), in
which Marcel looks at a photograph of Mme de Guermantes:

> For this photograph was like one encounter more, added to all those that I had
> already had, with Mme. de Guermantes; better still, a prolonged encounter, as if, by
> some sudden progress in our relations, she had stopped beside me, in a garden hat,
> and had allowed me for the first time to gaze at my leisure at that plump cheek, that
> arched neck, that tapering eyebrow. . . . Later on, when I looked at Robert, I noticed
> that he too was a little like the photograph of his aunt, and by a mystery which I
> found almost as moving, since, if his face had not been directly created by hers, the
> two had nevertheless a common origin. The features of the Duchesse de Guerman-
> tes which were pinned to my vision of Combray, the nose like a falcon's beak, the
> piercing eyes, seemed to have served also as a pattern for the cutting out—in an-
> other copy analogous and slender, with too delicate a skin—of Robert's figure,
> which might almost be superimposed upon his aunt's. (*Remembrance of Things Past*,
> 1:770 / *Recherche du temps perdu*, 2:379)

100. For an analysis of the relation between prosopopeia and the writing of autobi-
ography, see de Man's "Autobiography as De-Facement." There, he reminds us that
the assumption of a face that takes place within the movement of prosopopeia "is
manifest in the trope's name, *prosopon poein*, to confer a mask or a face (*prosopon*)"
(76).

101. Hamacher makes this point not in relation to Benjamin in particular but to
words in general. See "Word *Wolke*—If It Is One," 152.

102. In holding the shell-ear [*Ohrmuschel*] of the little Kafka to his ear, Benjamin
reminds us that the word *Hörmuschel* also names the receiver (the *earpiece*) of a tele-
phone. Asserting a kind of telephonic relation between Kafka and himself, he directs

us to the telephonic connection that exists in Kafka's short story "The Neighbor" between the narrator and his neighbor, Harras. There, the narrator suspects that Harras can overhear his telephone conversations through the thin walls that connect rather than separate their two rooms. Claiming that this neighbor no longer needs a phone because he uses the narrator's, the narrator tells us that no matter where he puts the telephone receiver [*die Hörmuschel*], he is unable "to prevent secrets from being revealed" (*Complete Stories*, 425 / *Sämtliche Erzählungen*, 301). As in the doubling that occurs between Kafka and Benjamin, the narrator is unable to control the relays that take place between him and his neighbor. This doubling is already anticipated in the story's title: the word *Nachbar* comes from *nach-* (a prefix that is always associated with a process of imitation, copying, reproducing, and that can be traced back to a word that means "near" or "close") and *bauer* (the one who builds), which together suggest that the neighbor is the one who, after you, builds close to you, the one who—a kind of *Nachbild*, a copy or an afterimage—has the capacity to imitate you. Like the camera, the neighbor names what Benjamin calls the mimetic faculty.

103. For an argument that claims that the "I" can only be constituted from the ear of the other, see Derrida, "Otobiographies" and "Heidegger's Ear."

104. Cf. here Hamacher's analysis of the relation between death and poetry in "History, Teary," 73.

BIBLIOGRAPHY

Abbas, Ackbar. "On Fascination: Walter Benjamin's Images." *New German Critique* 48 (fall 1989): 43–62.

Adorno, Theodor W. "Benjamin the Letter Writer." Trans. Shierry Weber Nicholsen. In *Notes to Literature II*, ed. Rolf Tiedemann, 233–39. New York: Columbia University Press, 1992.

———. "Commitment." Trans. Shierry Weber Nicholsen. In *Notes to Literature II*, ed. Rolf Tiedemann, 76–94. New York: Columbia University Press, 1992.

———. "The Handle, the Pot, and Early Experience." Trans. Shierry Weber Nicholsen. In *Notes to Literature II*, ed. Rolf Tiedemann, 211–19. New York: Columbia University Press, 1992.

———. "Introduction to Benjamin's *Schriften*." Trans. Shierry Weber Nicholsen. In *Notes to Literature II*, ed. Rolf Tiedemann, 220–32. New York: Columbia University Press, 1992.

———. "Looking Back on Surrealism." Trans. Shierry Weber Nicholsen. In *Notes to Literature I*, ed. Rolf Tiedemann, 86–90. New York: Columbia University Press, 1991.

———. "Nachwort zur *Berliner Kindheit um neunzehnhundert*." In *Über Walter Benjamin*, 74–77. Frankfurt am Main: Suhrkamp Verlag, 1970.

———. "A Portrait of Walter Benjamin." In *Prisms*, trans. Samuel and Shierry Weber, 227–41. Cambridge: MIT Press, 1967.

Agamben, Giorgio. *Infancy and History: Essays on the Destruction of Experience*. Trans. Liz Heron. London: Verso, 1993.

Amelunxen, Hubertus von. "Ein Eindruck der Vergängnis: Vorläufige Bemerkung zu Walter Benjamin." *Fotogeschichte* 9, no. 34 (1989): 3–10.

———. "Skiagraphia—Silberchlorid und schwarze Galle: Zur allegorischen Bestimmung des photographischen Bildes." In *Allegorie und Melancholie*, ed. Willem van Reijen, 90–108. Frankfurt am Main: Suhrkamp Verlag, 1992.

Bahti, Timothy. *Allegories of History: Literary Historiography after Hegel*. Baltimore: Johns Hopkins University Press, 1992.

———. "History as Rhetorical Enactment: Walter Benjamin's Theses 'On the Concept of History.'" *diacritics* 9, no. 3 (September 1979): 2–17.

Balfour, Ian. "Reversal, Quotation (Benjamin's History)." *MLN* 106, no. 3 (April 1991): 622–47.

Barthes, Roland. *Camera Lucida: Reflections on Photography*. Trans. Richard Howard. New York: Farrar, Straus, and Giroux, 1981.

Batchen, Geoffrey. "Burning with Desire: The Birth and Death of Photography." *Afterimage* 17, no. 6 (January 1990): 8–11.

——. "Desiring Production Itself: Notes on the Invention of Photography." In *Cartographies: Poststructuralism and the Mapping of Bodies and Spaces*, ed. Rosalyn Diprose and Robyn Ferrell, 13–26. Sydney: Allan and Unwin, 1991.

Baudelaire, Charles. "The Salon of 1859." In *Selected Writings on Art and Literature*, trans. P. E. Charvet, 285–324. London: Penguin Books, 1992.

Bellour, Raymond. "Ideal Hadaly." *Camera Obscura* 15 (1986): 111–33.

Benjamin, Walter. *Briefe*. Ed. Gershom Scholem and Theodor W. Adorno. Frankfurt am Main: Suhrkamp Verlag, 1978.

——. "Central Park." Trans. Lloyd Spencer. *New German Critique* 34 (winter 1985): 32–58.

——. *Charles Baudelaire: A Lyric Poet in the Era of High Capitalism*. Trans. Harry Zohn. London: New Left Books, 1973.

——. *The Correspondence of Walter Benjamin and Gershom Scholem: 1932–1940*. Ed. Gershom Scholem. Trans. Gary Smith and Andre Lefevere. New York: Schocken Books, 1989.

——. *The Correspondence of Walter Benjamin, 1910–1940*. Ed. Gershom Scholem and Theodor W. Adorno. Trans. Manfred R. Jacobson and Evelyn M. Jacobson. Chicago: University of Chicago Press, 1994.

——. "Doctrine of the Similar." Trans. Knut Tarnowski. *New German Critique* 17 (spring 1979): 65–69.

——. *Gesammelte Schriften*. 7 vols. Ed. Rolf Tiedemann and Hermann Schweppenhäuser. Frankfurt am Main: Suhrkamp Verlag, 1972–.

——. *Illuminations*. Ed. Hannah Arendt. Trans. Harry Zohn. New York: Schocken Books, 1968.

——. "N [Theoretics of Knowledge; Theory of Progress]." Trans. Leigh Hafrey and Richard Sieburth. In *Benjamin: Philosophy, Aesthetics, History*, ed. Gary Smith, 43–83. Chicago: University of Chicago Press, 1989.

——. *One-Way Street, and Other Writings*. Trans. Edmund Jephcott and Kingsley Shorter. London: New Left Books, 1979.

——. *Origin of German Tragic Drama*. Trans. John Osborne. London: New Left Books, 1977.

——. *Reflections*. Ed. Peter Demetz. Trans. Edmund Jephcott. New York: Harcourt Brace, 1978.

——. "Theories of German Fascism." Trans. Jerolf Wikoff. *New German Critique* 17 (spring 1979): 120–28.

——. *Walter Benjamin/Gershom Scholem: Briefwechsel, 1933–1940*. Ed. Gershom Scholem. Frankfurt am Main: Suhrkamp Verlag, 1980.

Bergson, Henri. *Creative Evolution*. Trans. Arthur Mitchell. New York: Random House, 1944.

——. *Matter and Memory*. Trans. Nancy Margaret Paul and W. Scott Palmer. New York: Zone Books, 1991.

Blanchot, Maurice. *The Infinite Conversation*. Trans. Susan Hanson. Minneapolis: University of Minnesota Press, 1993.

——. "The Two Versions of the Imaginary." In *The Space of Literature*, trans. Ann Smock, 254–63. Lincoln: University of Nebraska Press, 1982.

——. *The Writing of Disaster*. Trans. Ann Smock. Lincoln: University of Nebraska Press, 1986.

Blanqui, Louis Auguste. *L'éternité par les astres: Hypothèse astronomique*. Paris: Ballière, 1872.

——. *Oeuvres*. Vol. 1, *Des origines à la Révolution de 1848*. Ed. Dominique Le Nuz. Nancy: Presses universitaires de Nancy, 1993.

Bloch, Ernst. *Geist der Utopie*. Munich: Verlag von Duncker und Humblot, 1918.

——. *Heritage of Our Times*. Trans. Neville and Stephen Plaice. Berkeley and Los Angeles: University of California Press, 1990.

——. *The Principle of Hope*. 3 vols. Trans. Neville Plaice, Stephen Plaice, and Paul Knight. Cambridge: MIT Press, 1986.

——. *Werkausgabe*. Vol. 1, *Spuren*. Frankfurt am Main: Suhrkamp Verlag, 1969.

Bolz, Norbert. "Der Fotoapparat der Erkenntnis." *Fotogeschichte* 9, no. 32 (1989): 21–27.

Buck-Morss, Susan. *The Dialectics of Seeing: Walter Benjamin and the Arcades Project*. Cambridge: MIT Press, 1989.

Caruth, Cathy. "Unclaimed Experience: Trauma and the Possibility of History." *Yale French Studies* 79 (1991): 181–92.

Chevrier, J. F. *Écrit sur l'image: Proust et la photographie*. Paris: Éditions de l'Étoile, 1982.

Chow, Rey. "Walter Benjamin's Love Affair with Death." *New German Critique* 48 (fall 1989): 63–86.

Cohen, Margaret. *Profane Illumination: Walter Benjamin and the Paris of Surrealist Revolution*. Berkeley and Los Angeles: University of California Press, 1993.

Comay, Rebecca. "Benjamin's Endgame." In *Walter Benjamin's Philosophy: Destruction and Experience*, ed. Andrew Benjamin and Peter Osborne, 251–91. London: Routledge, 1994.

Corngold, Stanley, and Michael Jennings. "Walter Benjamin / Gershom Scholem." *Interpretation* 12 (1984): 357–66.

Deleuze, Gilles. *Cinema I: The Movement-Image*. Trans. Hugh Tomlinson and Barbara Habberjam. London: Athlone Press, 1986.

——. *Nietzsche and Philosophy*. Trans. Hugh Tomlinson. New York: Columbia University Press, 1983.

De Man, Paul. "Autobiography as De-Facement." In *The Rhetoric of Romanticism*, 67–82. New York: Columbia University Press, 1984.

——. "'Conclusions' on Walter Benjamin's 'The Task of the Translator.'" *Yale French Studies* 69 (1985): 25–46.

Derrida, Jacques. *Aporias*. Trans. Thomas Dutoit. Stanford: Stanford University Press, 1993.

Derrida, Jacques. "By Force of Mourning." Trans. Pascale-Anne Brault and Michael Naas. *Critical Inquiry* 22, no. 2 (winter 1996): 171–92.

———. "The Deaths of Roland Barthes." Trans. Pascale-Anne Brault and Michael Naas. In *Philosophy and Non-Philosophy since Merleau-Ponty*, ed. Hugh Silverman, 259–96. New York: Routledge, 1989.

———. "Differánce." In *Margins of Philosophy*, trans. Alan Bass, 1–27. Chicago: University of Chicago Press, 1982.

———. "Force and Signification." In *Writing and Difference*, trans. Alan Bass, 3–30. Chicago: University of Chicago Press, 1978.

———. "Force of Law: The 'Mystical Foundation of Authority.'" Trans. Mary Quaintance. *Cardozo Law Review* 11, no. 5–6 (July/August 1994): 919–1045.

———. "Freud and the Scene of Writing." In *Writing and Difference*, trans. Alan Bass, 196–231. Chicago: University of Chicago Press, 1978.

———. "Heidegger's Ear: Philopolemology (*Geschlecht* IV)." Trans. John P. Leavey, Jr. In *Reading Heidegger: Commemorations*, ed. John Sallis, 163–218. Bloomington: Indiana University Press, 1993.

———. "Limited Inc a b c . . ." In *Limited Inc.*, trans. Samuel Weber, 29–110. Evanston: Northwestern University Press, 1988.

———. *Mal d'archive*. Paris: Éditions Galilée, 1995.

———. *Mémoires: For Paul de Man*. Trans. Cecile Lindsay, Jonathan Culler, and Eduardo Cadava. New York: Columbia University Press, 1986.

———. *Of Grammatology*. Trans. Gayatri Chakravorty Spivak. Baltimore: Johns Hopkins University Press, 1976.

———. "Otobiographies: The Teaching of Nietzsche and the Politics of the Proper Name." In *The Ear of the Other*, trans. Avital Ronell, 1–38. Lincoln: University of Nebraska Press, 1988.

———. "The Right to Inspection." Trans. David Wills. *Art and Text* 32 (autumn 1989): 20–97.

———. "Signature Event Context." In *Limited Inc.*, trans. Samuel Weber, 1–23. Evanston: Northwestern University Press, 1988.

Desnos, Robert. "Spectacles of the Street—Eugène Atget." Trans. Berenice Abbott. In *Photography in the Modern Era: European Documents and Critical Writings, 1913–1940*, ed. Christopher Phillips, 16–17. New York: Metropolitan Museum of Art/Aperture, 1989.

Dienst, Richard. *Still Life in Real Time: Theory after Television*. Durham, N.C.: Duke University Press, 1994.

Dommanget, Maurice. *Blanqui: La guerre de 1870–1871 et la Commune*. Paris: Éditions Domat, 1947.

Düttmann, Alexander García. *La parole donnée: Mémoire et promesse*. Paris: Éditions Galilée, 1989.

———. "Tradition and Destruction: Benjamin's Politics of Language." Trans. Debbie Keates. *MLN* 106, no. 3 (April 1991): 528–54.

Fenves, Peter. *A Peculiar Fate: Metaphysics and World-History in Kant.* Ithaca, N.Y.: Cornell University Press, 1991.

Freud, Sigmund. *The Standard Edition of the Complete Psychological Works of Sigmund Freud.* 24 vols. Ed. and trans. James Strachey. London: Hogarth Press, 1953–74.

Freund, Gisèle. *La photographie en France au dix-neuvième siècle: Étude de sociologie et d'esthétique, avec vingt-quatre photographie hors-texte.* Paris: La maison des amis des livres, A. Monnier, 1936.

———. *Photography and Society.* Trans. Richard Dunn et al. Boston: David R. Godine, 1980.

Fürnkäs, Josef. *Surrealismus als Erkenntnis: Walter Benjamin—Weimarer Einbahnstraße und Pariser Passagen.* Stuttgart: Metzler, 1988.

Fynsk, Christopher. "The Claim of History." *diacritics* 22, no. 3–4 (fall/winter 1992): 115–26.

Gasché, Rodolphe. "Objective Diversions: On Some Kantian Themes in Benjamin's 'The Work of Art in the Age of Mechanical Reproduction.'" In *Walter Benjamin's Philosophy: Destruction and Experience*, ed. Andrew Benjamin and Peter Osborne, 183–204. London: Routledge, 1994.

———. "The Stelliferous Fold: On Villiers de l'Isle-Adam's *L'Eve future.*" *Studies in Romanticism* 22 (summer 1983): 293–327.

Geulen, Eva. "Zeit zur Darstellung: Walter Benjamins *Das Kunstwerk im Zeitalter seiner technischen Reproduzierbarkeit.*" *MLN* 107, no. 3 (April 1992): 580–605.

Gunning, Tom. "Phantom Images and Modern Manifestations: Spirit Photography, Magic Theater, Trick Films, and Photography's Uncanny." In *Fugitive Images: From Photography to Video*, ed. Patrice Petro, 42–71. Bloomington: Indiana University Press, 1995.

Hamacher, Werner. "History, Teary: Some Remarks on *La jeune parque.*" Trans. Michael Shae. *Yale French Studies* 74 (1988): 67–94.

———. "Journals, Politics." Trans. Peter Burgard et al. In *Responses: On Paul de Man's Wartime Journalism*, ed. Werner Hamacher, Neil Hertz, and Thomas Keenan, 438–67. Lincoln: University of Nebraska Press, 1988.

———. "The Word *Wolke*—If It Is One." Trans. Peter Fenves. *Studies in Twentieth-Century Literature* 11, no. 1 (fall 1986): 133–61.

Hansen, Miriam. "Benjamin, Cinema, and Experience: 'The Blue Flower in the Land of Technology.'" *New German Critique* 40 (winter 1987): 179–224.

———. "'With Skin and Hair': Kracauer's Theory of Film, Marseille 1940." *Critical Inquiry* 19, no. 3 (spring 1993): 437–69.

Heidegger, Martin. "The Age of the World Picture." Trans. William Lovitt. In *The Question Concerning Technology and Other Essays*, 115–54. New York: Harper and Row, 1977.

———. "Das Ding." In *Vorträge und Augsätze*, 37–55. Pfullingen, Germany: Neske, 1954.

———. *Holzwege.* Frankfurt am Main: Vittorio Klostermann, 1980.

Heidegger, Martin. *Kant and the Problem of Metaphysics*. Trans. Richard Taft. Bloomington: Indiana University Press, 1990.

————. *On the Way to Language*. Trans. Peter D. Hertz. New York: Harper and Row, 1971.

————. *The Principle of Reason*. Trans. Reginald Lilly. Bloomington: Indiana University Press, 1991.

————. "The Thing." In *Poetry, Language, Thought*, trans. Albert Hofstadter, 163–86. New York: Harper and Row, 1971.

————. *Unterwegs zur Sprache*. Pfullingen, Germany: Neske, 1959.

Hitler, Adolf. *Mein Kampf*. Munich: Zentralverlag der NSDAP, 1938.

————. *Mein Kampf*. Trans. Alvin Johnson et al. New York: Reynal and Hitchcock, 1940.

Homer. *The Odyssey*. Trans. Robert Fitzgerald. New York: Doubleday, 1963.

Hutton, Patrick H. *The Cult of the Revolutionary Tradition: The Blanquists in French Politics, 1864–1893*. Berkeley and Los Angeles: University of California Press, 1981.

Huyssen, Andreas. "Fortifying the Heart—Totally: Ernst Jünger's Armored Texts." *New German Critique* 59 (spring/summer 1993): 3–23.

Jacobs, Carol. "Benjamin's Tessera: 'Myslowitz—Braunschweig—Marseille.'" *diacritics* 22, nos. 3–4 (fall/winter 1992): 36–47.

————. "The Monstrosity of Translation: Walter Benjamin's 'The Task of the Translator.'" In *Telling Time: Lévi-Strauss, Ford, Lessing, Benjamin, de Man, Wordsworth, Rilke*, 128–41. Baltimore: Johns Hopkins University Press, 1993.

————. "Walter Benjamin: Image of Proust." In *The Dissimulating Harmony: The Image of Interpretation in Nietzsche, Rilke, Artaud, and Benjamin*, 87–110. Baltimore: Johns Hopkins University Press, 1978.

Jameson, Frederic. "Benjamin's Readings." *diacritics* 22, nos. 3–4 (fall/winter 1992): 19–34.

Janouch, Gustav. *Gespräche mit Kafka*. Frankfurt am Main: S. Fischer Verlag, 1968.

Jay, Martin. *Downcast Eyes: The Denigration of Vision in Twentieth-Century French Thought*. Berkeley and Los Angeles: University of California Press, 1993.

Jennings, Michael. *Dialectical Images: Walter Benjamin's Theory of Literary Criticism*. Ithaca, N.Y.: Cornell University Press, 1987.

Jünger, Ernst. "Krieg und Lichtbild." In *Das Antlitz des Weltkrieges: Fronterlebnisse deutscher Soldaten*, ed. Ernst Jünger, 9–11. Berlin: Neufeld und Henius, 1930.

————. "On Danger." Trans. Donald Reneau. *New German Critique* 59 (spring/summer 1993): 27–32.

————. "Photography and the 'Second Consciousness': An Excerpt from 'On Pain.'" Trans. Joel Agee. In *Photography in the Modern Era: European Documents and Critical Writings, 1913–1940*, ed. Christopher Phillips, 207–10. New York: Metropolitan Museum of Art/Aperture, 1989.

————. "Die Totale Mobilmachung." In *Sämtliche Werke*. Vol. 7, *Essays I: Betrachtungen zur Zeit*, 119–42. Stuttgart: Klett-Cotta Verlag, 1980.

————. "Total Mobilization." Trans. Joel Golb and Richard Wolin. In *The Heidegger*

Controversy: A Critical Reader, ed. Richard Wolin, 119–39. New York: Columbia University Press, 1991.

————. "Über den Schmerz." In *Sämtliche Werke*. Vol. 7, *Essays I: Betrachtungen zur Zeit*, 143–91. Stuttgart: Klett-Cotta Verlag, 1980.

————. "Über die Gefahr." In *Der gefährliche Augenblick: Eine Bilderfibel unserer Zeit*, ed. Ferdinand Bucholtz, 11–16. Berlin: Junker und Dünhaupt, 1931.

————. "War and Photography." Trans. Anthony Nassar. *New German Critique* 59 (spring/summer 1993): 24–26.

Kaes, Anton. "The Cold Gaze: Notes on Mobilization and Modernity." *New German Critique* 59 (spring/summer 1993): 105–17.

Kafka, Franz. *The Complete Stories*. Ed. Nahum N. Glatzer. New York: Schocken Books, 1971.

————. *Sämtliche Erzählungen*. Ed. Paul Raabe. Frankfurt: S. Fischer Verlag, 1970.

Kant, Immanuel. *Critique of Pure Reason*. Trans. Norman Kemp Smith. New York: St. Martin's Press, 1965.

Keenan, Thomas. "The Point Is to (Ex)Change It: Reading *Capital*, Rhetorically." In *Fetishism as Cultural Discourse*, ed. Emily Apter and William Pietz, 152–85. Ithaca, N.Y.: Cornell University Press, 1993.

Kracauer, Siegfried. "The Cult of Distraction." In *The Mass Ornament: Weimar Essays*, trans. and ed. Thomas Y. Levin, 323–28. Cambridge: Harvard University Press, 1995.

————. *History: The Last Things before the Last*. New York: Oxford University Press, 1969.

————. "Die Photographie." In *Das Ornament der Masse: Essays*, 21–39. Frankfurt: Suhrkamp Verlag, 1977.

————. "Photography." In *The Mass Ornament: Weimar Essays*, trans. and ed. Thomas Y. Levin, 47–63. Cambridge: Harvard University Press, 1995.

————. *Schriften*. Vol. 1, *Die Angestellten: Aus dem neuesten Deutschland*. Ed. Inka Mülder-Bach. Frankfurt am Main: Suhrkamp Verlag, 1990.

Krauss, Rosalind. "Corpus Delicti." In *L'amour fou: Photography and Surrealism*, ed. Rosalind Krauss and Janet Livingston, 55–112. New York: Abbeville Press, 1986.

————. "The Photographic Conditions of Surrealism." In *The Originality of the Avante-Garde and Other Modernist Myths*, 87–118. Cambridge: MIT Press, 1985.

————. "Photography in the Service of Surrealism." In *L'amour fou: Photography and Surrealism*, ed. Rosalind Krauss and Janet Livingston, 13–54. New York: Abbeville Press, 1986.

Lacan, Jacques. *The Four Fundamental Concepts of Psychoanalysis*. Trans. Alan Sheridan. Ed. Jacques-Alain Miller. New York: W. W. Norton, 1981.

Lacoue-Labarthe, Philippe. *Heidegger, Art and Politics*. Trans. Chris Turner. Oxford: Basil Blackwell, 1990.

————. *La poésie comme expérience*. Paris: Christian Bourgois éditeur, 1986.

————. "The Unpresentable." Trans. Claudette Sartiliot. In *The Subject of Philosophy*, ed. Thomas Trezise, 116–57. Minneapolis: University of Minnesota Press, 1993.

Lacoue-Labarthe, Philippe, and Jean-Luc Nancy. "The Nazi Myth." Trans. Brian Holmes. *Critical Inquiry* 16, no. 2 (winter 1990): 291–312.

Lehning, Arthur. "Walter Benjamin and *i10*." Trans. Timothy Nevill. In *For Walter Benjamin*, ed. Ingrid Scheurmann and Konrad Scheurmann, 56–67. Bonn: Arbeitskreis selbständiger Kultur-Institute, 1993.

Mac Orlan, Pierre. "Elements of a Social Fantastic." Trans. Robert Erich Wolf. In *Photography in the Modern Era: European Documents and Critical Writings, 1913–1940*, ed. Christopher Phillips, 31–33. New York: Metropolitan Museum of Art / Aperture, 1989.

———. "Preface to *Atget photographe de Paris*." Trans. Robert Erich Wolf. In *Photography in the Modern Era: European Documents and Critical Writings, 1913–1940*, ed. Christopher Phillips, 41–49. New York: Metropolitan Museum of Art / Aperture, 1989.

Marder, Elissa. "Flat Death: Snapshots of History." *diacritics* 22, nos. 3–4 (fall / winter 1992): 128–44.

Mehlman, Jeffrey. *Walter Benjamin for Children: An Essay on His Radio Years*. Chicago: University of Chicago Press, 1993.

Menke, Bettine. *Sprachfiguren: Name, Allegorie, Bild nach Benjamin*. Munich: Wilhelm Fink Verlag, 1991.

Moholy-Nagy, László. "Light Painting." Trans. Erich Roll. In Krisztina Passuth, *Moholy-Nagy*, trans. Éva Grusz et al., 343–44. London: Thames and Hudson, 1987.

———. "Photography in Advertising." Trans. Joel Agee. In *Photography in the Modern Era: European Documents and Critical Writings, 1913–1940*, ed. Christopher Phillips, 83–85. New York: Metropolitan Museum of Art / Aperture, 1989.

———. "Unprecedented Photography." Trans. Joel Agee. In *Photography in the Modern Era: European Documents and Critical Writings, 1913–1940*, ed. Christopher Phillips, 86–93. New York: Metropolitan Museum of Art / Aperture, 1989.

———. "Zur Diskussion über Malerei und Photographie." *i10* 6 (1927): 227–40.

Moses, Stéphane. "Ideas, Names, Stars: On Walter Benjamin's Metaphors of Origin." Trans. Timothy Nevill. In *For Walter Benjamin*, ed. Ingrid Scheurmann and Konrad Scheurmann, 180–88. Bonn: Arbeitskreis selbständiger Kultur-Institute, 1993.

Nadar [Felix Tournachon]. "My Life as a Photographer." Trans. Thomas Repensek. *October* 5 (summer 1978): 7–28.

———. *Quand j'étais photographe*. Paris: Éditions d'aujourd'hui, 1979.

Nägele, Rainer. *Theater, Theory, Speculation: Walter Benjamin and the Scenes of Modernity*. Baltimore: Johns Hopkins University Press, 1991.

Nancy, Jean-Luc. *The Experience of Freedom*. Trans. Bridget McDonald. Stanford: Stanford University Press, 1993.

———. "Finite History." In *The States of Theory*, ed. David Carroll, 149–72. New York: Columbia University Press, 1990.

———. *The Inoperative Community*. Trans. Peter Connor. Minneapolis: University of Minnesota Press, 1991.

———. *L'oubli de la philosophie*. Paris: Éditions Galilée, 1986.

————. *Le poids d'une pensée*. Sainte-Foy, Québec: Les éditions Le griffon d'argile, 1991.

Nietzsche, Friedrich. *The Will to Power*. Trans. Walter Kaufmann and R. J. Hollingdale. New York: Random House, 1967.

Passuth, Krisztina. *Moholy-Nagy*. Trans. Éva Grusz et al. London: Thames and Hudson, 1987.

Ponge, Francis. *Things*. Trans. Cid Corman. New York: Grossman, 1971.

Price, Mary. *The Photograph: A Strange Confined Space*. Stanford: Stanford University Press, 1994.

Proust, Marcel. *À la recherche du temps perdu*. 4 vols. Ed. Jean-Yves Tadié et al. Paris: Éditions Gallimard, 1987.

————. *Remembrance of Things Past*. Trans. C. K. Scott Moncrieff. New York: Random House, 1961.

Puppe, Heinz W. "Walter Benjamin on Photography." *Colloquia Germania* 12, no. 3 (1979): 273–91.

Rauch, Angelika. "The *Trauerspiel* of the Prostituted Body, or Woman as Allegory of Modernity." *Cultural Critique* 10 (fall 1988): 77–88.

Ray, Man. "The Age of Light." In *Photography in the Modern Era: European Documents and Critical Writings, 1913–1940*, ed. Christopher Phillips, 52–54. New York: Metropolitan Museum of Art/Aperture, 1989.

Reichel, Peter. *Der schöne Schein des Dritten Reiches: Faszination und Gewalt des Faschismus*. Munich: Carl Hanser Verlag, 1991.

Reimann, Viktor. *The Man Who Created Hitler*. London: William Kimber, 1977.

Rella, Franco. "Benjamin e Blanqui." In *Critica e Storia: Materiali su Benjamin*, ed. Franco Rella, 181–200. Venice: Cluva Libreria Editrice, 1980.

Rickels, Laurence. *Aberrations of Mourning: Writings on German Crypts*. Detroit: Wayne State University Press, 1988.

Ronell, Avital. "The *Differends* of Man." In *Finitude's Score: Essays for the End of the Millennium*, 255–68. Lincoln: University of Nebraska Press, 1994.

————. "Support Our Tropes: Reading Desert Storm." In *Finitude's Score: Essays for the End of the Millennium*, 269–92. Lincoln: University of Nebraska Press, 1994.

————. *The Telephone Book: Technology, Schizophrenia, Electric Speech*. Lincoln: University of Nebraska Press, 1989.

————. "Trauma TV: Twelve Steps beyond the Pleasure Principle." In *Finitude's Score: Essays for the End of the Millennium*, 305–28. Lincoln: University of Nebraska Press, 1994.

Rouillé, André. "*When I Was a Photographer*: The Anatomy of a Myth." In *Nadar*, ed. Maria M. Hambourg, 107–14. New York: Metropolitan Museum of Art, 1995.

Schaaf, Larry. *Out of the Shadows: Herschel, Talbot, and the Invention of Photography*. New Haven: Yale University Press, 1992.

Scholem, Gershom. "Toward an Understanding of the Messianic Idea in Judaism." Trans. Michael A. Meyer. In *The Messianic Idea in Judaism and Other Essays on Jewish Spirituality*, 1–36. New York: Schocken Books, 1971.

Scholem, Gershom. *Walter Benjamin: The Story of a Friendship.* Trans. Harry Zohn. New York: Schocken Books, 1981.

Schwarz, Heinrich. *David Octavius Hill: Der Meister der Photographie, mit 80 Bildtafeln.* Leipzig: Insel-Verlag, 1931.

Shattuck, Roger. *Proust's Binoculars: A Study of Memory, Time, and Recognition in À la recherche du temps perdu.* Princeton: Princeton University Press, 1983.

Silverman, Kaja. "What Is a Camera? Or, History in the Field of Vision." *Discourse* 15, no. 3 (spring 1993): 3–56.

Soupault, Philippe. *Baudelaire.* Paris: Les éditions Rieder, 1931.

Stevenson, Sara, ed. *David Octavius Hill and Robert Adamson: Catalogue of their Calotypes Taken between 1843 and 1847 in the Collection of the Scottish National Portrait Gallery.* Edinburgh: National Galleries of Scotland, 1981.

Stiegler, Bernard. "Mémoires gauches." *Revue philosophique* 2 (1990): 361–94.

————. *La technique et le temps.* Vol. 1, *La faute d'Épiméthée.* Paris: Éditions Galilée, 1994.

Stüssi, Anna. *Erinnerung an die Zukunst: Walter Benjamins "Berliner Kindheit um 1900."* Göttingen: Vandenhoeck und Ruprecht, 1977.

Syberberg, Hans-Jürgen. *Die freudlose Gesellschaft: Notizen aus dem letzten Jahr.* Munich: Hanser Verlag, 1981.

————. *Hitler: A Film from Germany.* Trans. Joachim Neugroschel. New York: Farrar, Straus, and Giroux, 1982.

Talbot, William Henry Fox. *The Pencil of Nature.* London: Longman, Brown, Green, and Longmans, 1844.

Tiedemann, Rolf, Christoph Gödde, and Henri Lonitz, eds. *Walter Benjamin: 1892–1940.* Marbach am Neckar: Deutsche Schillergesellschaft, 1990.

Valéry, Paul. "Centenaire de la photographie." In Liborio Termine, *Paul Valéry e la mosca sul vetro: Fotografia e modernità,* 88–109. Turin: Aleph Editore, 1991.

————. "The Centenary of Photography." Trans. Roger Shattuck and Frederick Brown. In *Classical Essays on Photography,* ed. Alan Trachtenberg, 191–98. Stony Creek, Conn.: Leete's Island Books, 1980.

Villiers de l'Isle-Adam. *Tomorrow's Eve.* Trans. Robert Martin Adams. Urbana: University of Illinois Press, 1982.

Virilio, Paul. *War and Cinema: The Logistics of Perception.* Trans. Patrick Camiller. New York: Verso, 1989.

Weber, Samuel. "Genealogy of Modernity: History, Myth, and Allegory in Benjamin's *Origin of the German Mourning Play.*" *MLN* 106, no. 3 (April 1991): 465–500.

————. "Mass Mediauras, or: Art, Aura, and Media in the Work of Walter Benjamin." In *Mass Mediauras: Form, Technics, Media,* 76–107. Stanford: Stanford University Press, 1996.

————. "The Media and the War." *Alphabet City* 1 (summer 1991): 22–26.

————. "Taking Exception to Decision: Walter Benjamin and Carl Schmitt." *diacritics* 22, no. 3–4 (fall/winter 1992): 5–18.

————. "Theater, Technics, and Writing." *1–800* (fall 1989): 15–20.

Welch, James. *Propaganda and the German Cinema: 1933–1945*. Oxford: Clarendon Press, 1983.

————. *The Third Reich: Politics and Propaganda*. New York: Routledge, 1995.

Werneburg, Brigitte. "Ernst Jünger and the Transformed World." *October* 62 (fall 1992): 43–64.

Witte, Bernd. *Walter Benjamin: An Intellectual Biography*. Trans. James Rolleston. Detroit: Wayne State University Press, 1991.

Wohlfarth, Irving. "The Measure of the Possible, the Weight of the Real, and the Heat of the Moment: Benjamin's Actuality Today." *New Formations* 20 (summer 1993): 1–20.

————. "On the Messianic Structure of Walter Benjamin's Last Reflections." In *Glyph 3*, 148–212. Baltimore: Johns Hopkins University Press, 1978.

————. "Walter Benjamin's Image of Interpretation." *New German Critique* 17 (spring 1979): 70–98.

Wolin, Richard. *Walter Benjamin: An Aesthetic of Redemption*. New York: Columbia University Press, 1982.

INDEX